MANGA MANIA
FANTASY WORLDS

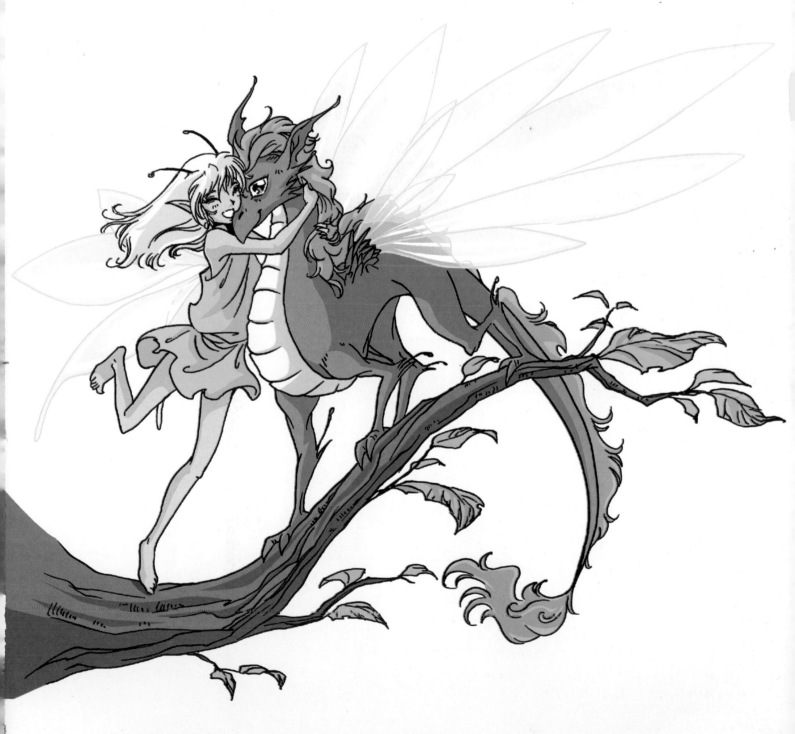

HOW TO DRAW THE AMAZING WORLDS OF JAPANESE COMICS

WATSON-GUPTILL PUBLICATIONS/NEW YORK

Dedicated to Maria, Isabella, and Francesca, the most wonderful people I know.

SPECIAL THANKS TO:

Everyone at Watson-Guptill:
my editor, Alisa Palazzo; Bob Ferro;
Candace Raney; Charles Whang;
Ellen Greene; Hector Campbell;
Bob Fillie; Sheila Emery;
and Lee Wiggins.

Senior Editor: Candace Raney
Project Editor: Alisa Palazzo
Designer: Bob Fillie, Graphiti Design, Inc.
Production Manager: Hector Campbell

First published in 2003
by Watson-Guptill Publications
a division of VNU Business Media, Inc.
770 Broadway, New York, NY 10003
www.watsonguptill.com

Copyright © 2003 Star Fire, LLC

Library of Congress Cataloging-in-Publication Data
Hart, Christopher.
 Manga mania fantasy worlds : how to draw the amazing worlds
 of Japanese comics / Christopher Hart.
 p. cm.
 Includes index.
 ISBN 0-8230-2972-7 (pbk.)
 1. Comic books, strips, etc.—Japan—Technique. 2. Drawing—Technique.
 3. Fantasy in art. I. Title.
 NC1764.5.J3H3693 2003
 741.5—dc21

 2003007972

Printed in the United States of America

4 5 6 7 8 / 10 09 08 07 06 05

CONTRIBUTING ARTISTS:

Svetlana Chmakova: 1, 58–83
Tim Eldred: 8, 42–45
Dan Fraga: 98, 110–114, 132–143
Ale Garza: 94, 95, 99–109
Christopher Hart: 9
Jin Song Kim: 10–29, 84–93, 96, 97
Ruben Martinez: 34–41
Pop Mhan: 6, 30–33, 46–57
Tim Smith: 2, 3, 115–131

Color by MADA Design, Inc.

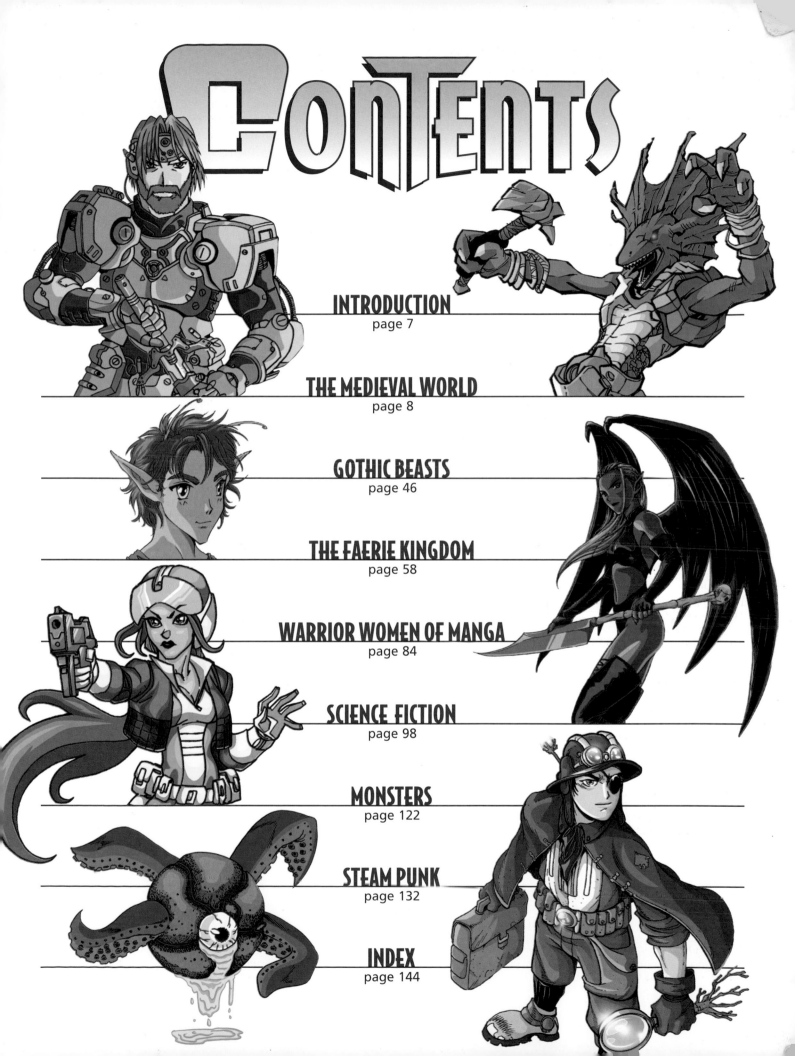

CONTENTS

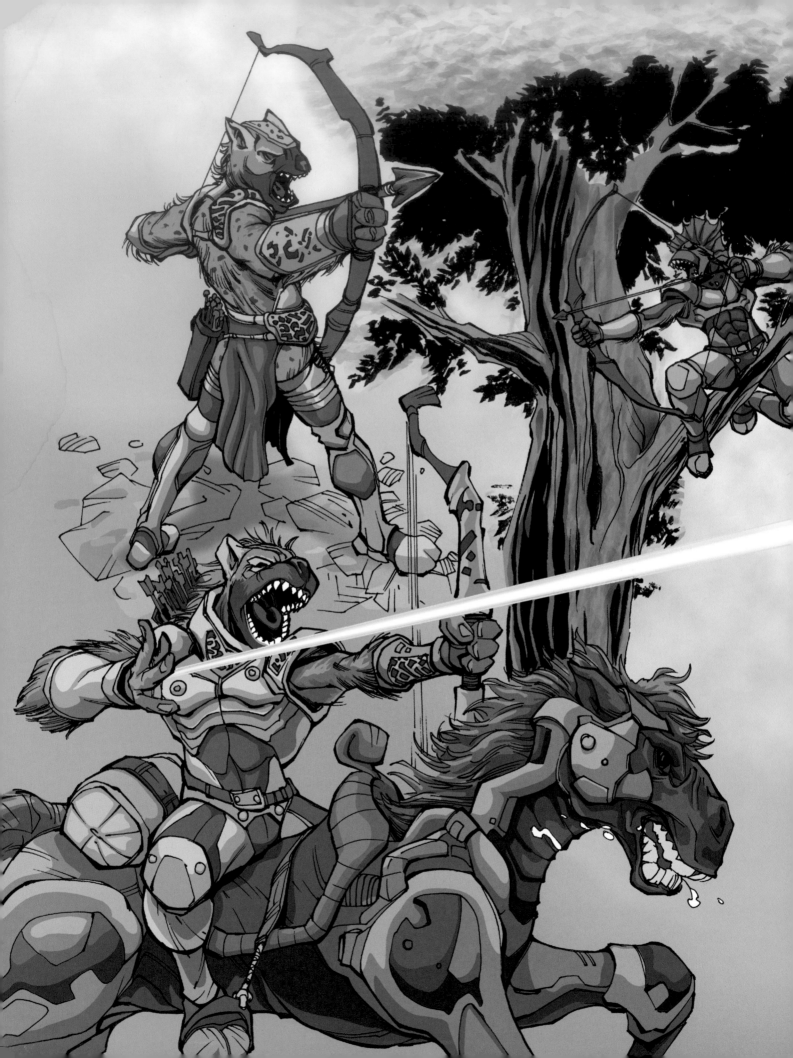

INTRODUCTION

With its unique blend of heroism, magic, and mystery, fantasy-based manga is fast becoming one of the most popular genres of Japanese comics, and manga's fantasy worlds are captivating fans all over the world. There are many manga books—and many series—dedicated exclusively to the fantasy realm. Nowadays, it's almost impossible to find an anime show (Japanese animation) that doesn't feature fantasy characters. It's simply an integral part of manga and something, as an aspiring artist or a professional, with which you should be familiar.

The techniques in this book will show, step-by-step, how to draw the most popular elements of the manga fantasy genre, as well as show you how to pose your characters, costume them, and give them special powers. There's also a cool section in which you'll be taken on a tour through a castle—dungeons and all—which will give you ideas for where to set your own scenes.

We'll start off with the knights of manga, known for their gallant looks, chivalrous manners, and high-tech weaponry. We'll see how to transform medieval weapons into their high-tech counterparts: laser swords and energy lances. We'll learn how to draw the knight's armor and weaponry. Then we'll move on to gothic beasts. All you video game fans will be glued to this section.

And, of course, there's a great section on drawing manga-style faeries. This is a truly magical section of the book, capturing the compelling nature of these charismatic creatures. Their faerie kingdom will come to life as never before. It's a world of elegance and grace, of bravery and betrayal. All the secrets for drawing manga faeries are right here, for you to get started with.

The next section brings us to the warrior women of fantasy manga, the strong but beautiful women who are among the most alluring characters in comics. Then, we move on to the most popular of all fantasy genres: science fiction. Visit the Earth as it fights for its very survival, pitted against the dark powers of the universe. Learn how to draw a topnotch crew of generals, pilots, and commanders to helm the battling spacecrafts.

There's also the netherworld of fantasy, a world in which the dreaded demons, monsters, and dragons dwell. These are amazing, impressive beasts that you'll want to draw. And finally, you'll be escorted through the newest trend in fantasy manga: the steam-punk genre. It's a great new twist on the fantasy theme that's sweeping Japan and making deep inroads into the American market. So, if you love manga fantasy art, you won't want to miss the book that shows you exactly how to draw it.

THE MEDIEVAL WORLD

Knights are the staple of the medieval fantasy world of manga. They possess traits that make for memorable characters, dramatic costumes, and displays of personal courage—and the medieval world of castles and dragons showcases all this perfectly. Many manga titles and popular anime shows feature knights in heroic roles. The knight is always ready and willing to fight for justice.

Young Knight

Knights are most popularly portrayed in armor. The armor is created as an idealized physique, with wide shoulders and a powerful chest.

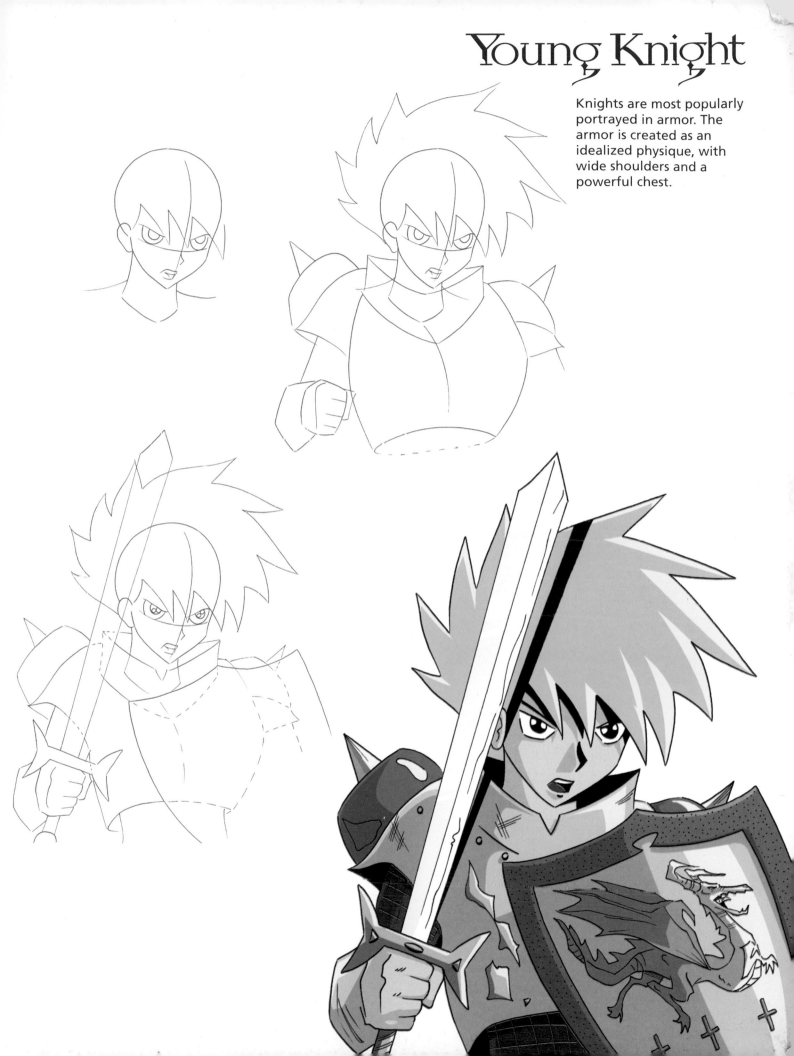

Choosing an Angle

It all begins with a good pose. As you proceed through this book, keep in mind that how you pose your characters makes a big impact on your reader. You don't want to labor over a drawing, only to realize that the pose is weak and that it, therefore, saps your drawing's impact. You want your drawings to blow your audience away. There's no benefit in drawing flat, boring pictures, especially in the world of manga! Start off on the right track from square one, and take a look at exactly what makes a pose strong or weak.

FRONT VIEW VS. 3/4 VIEW

A front view of a character works well in specific instances, such as close-ups and fighting poses. But more often than not, it looks flat and makes the character appear frozen, like a statue. A 3/4 view, on the other hand, is an effective, dramatic choice.

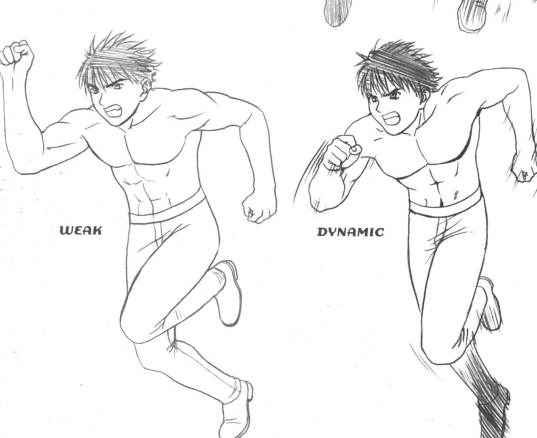

WEAK

DYNAMIC

WEAK

DYNAMIC

ROTATING THE TORSO

Even a 3/4 view can look static if the body is completely facing forward. To add a dramatic look, rotate the upper body so that a runner, for example, looks like he's really digging in for an all-out chase. Note the generous use of speed lines, which help lend a feeling of motion.

EXAGGERATION

Whichever part of a character is nearest the reader—whether it's a fist, leg, head, foot, or something held (a laser rifle, perhaps)—can be exaggerated in size so that it feels like the character is coming right at you. This technique gives the reader no choice but to feel the strength of the pose.

It's important to point out that not every single pose has to achieve this degree of maximum impact. That would only lead to eye fatigue. Rather, you should use these techniques at strategic moments in the story to heighten the drama.

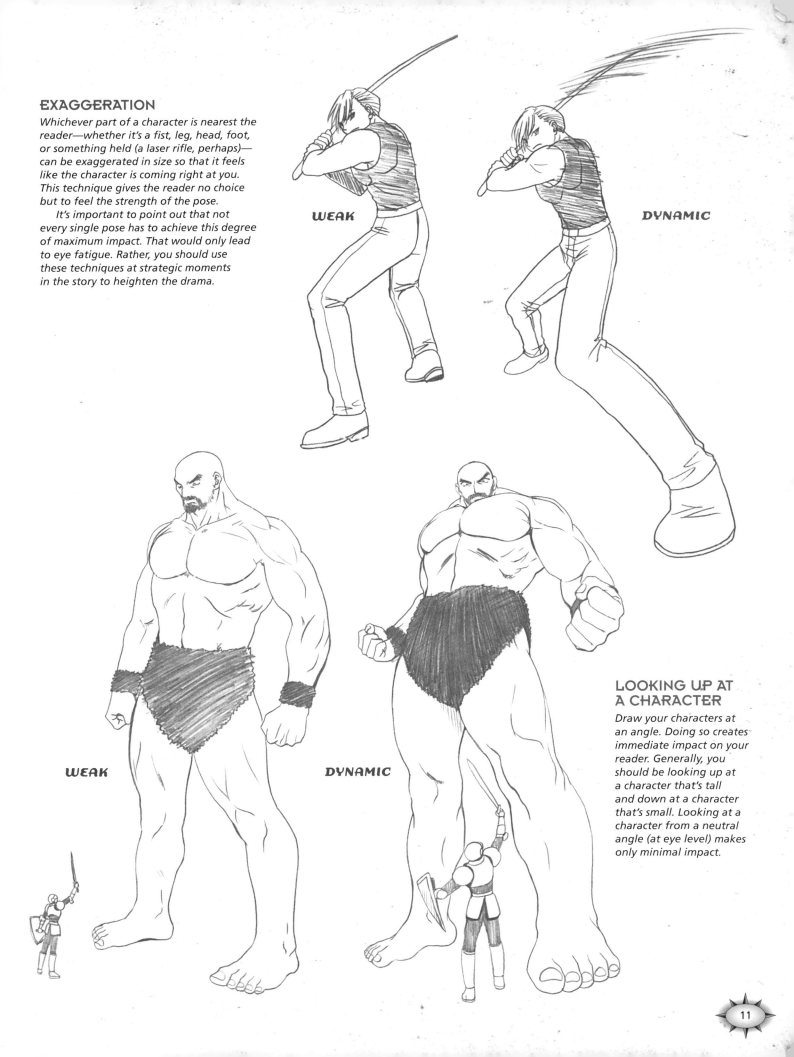

WEAK

DYNAMIC

WEAK

DYNAMIC

LOOKING UP AT A CHARACTER

Draw your characters at an angle. Doing so creates immediate impact on your reader. Generally, you should be looking up at a character that's tall and down at a character that's small. Looking at a character from a neutral angle (at eye level) makes only minimal impact.

How to Draw the Knight

Always start by drawing the figure first, then adding the armor. Not all armor is constructed like a tin can. More often, it consists of protective plates strapped to vital body parts, with the underlying clothing made of cloth and leather.

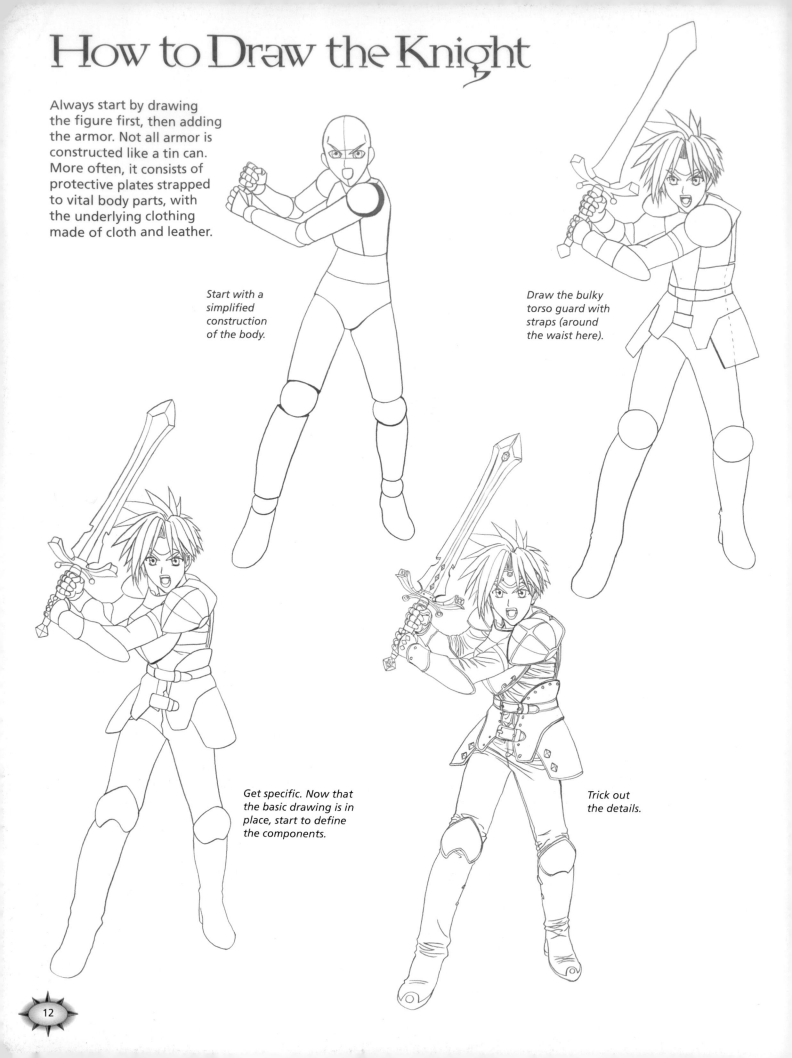

Start with a simplified construction of the body.

Draw the bulky torso guard with straps (around the waist here).

Get specific. Now that the basic drawing is in place, start to define the components.

Trick out the details.

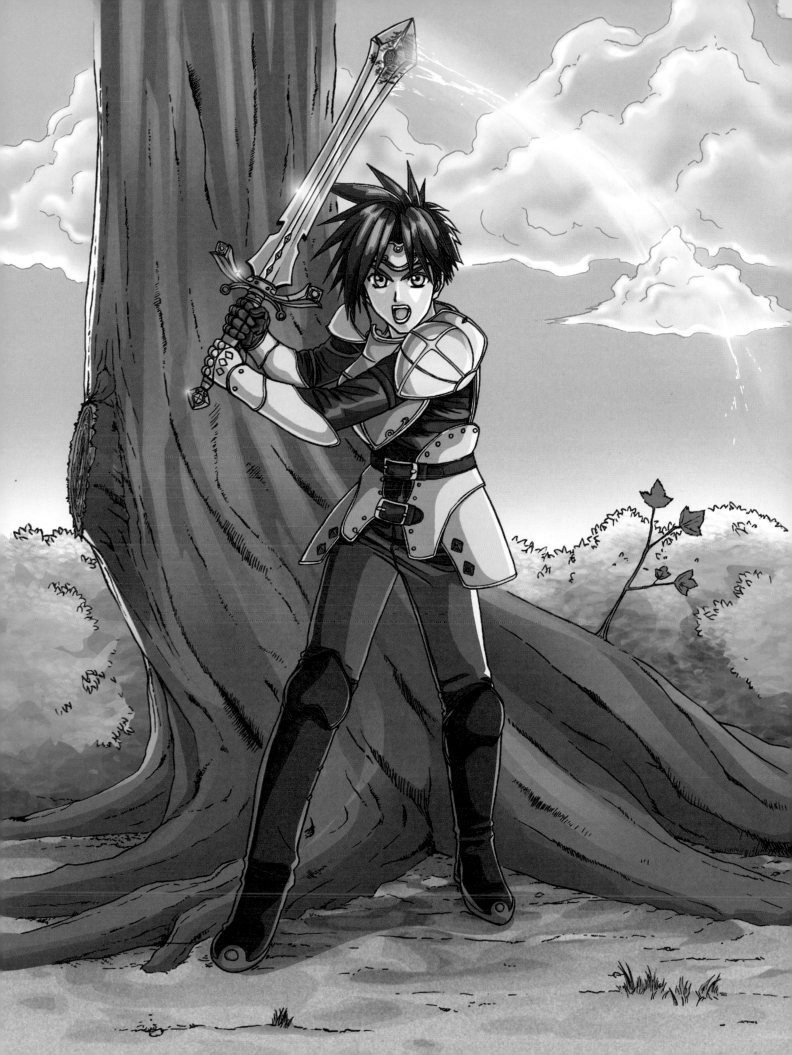

Turnarounds

When comic book artists get a character to draw, the publisher gives them a sheet of character *turnarounds.* This is a sheet of drawings showing the character from various angles that aids the artist in making the drawings of that character more confident and accurate in any pose.

The turnarounds here are of a traditional knight. As you'll discover in coming chapters, the knights of manga are a far more versatile group than you may have previously imagined; they can cross over to unlikely time periods beyond their medieval era. The basic knights usually wear layers of cloth, leather, armor, and chain mail. Their hands are usually gloved, weapons are always close at hand, and the hair is most often long and flowing.

Note that the largest pieces of armor protect the chest and back. The medium-sized pieces protect the shoulders and neck, which would otherwise be quite vulnerable to attack. The forearms also need protection from slashing swords, but the elbows are left without protection to allow for maximum movement. If you hide your knight in a total body suit of armor and a helmet, you'll end up hiding your character from your reader. By opening the armor up a bit, you make a connection with the reader. Some knights wear mainly leather, which doesn't obscure the character, but that tends to make them look like peasants rather than the upper class, which they were. By combining armor with leather, you get the best of both worlds.

FRONT VIEW

3/4 VIEW

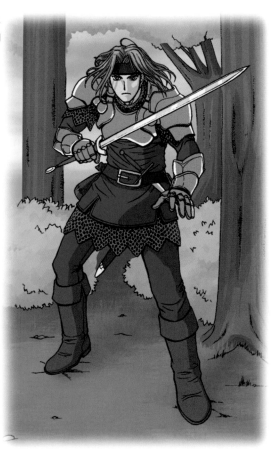

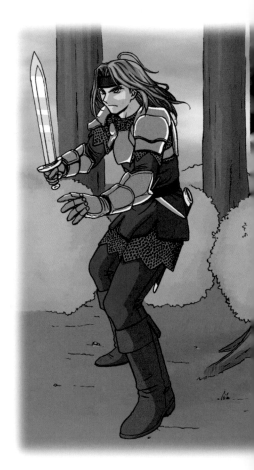

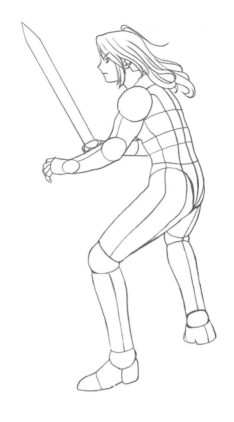

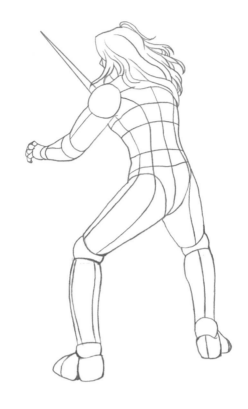

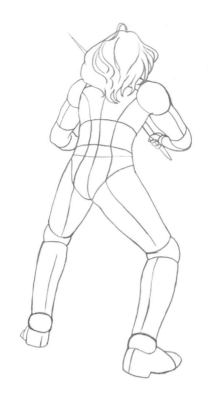

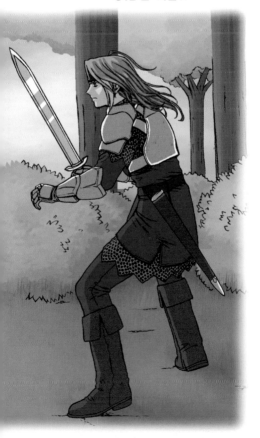

SIDE VIEW

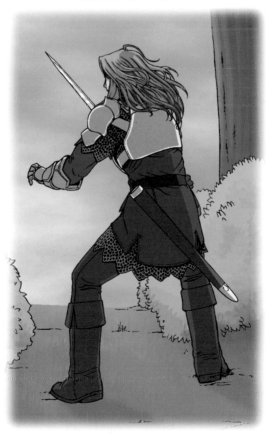

REAR 3/4 VIEW

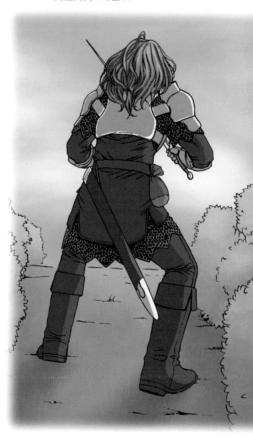

REAR VIEW

Female Knight Turnaround

Whether there actually *were* any female knights in combat is totally irrelevant. And, if there weren't female knights back then, there should have been—and this is how they would've looked. Armor tends to bulk up female combatants, and it's less flattering. So keep it to a minimum, or at least make it formfitting. Besides, if she wears no armor, fights in battle, and is still alive, she has to be one heck of an expert with a blade.

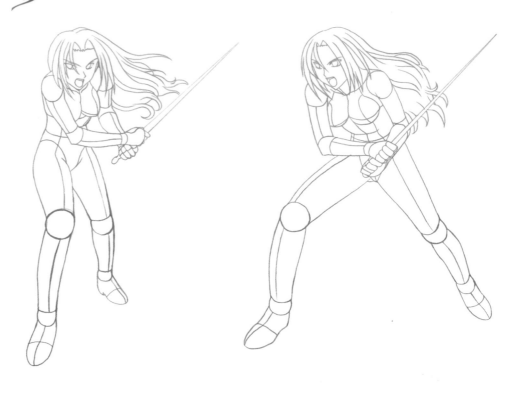

FRONT VIEW

3/4 VIEW

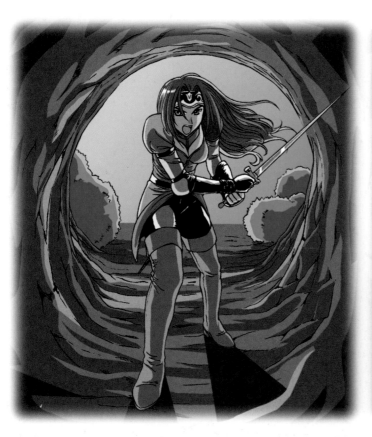

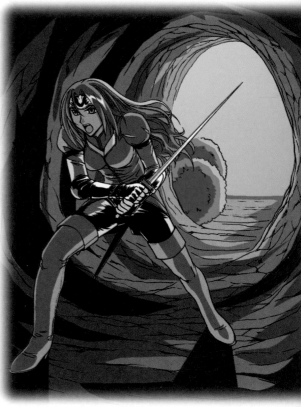

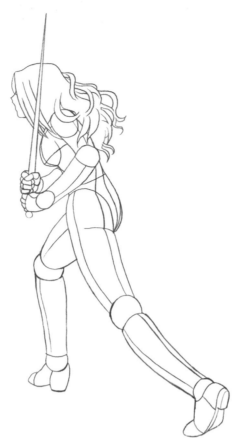

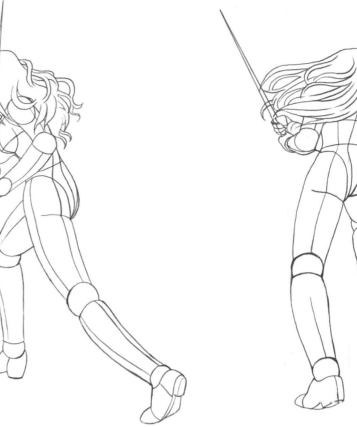

SIDE VIEW REAR 3/4 VIEW REAR VIEW

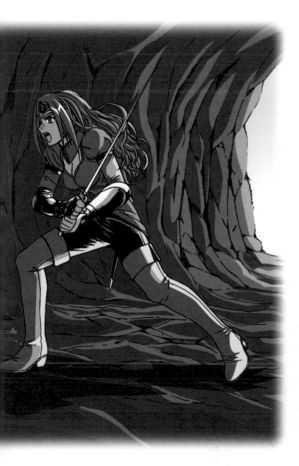

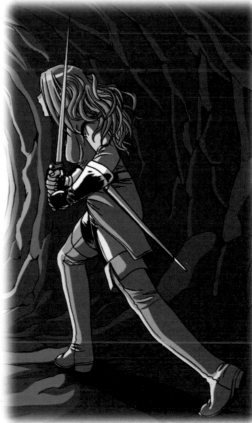

Fantasy Knights

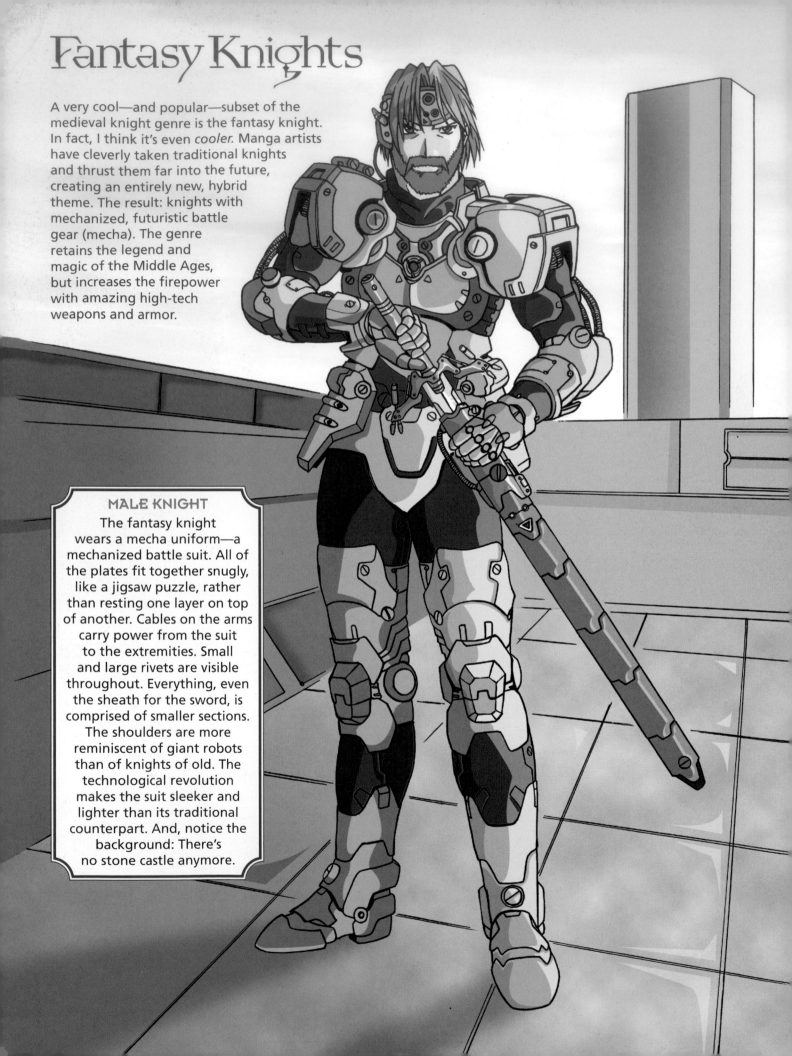

A very cool—and popular—subset of the medieval knight genre is the fantasy knight. In fact, I think it's even *cooler*. Manga artists have cleverly taken traditional knights and thrust them far into the future, creating an entirely new, hybrid theme. The result: knights with mechanized, futuristic battle gear (mecha). The genre retains the legend and magic of the Middle Ages, but increases the firepower with amazing high-tech weapons and armor.

MALE KNIGHT

The fantasy knight wears a mecha uniform—a mechanized battle suit. All of the plates fit together snugly, like a jigsaw puzzle, rather than resting one layer on top of another. Cables on the arms carry power from the suit to the extremities. Small and large rivets are visible throughout. Everything, even the sheath for the sword, is comprised of smaller sections. The shoulders are more reminiscent of giant robots than of knights of old. The technological revolution makes the suit sleeker and lighter than its traditional counterpart. And, notice the background: There's no stone castle anymore.

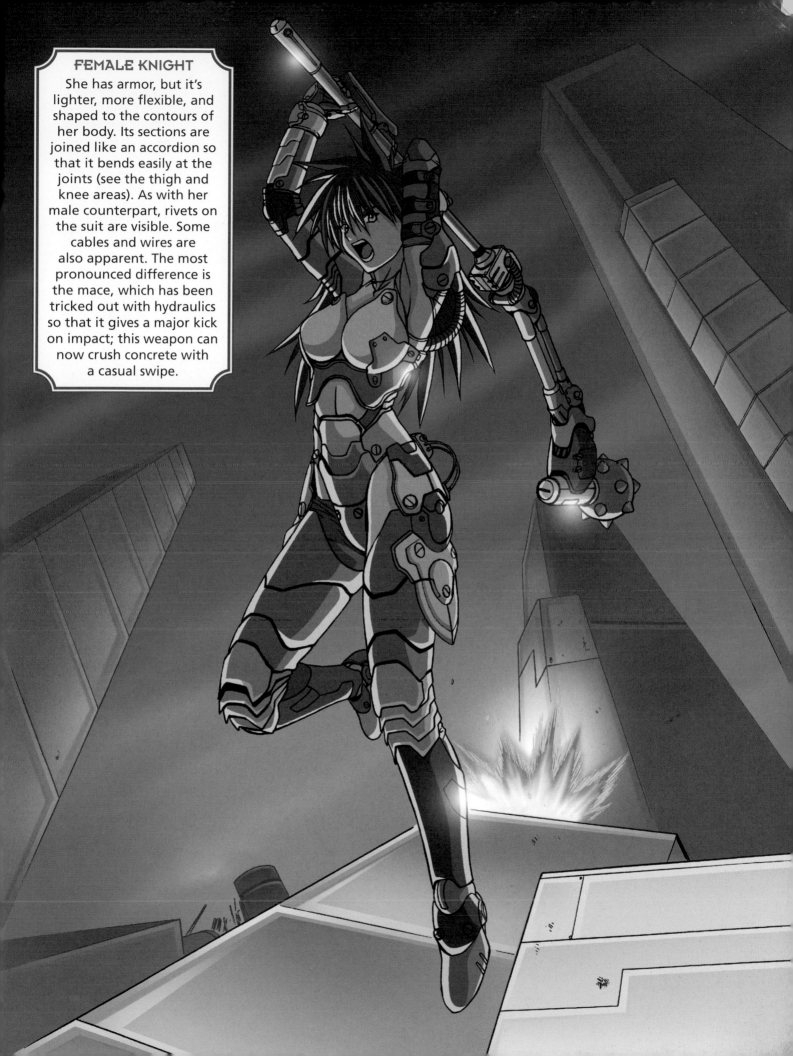

FEMALE KNIGHT

She has armor, but it's lighter, more flexible, and shaped to the contours of her body. Its sections are joined like an accordion so that it bends easily at the joints (see the thigh and knee areas). As with her male counterpart, rivets on the suit are visible. Some cables and wires are also apparent. The most pronounced difference is the mace, which has been tricked out with hydraulics so that it gives a major kick on impact; this weapon can now crush concrete with a casual swipe.

Other Characters

Now that you have an idea of how basic fantasy knights should look, you can draw some cool characters from the fantasy genre. Notice that the step-by-step instructions start with the simplest, largest forms and work toward the details. You don't mechanize the character or weapons until the last stage, when everything is set in place. I know you want to get to the gadgets and fun stuff first, but trust me—save your dessert for last. You won't regret it.

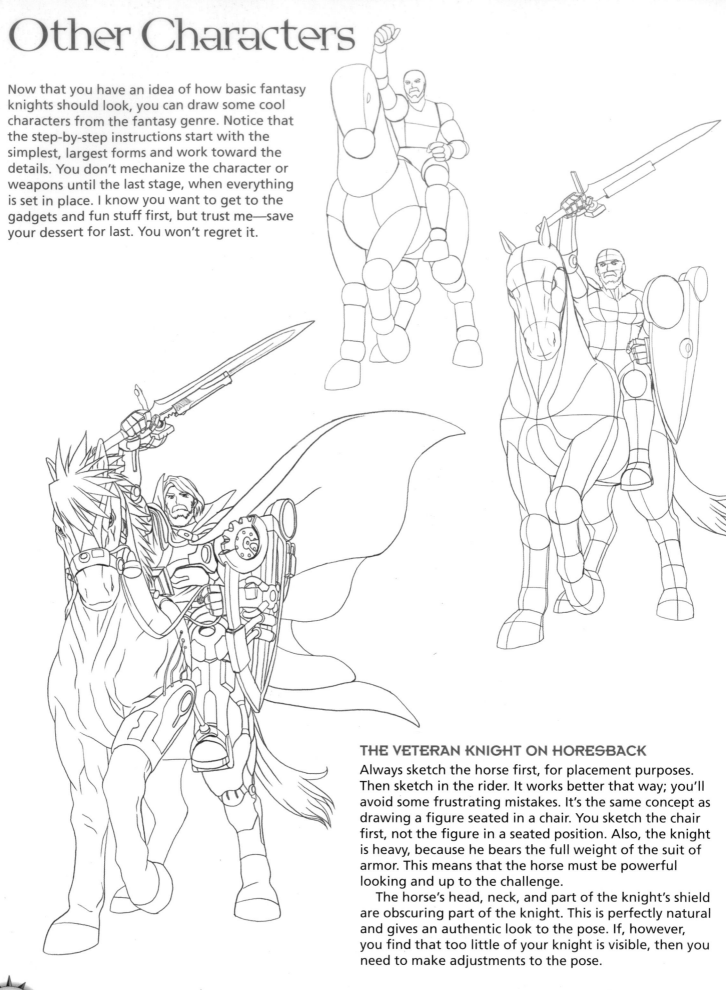

THE VETERAN KNIGHT ON HORESBACK

Always sketch the horse first, for placement purposes. Then sketch in the rider. It works better that way; you'll avoid some frustrating mistakes. It's the same concept as drawing a figure seated in a chair. You sketch the chair first, not the figure in a seated position. Also, the knight is heavy, because he bears the full weight of the suit of armor. This means that the horse must be powerful looking and up to the challenge.

The horse's head, neck, and part of the knight's shield are obscuring part of the knight. This is perfectly natural and gives an authentic look to the pose. If, however, you find that too little of your knight is visible, then you need to make adjustments to the pose.

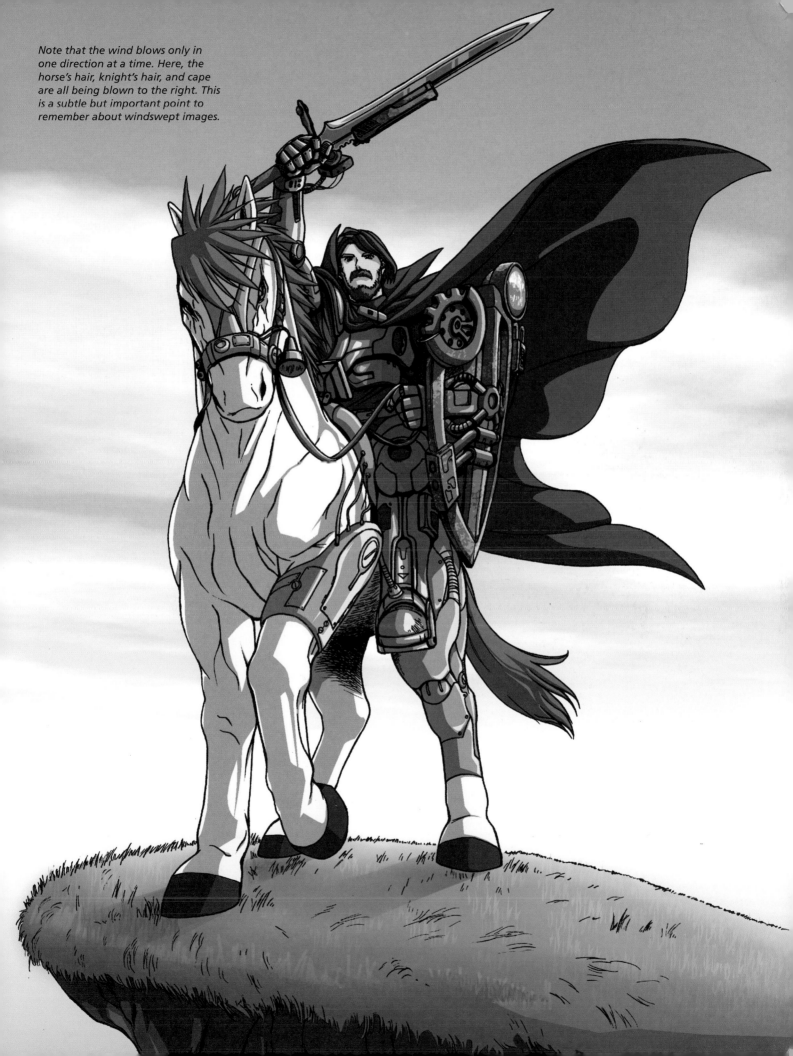

Note that the wind blows only in one direction at a time. Here, the horse's hair, knight's hair, and cape are all being blown to the right. This is a subtle but important point to remember about windswept images.

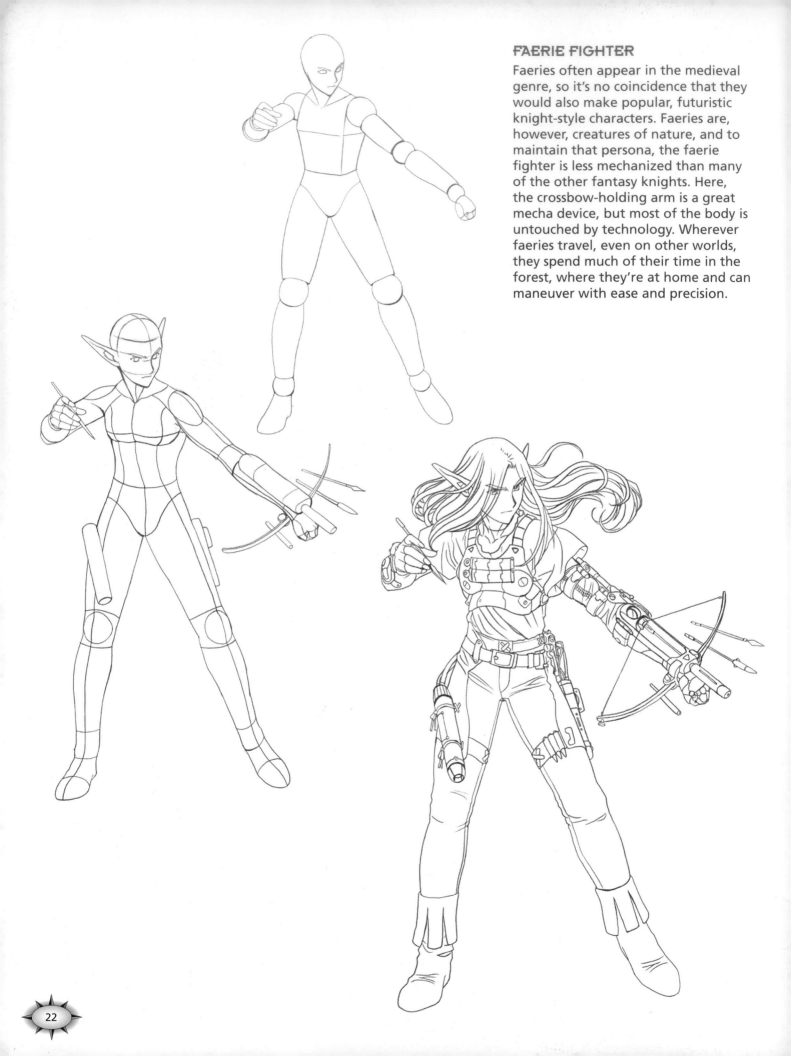

FAERIE FIGHTER

Faeries often appear in the medieval genre, so it's no coincidence that they would also make popular, futuristic knight-style characters. Faeries are, however, creatures of nature, and to maintain that persona, the faerie fighter is less mechanized than many of the other fantasy knights. Here, the crossbow-holding arm is a great mecha device, but most of the body is untouched by technology. Wherever faeries travel, even on other worlds, they spend much of their time in the forest, where they're at home and can maneuver with ease and precision.

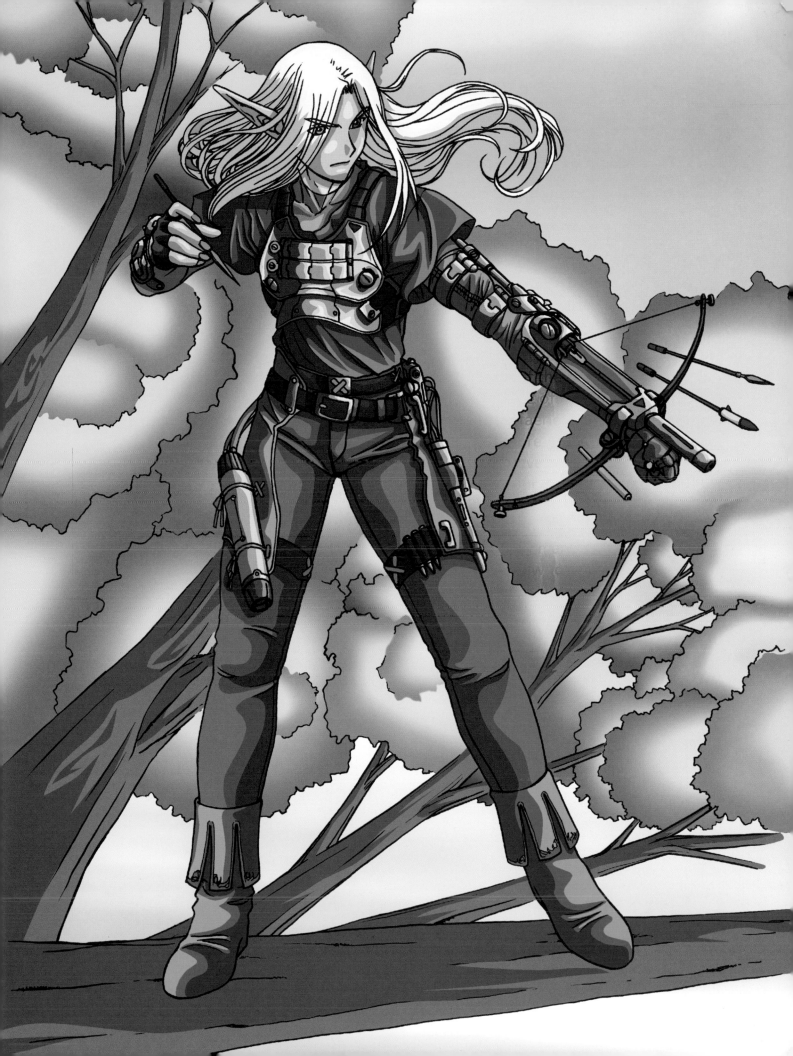

EXECUTIONER

Although technology in the manga fantasy world has evolved, the punishments have not. The stakes have to be very high in a story to keep your audience on the edge of its seat. Death still looms as the ultimate threat in the fantasy-adventure genre. This requires a character who looks like he (or she) means business, like this guy here.

When you're drawing a brute, give him overly developed trapezius muscles (the muscles that travel from just below the ears to the shoulders). If you really build up those muscles, you can eliminate the neck, resulting in a hunched posture that looks exceedingly menacing and powerful. Give him wide shoulders, but don't make the waist narrow. That's for action heroes. That ain't this guy. He's not vain, just mean. Even his hands should be oversized. Everything about him is thick.

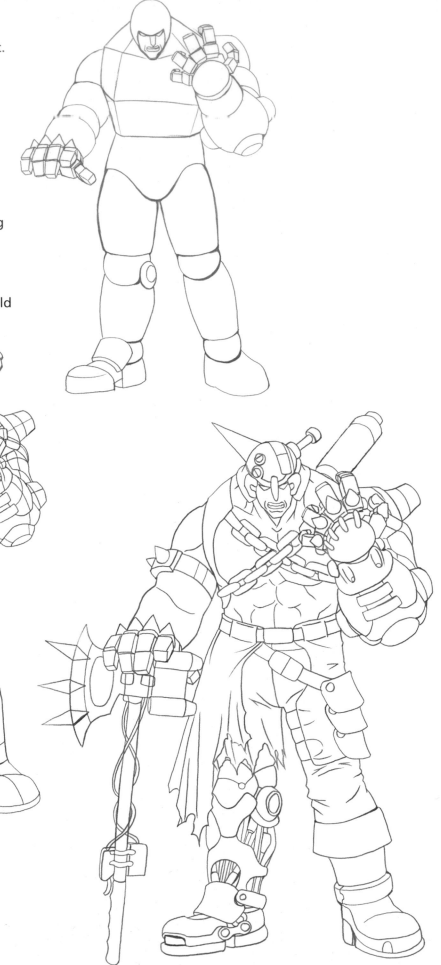

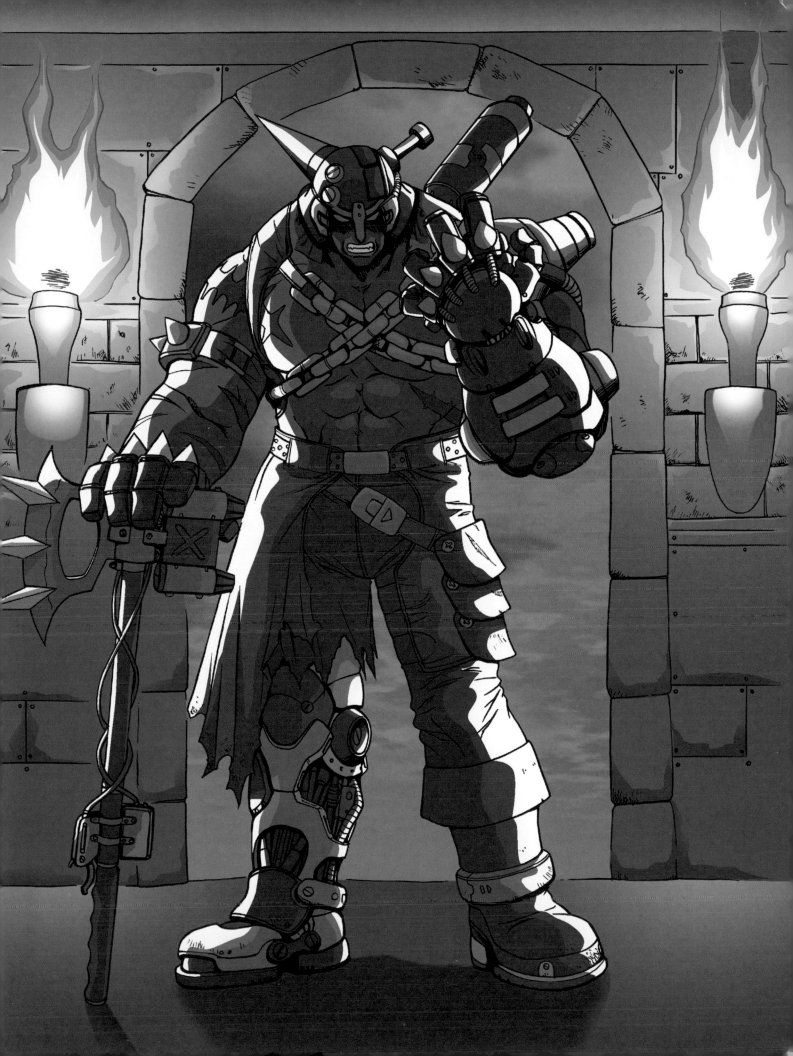

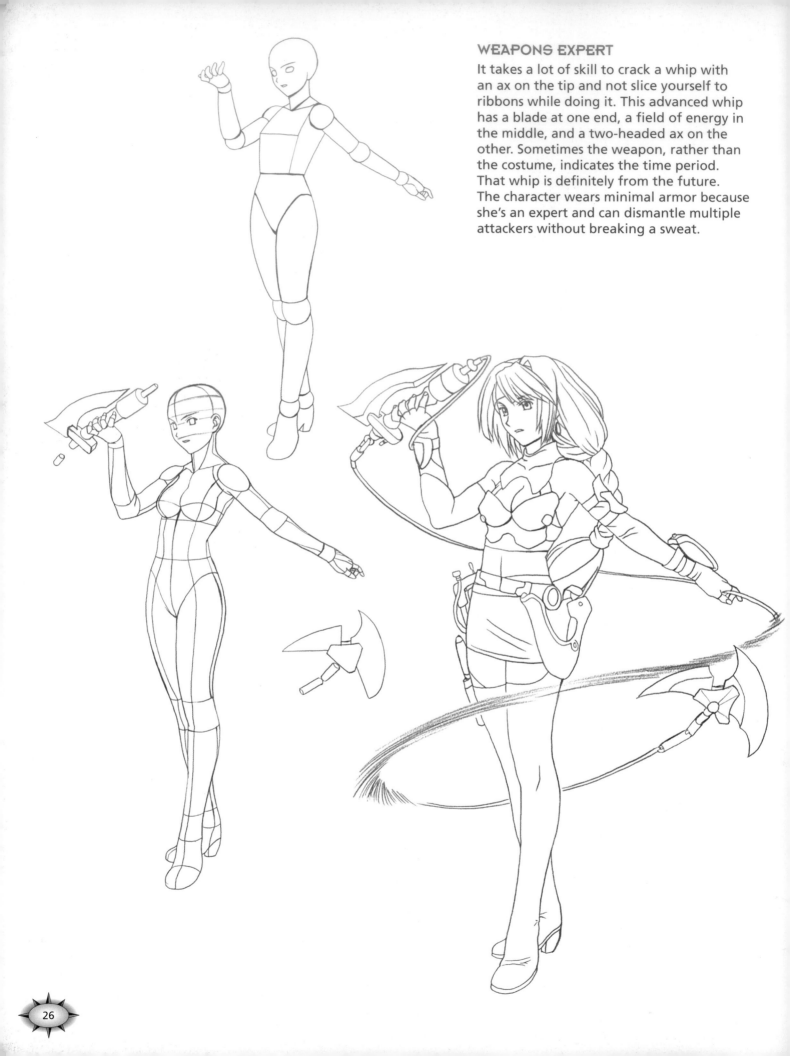

WEAPONS EXPERT

It takes a lot of skill to crack a whip with an ax on the tip and not slice yourself to ribbons while doing it. This advanced whip has a blade at one end, a field of energy in the middle, and a two-headed ax on the other. Sometimes the weapon, rather than the costume, indicates the time period. That whip is definitely from the future. The character wears minimal armor because she's an expert and can dismantle multiple attackers without breaking a sweat.

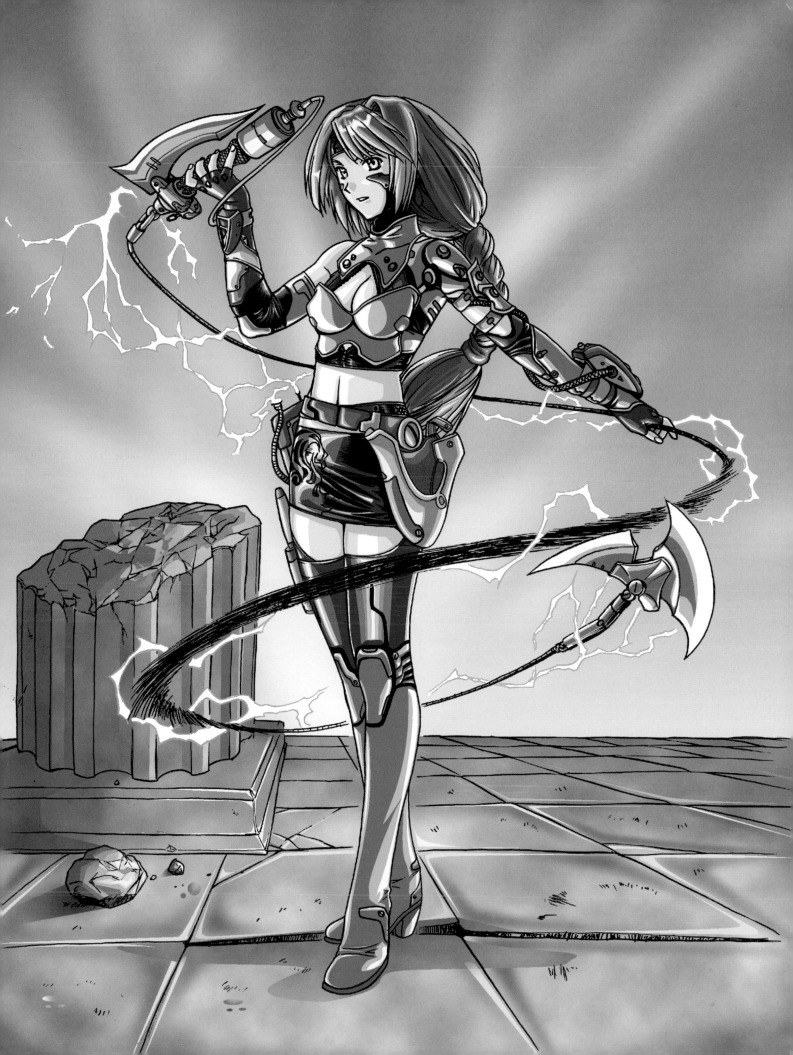

YOUNG HERO ON HORSEBACK

The young hero's posture is typically forward-leaning. He's hot-blooded, eager for revenge. He thinks with his heart, not his head. Hey, sometimes that's what it takes to win—one young fighter with the heart of a lion. This hero lost his helmet in an earlier skirmish or tossed it aside in a hurry. Either way, most heroes do without the headgear. They're brave but foolish. But like I said, that's what it takes. Young hero knights are reckless but exciting to watch.

Note that the hero leans to the left (his right) so that he can see past the horse's head and, in a more practical sense, so that *we* can see *him.* The forward thrust of the body makes the pose look more natural, not like he's just mugging for the camera. The horse has a mecha foreleg to enable running at breakneck speed. And get a load of that technolance!

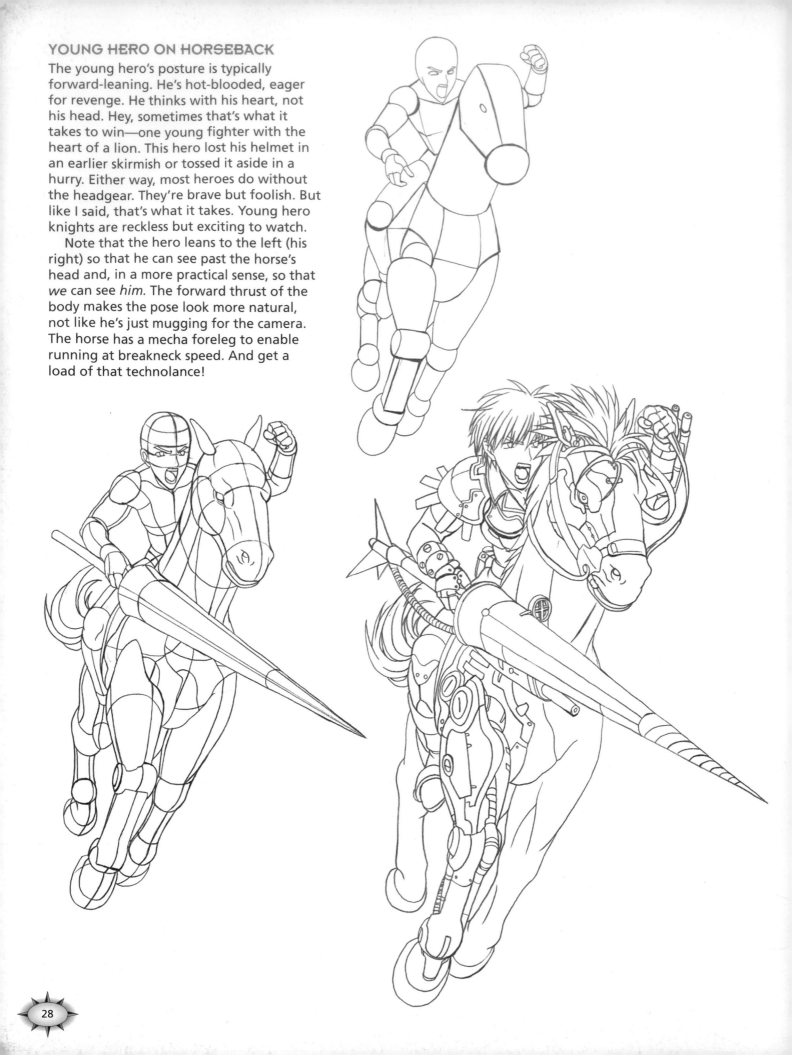

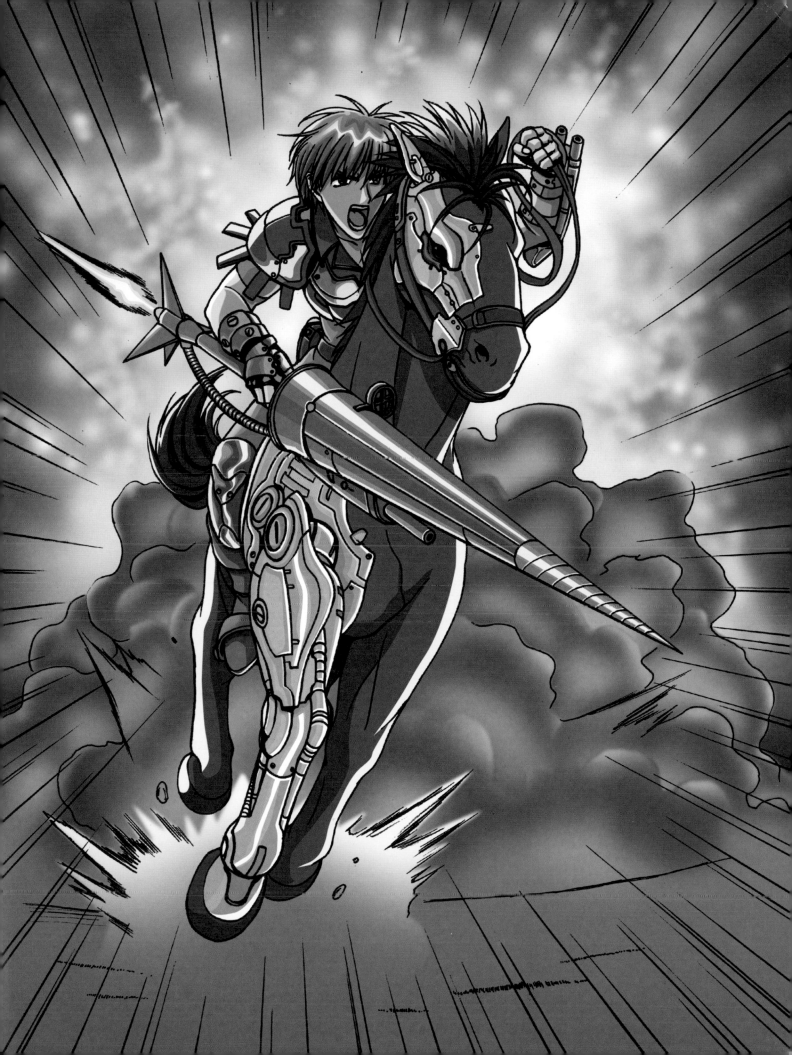

Evolving Medieval Weapons

Artists are always putting new spins on their subjects, and the battling knights of manga are no exception. As the characters have evolved, so have their weapons. For a knight, for instance, a high-tech laser sword is very cool. Believe me, all the squires want one. Energy-based weapons tell readers that the battle will be huge and splashy with amazing special effects.

A NOTE ABOUT DRAWING STYLE
The more futuristic the character, the more jagged and angular the drawing style can become.

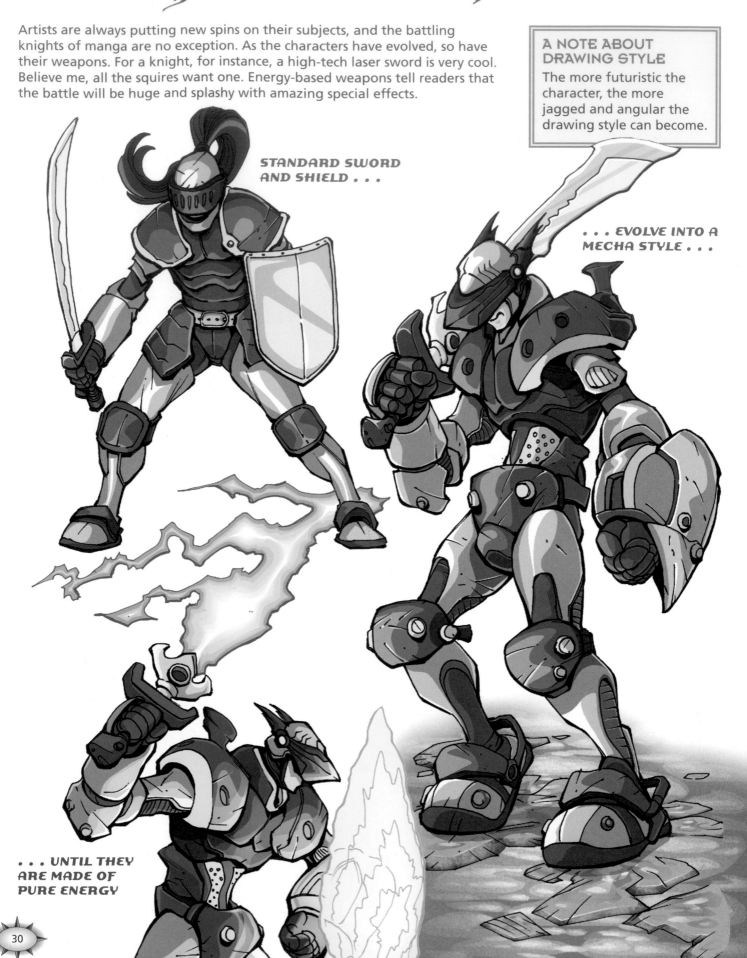

STANDARD SWORD AND SHIELD . . .

. . . EVOLVE INTO A MECHA STYLE . . .

. . . UNTIL THEY ARE MADE OF PURE ENERGY

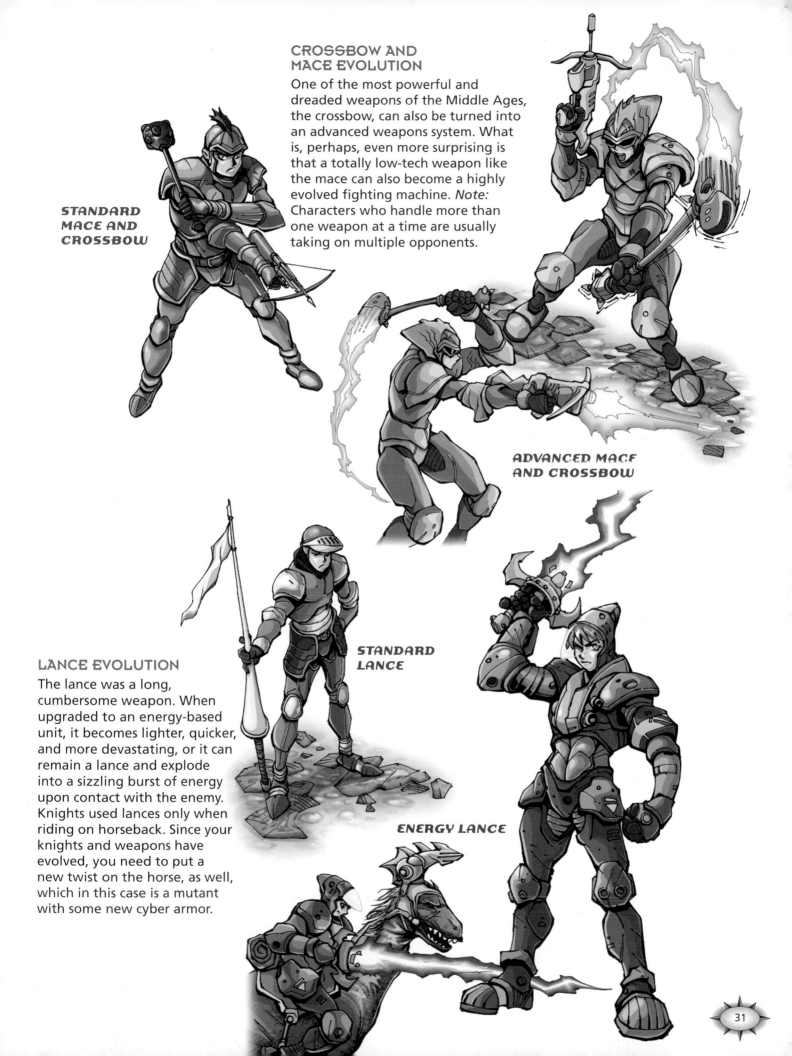

CROSSBOW AND MACE EVOLUTION

One of the most powerful and dreaded weapons of the Middle Ages, the crossbow, can also be turned into an advanced weapons system. What is, perhaps, even more surprising is that a totally low-tech weapon like the mace can also become a highly evolved fighting machine. *Note:* Characters who handle more than one weapon at a time are usually taking on multiple opponents.

STANDARD MACE AND CROSSBOW

ADVANCED MACE AND CROSSBOW

STANDARD LANCE

LANCE EVOLUTION

The lance was a long, cumbersome weapon. When upgraded to an energy-based unit, it becomes lighter, quicker, and more devastating, or it can remain a lance and explode into a sizzling burst of energy upon contact with the enemy. Knights used lances only when riding on horseback. Since your knights and weapons have evolved, you need to put a new twist on the horse, as well, which in this case is a mutant with some new cyber armor.

ENERGY LANCE

Fighting Multiple Attackers

In setting up great fight scenes, you must stack the odds overwhelmingly against your hero. After all, your audience already expects him to win a fight against a typical thug. What's the excitement in that? You've got to give your audience the how-the-heck-is-he-going-to-get-out-of-this-one moment. To do that, pit the hero against multiple opponents, each with a weapon.

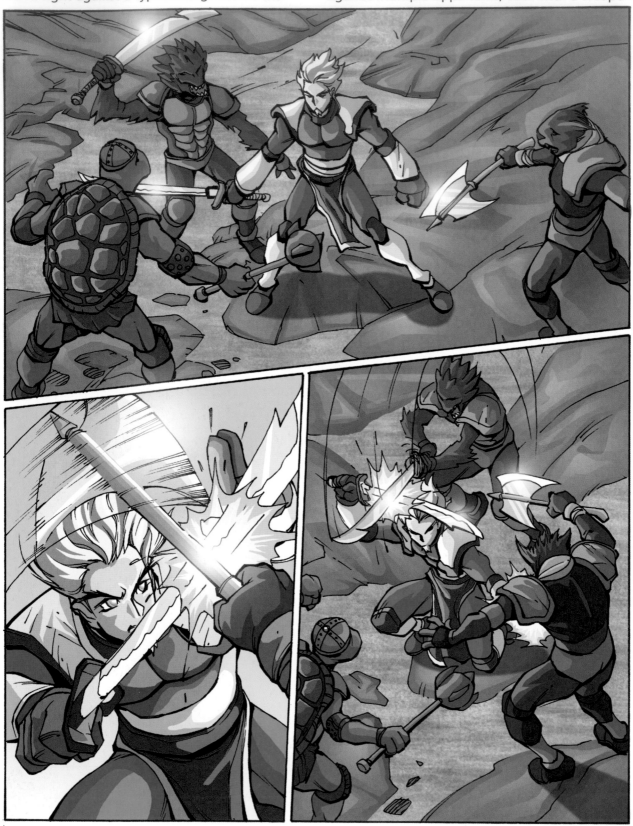

When staging a fight scene with multiple opponents, the attackers should attack one at a time. If they all pile on at once, the scene looks cluttered. The second panel cuts in to a closer shot so that we don't see the other two attackers just standing there doing nothing. Then, the third panel widens out again as the hero is attacked from behind by the swordsman. In response, the hero defends himself while simultaneously attacking the ax-holder, creating lots of action. From there until the end, it's bang-crunch-bang until all the bad guys fall. And, fall they must. You can't leave them on their knees. They've got to be flat on their backs or stomachs for the scene to be over. Even then, one of them might rise up in a sneaky fashion and attack the hero from behind—they don't call 'em bad guys for nothing.

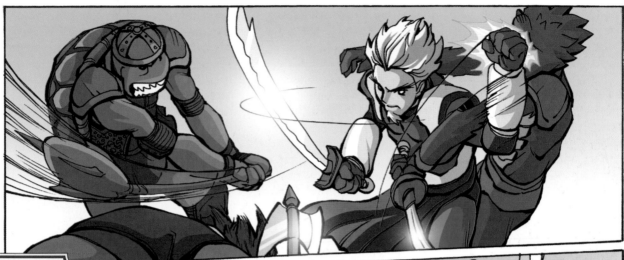

WHO GETS THE COOL WEAPONS?

If a hero and a villain meet, who should have the high-tech weapons? The bad guy! The hero's life should hang by a thread. Make the audience worry. That's the key to good suspense.

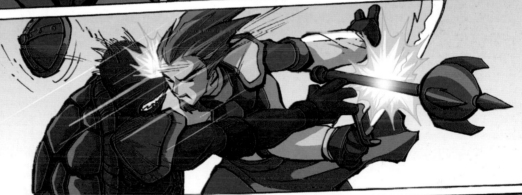

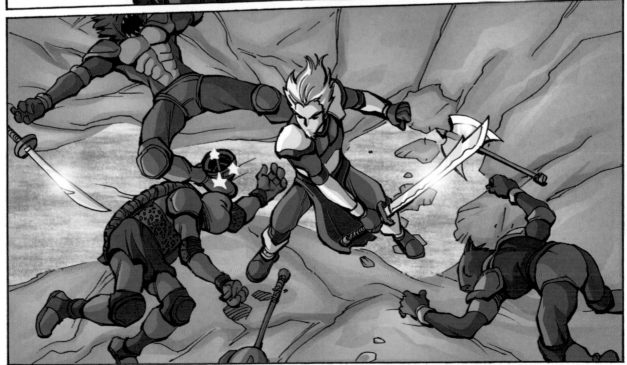

A World of Dragons and Fire

Dragons are the ultimate fantasy monster. They appear in all genres, from knights to faeries and science fiction to science fantasy. They're the home runs of bad guys. When your team of good guys happens to encounter a dragon, the scene is going to be nothing short of climactic. After all, the dragon comes with built-in fireworks—the ability to breath fire.

Besides being fearsome in appearance, they're also giants, with necks and tails that are incredibly long. They're loosely based on dinosaurs, with large heads and small, useless forelegs. But, if you thought there was only 1 way to draw a dragon, you're in for a treat. These wicked creatures come in amazing varieties, one cooler than the next. When you design a dragon, keep in mind what its role or purpose will be and design it accordingly. If you have a scene taking place at the top of a building, you'll want a dragon that's a real flier, with an incredible wingspan, for example. Dragons can be used in any genre, even way off in the distant future. So, take a look at these popular dragon types.

TYPE 1: SERPENTINE FLIER

The serpent dragon has a snakelike body. It slithers along the ground, but once airborne, it owns the sky. Its hard back is replete with spikes. Its soft underbelly is a series of sections. The wings are spiny with webbing made of flexible skin. Some dragons have useless, decorative wings, but this expert flier sports the full-size variety. The wings make full strokes that allow the dragon to glide and then dive in a vicious attack. The "hands" and "feet" are always claws. Again, the forelegs are reminiscent of those of dinosaurs in that they are tiny and practically useless. The crown of the head displays a shield similar to that of the triceratops, and the muzzle is long and crooked (crooked jaws are a sure sign of evil). The tongue is forked, like a snake's. And, the tail is huge and weighted heavily at the tip, which the dragon can use to smash things.

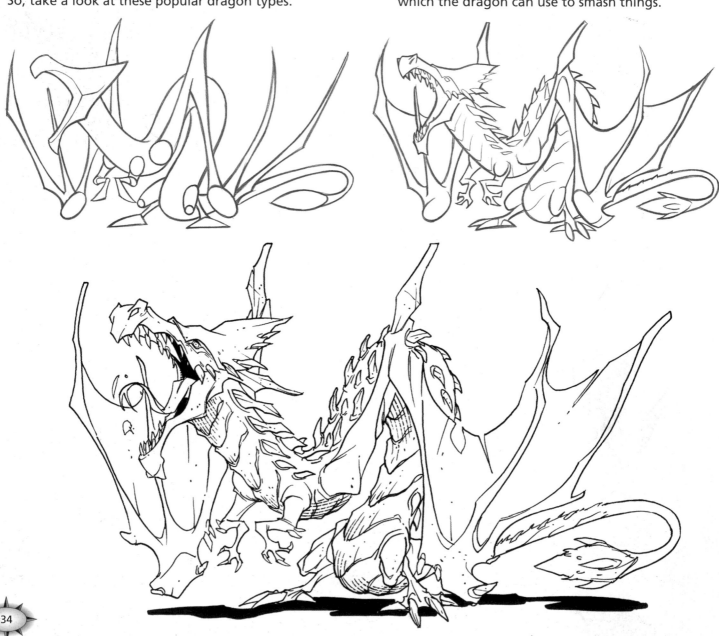

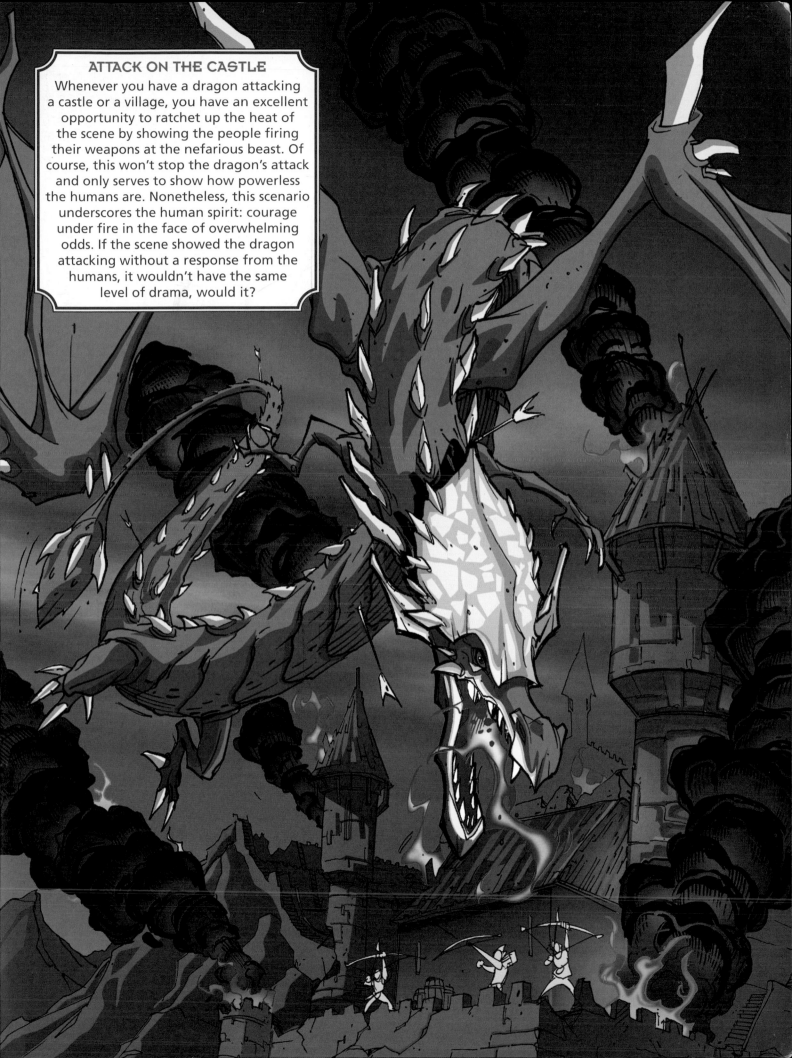

ATTACK ON THE CASTLE

Whenever you have a dragon attacking a castle or a village, you have an excellent opportunity to ratchet up the heat of the scene by showing the people firing their weapons at the nefarious beast. Of course, this won't stop the dragon's attack and only serves to show how powerless the humans are. Nonetheless, this scenario underscores the human spirit: courage under fire in the face of overwhelming odds. If the scene showed the dragon attacking without a response from the humans, it wouldn't have the same level of drama, would it?

TYPE 2: MULTIHORNED

Some creatures get all the girls, but not this one. It has been thumped by the ugly stick. As if having a bony face weren't bad enough, this dragon has crooked, massive horns and even a set of small chin spikes. The nose ring is a funny addition; it tells us that somewhere there's a dude bad enough to be able to tie this critter to a post and tell it to "stay." The snout has been shortened so that it doesn't overpower the horns, but that set of teeth more than makes up for it. You can add any type of body you want to the multihorned dragon, provided that it has additional horns or spikes protruding from it. In this unique variation, the torso and forelegs are quasihuman, but the hind legs are animal.

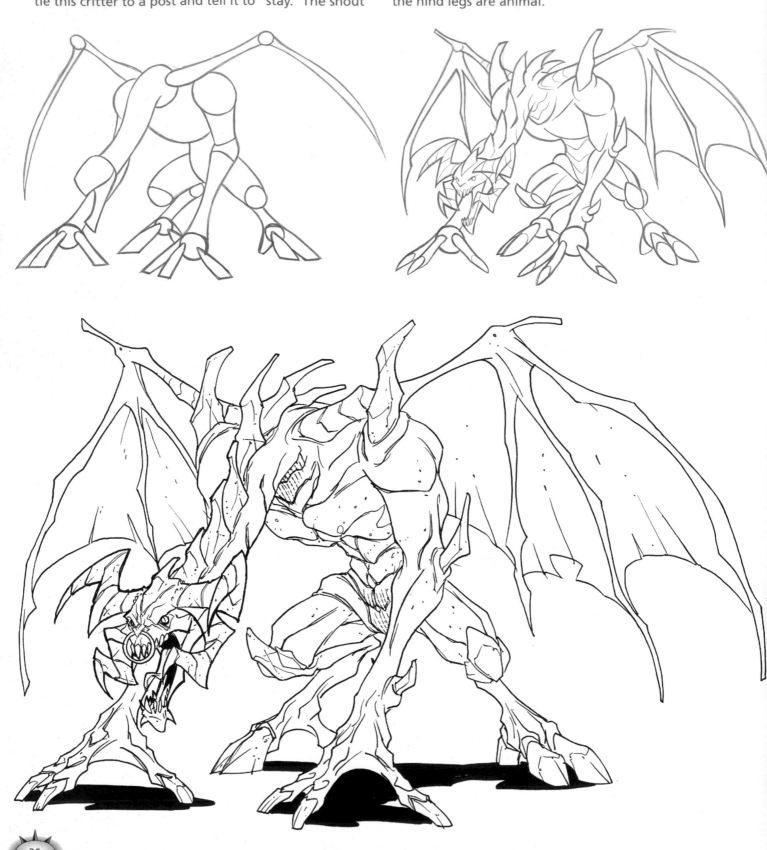

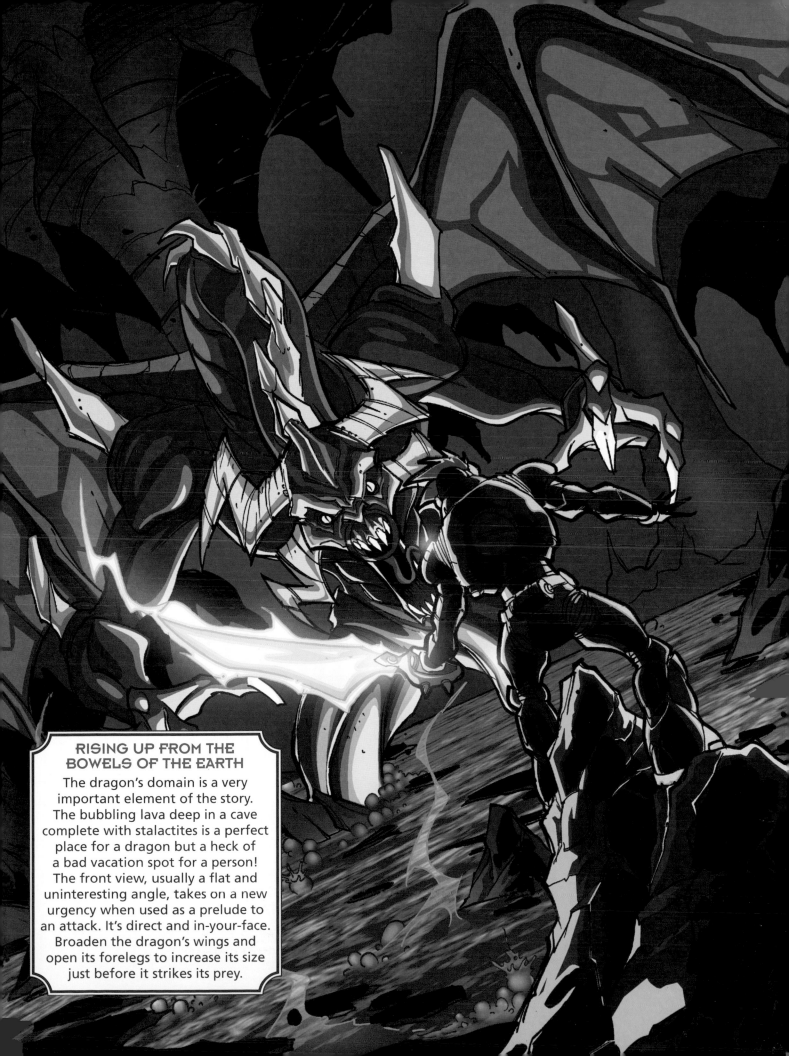

RISING UP FROM THE BOWELS OF THE EARTH

The dragon's domain is a very important element of the story. The bubbling lava deep in a cave complete with stalactites is a perfect place for a dragon but a heck of a bad vacation spot for a person! The front view, usually a flat and uninteresting angle, takes on a new urgency when used as a prelude to an attack. It's direct and in-your-face. Broaden the dragon's wings and open its forelegs to increase its size just before it strikes its prey.

TYPE 3: MULTIHEADED DRAGON

As if it couldn't get any worse for our poor humans, along comes a two-headed dragon to spoil the picnic. Add as many heads as you like. I've seen dragons with as many as 7 heads work effectively. Be sure to *always* draw the heads at different angles from one another to avoid the problem of *twinning,* when one head mirrors another. The thick collars around the necks are a good effect. The necks don't have to be thin. If you look at an image of a tyrannosaurus rex, you'll see that it has a very thick neck that's thickest near the head.

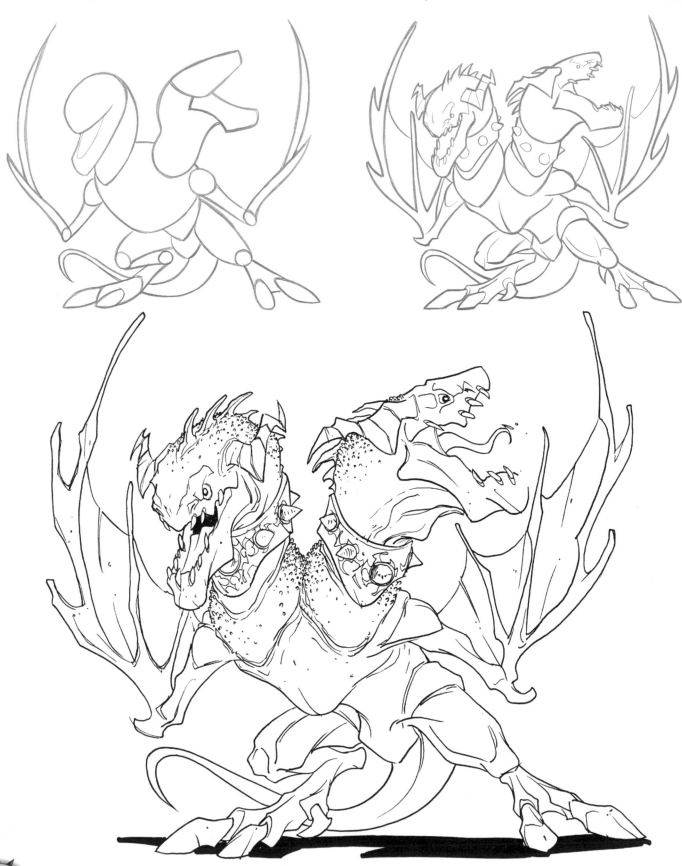

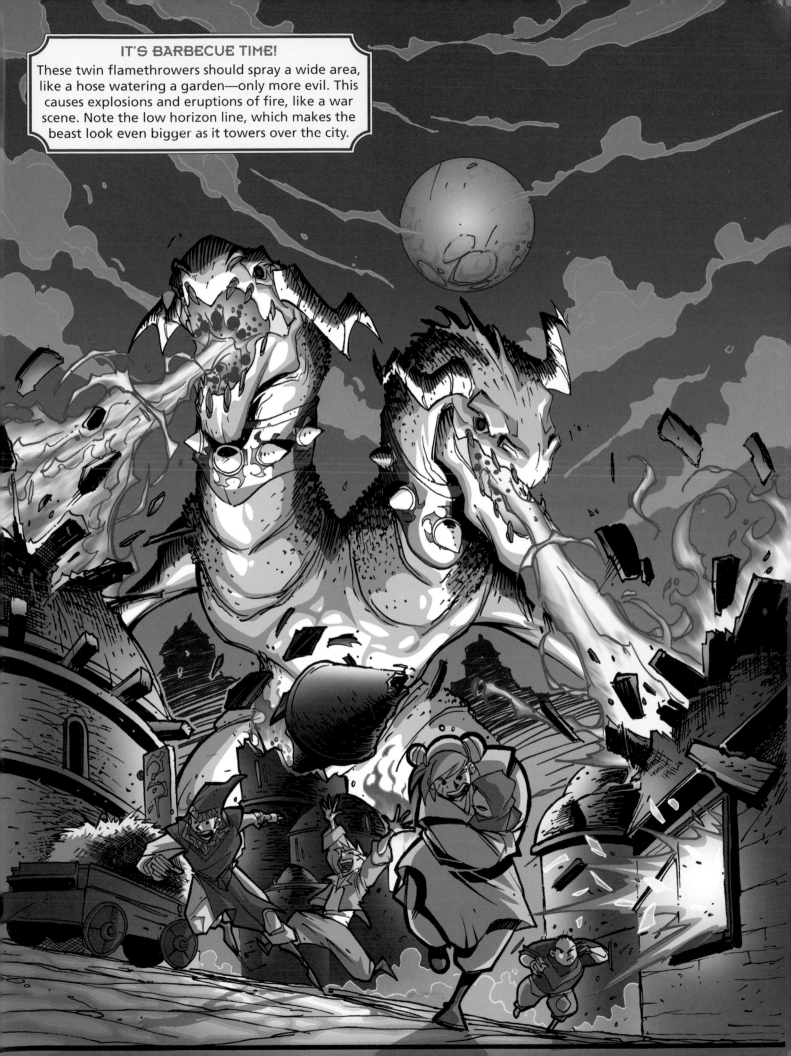

IT'S BARBECUE TIME!
These twin flamethrowers should spray a wide area, like a hose watering a garden—only more evil. This causes explosions and eruptions of fire, like a war scene. Note the low horizon line, which makes the beast look even bigger as it towers over the city.

TYPE 4: MECHA

See what happens when you let your kid order a hobby construction set off the Internet? This is basically a mechanical version of the multihorned dragon. As complex as this figure looks, it still begins with simple shapes and organic forms. By organic I mean that the shapes start out as if made from living tissue—no nuts and bolts in the initial step. Just draw a dragon. Then begin to create the mechanical design. To do that, divide each part into sections that get gradually smaller. Then, add bolts, hinges, plates, and shields to connect the sections.

This is an advanced character. It's important for you to understand that you don't have to make your creatures as complex as this. If you find it too challenging, simplify the parts that are giving you trouble. Your audience isn't going to care if your dragon's tail only has 4 parts instead of 12, for example. It's the overall look that counts.

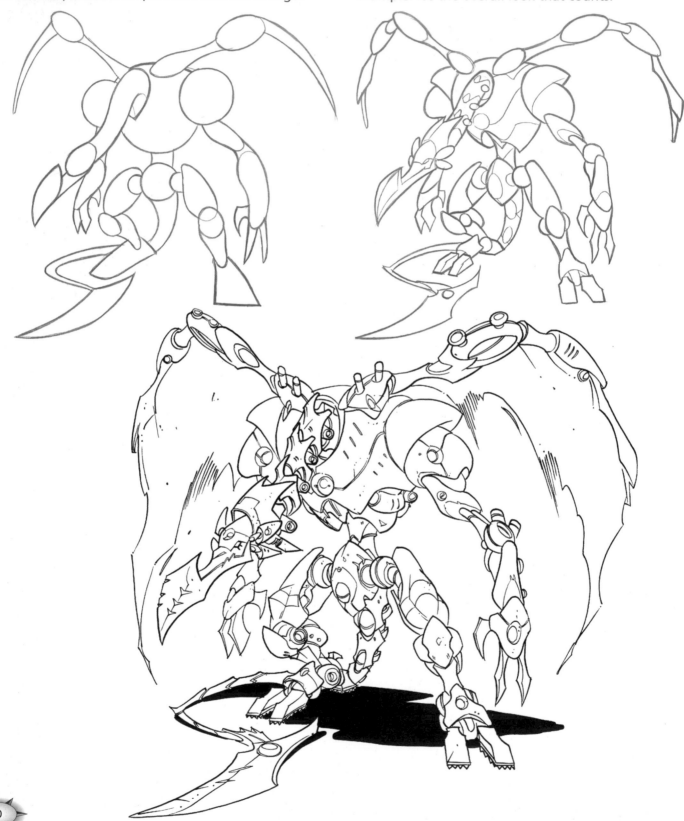

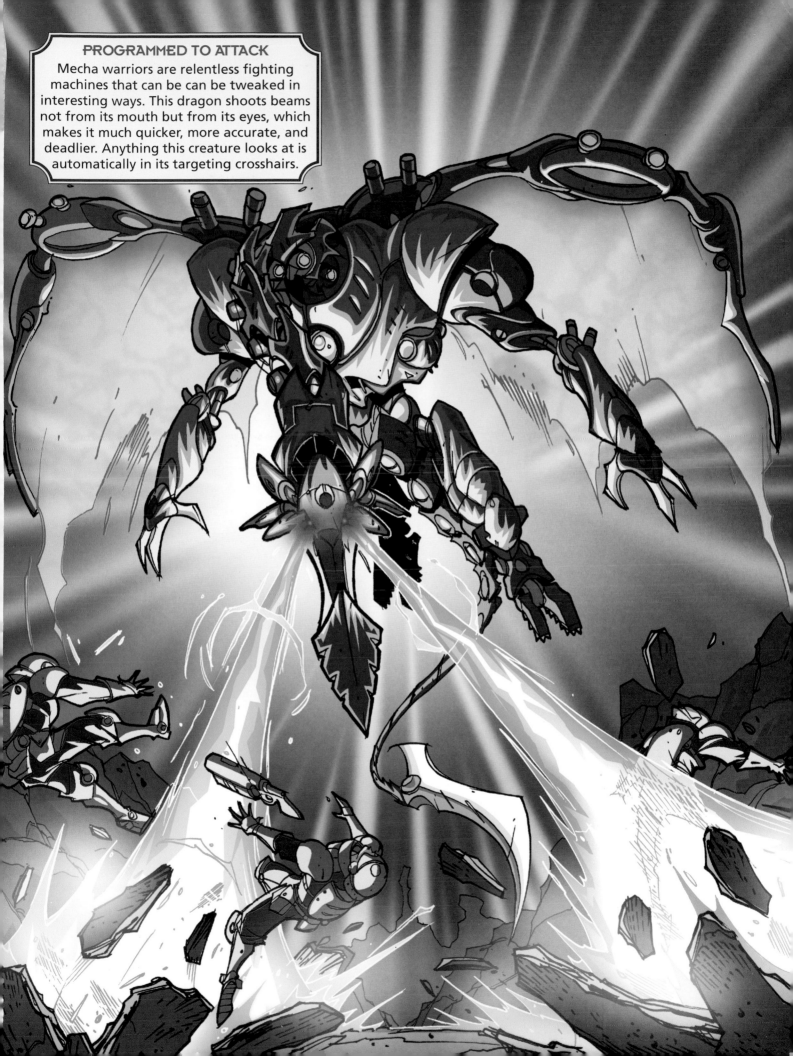

PROGRAMMED TO ATTACK
Mecha warriors are relentless fighting machines that can be can be tweaked in interesting ways. This dragon shoots beams not from its mouth but from its eyes, which makes it much quicker, more accurate, and deadlier. Anything this creature looks at is automatically in its targeting crosshairs.

Welcome to the Castle

Whether you're drawing knights, faeries (page 58), or science fiction (page 98), the castle is the home base. It's the center of the fantasy world. Within its walls lie intrigue, betrayal, blood oaths, plans for war, and hopes for peace. It's a city unto itself. It's a home for the king and queen, a fortress for the soldiers, and a protective shelter for the peasants. And, it's visually stunning, with many locations you can use to create eye-catching scenes that will enthrall your readers.

Whatever your castle looks like, first show it in an establishing shot, like the one below, which should be magnificent. The establishing shot gives readers their bearings and sets you up to cut in to closer shots. It's a great way—with the entire castle shown against the landscape—to both begin and *end* a story. Be sure that the height of the sun (or suns) in the sky corresponds to the time of day; for example, the sun is low at sunset or sunup, and high at noon.

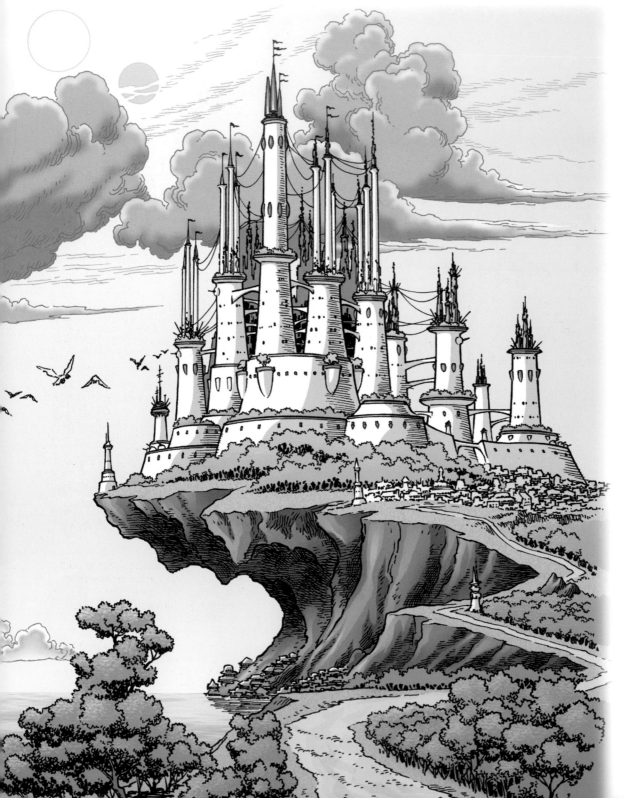

THE CASTLE ON THE HILL

A castle must be perched high in a reclusive spot to make access difficult for invaders. The sea is a natural boundary. The vistas it provides are also a treat for your readers. Go for big skies and a pastoral landscape. Note the winding road leading up to the castle walls and the dense trees surrounding it, reminiscent of the English countryside and, in denser areas, the forest. This particular castle is of the science-fantasy variety, as indicated by the high-tech spires. Also, the towers taper as they rise, which you wouldn't expect on authentic castles from the Middle Ages. It's also much more massive and interconnected than a castle of old.

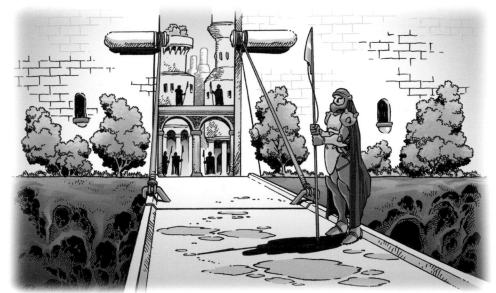

DRAWBRIDGE

This is the only way in. It's a good location for welcoming dignitaries or bidding them farewell. Also, it's quite dramatic to have the hero gallop over the drawbridge while the guards work like heck to reel it closed behind him before the bad guys arrive.

CASTLE ENTRANCEWAY

The fantasy genre borrows not only from the Middle Ages, but also from Greek and Roman architecture and mythology, which is evident here in the columns. This is the courtyard, a peaceful place where the people gather and stroll.

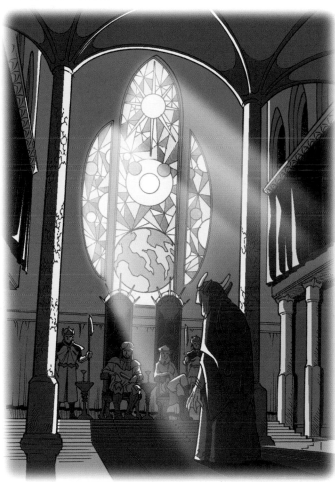

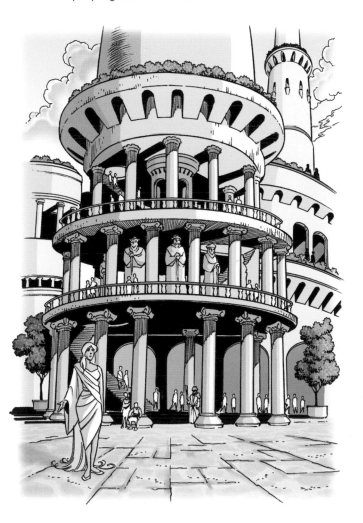

KING'S COURT

This is where you come to greet the king. He doesn't come to you. It's also the place where you plead your case, ask for assistance, or bring messages. The high stained-glass windows are reminiscent of a church, but instead of any particular religious symbols, there are clusters of stars and planets with galactic symbolism. This is the future, and this is a separate race, not the human race.

The king and queen must be treated differently, visually, than everyone else. Note the height of their throne backs. Do you think they're tall enough? They're also flanked by two guards with serious weapons. Find opportunities to emphasize the stature of the king and queen using space. Here, there's a wide walkway in front of them and a small set of stairs leading up to them so that they are always, in effect, looking down at everyone.

WIZARD'S TOWER

This wizard doesn't fool around mixing eye of newt with monkey paw. We're talking wizardry from the 25th century here. He's mixing quarks with neutrinos to make a powerful proton soup that can blast away half his enemy's planet. He has moved on from commanding hawks to commanding giant weapons systems. He's still in a tower (indicated by the circular walls), but it's a multilevel one, glittering and powerful. Note the candles and the potions in the foreground; this is the essence of good science fantasy—the mixing of the past with the future. It's a cool look.

DUNGEON

Society's technical prowess may have evolved but not the methods for extracting confessions—even in the future. The good old dungeon still has some nasty tricks. The racks, fire, iron maidens, and all the greatest hits are still playing in this theater of the macabre. Still, there are some new, high-tech tortures. Witness the mummy suit in the background, which conducts fields of excruciating electricity. They call it The Convincer. That's one suit you don't want to try on.

The dungeon is dark, always in the bowels of the castle, and made of stone. Wood would be too warm and fuzzy. Use heavy shadows and pools of black to evoke the melodrama of the moment. Combine low-tech with high-tech stuff for a cool look. For example, the spiked platform in the lower right corner has an electronic On/Off switch.

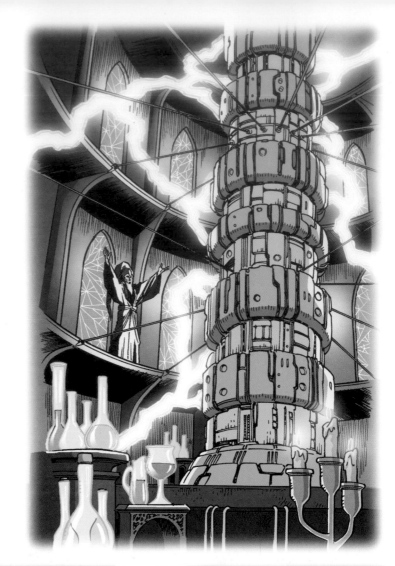

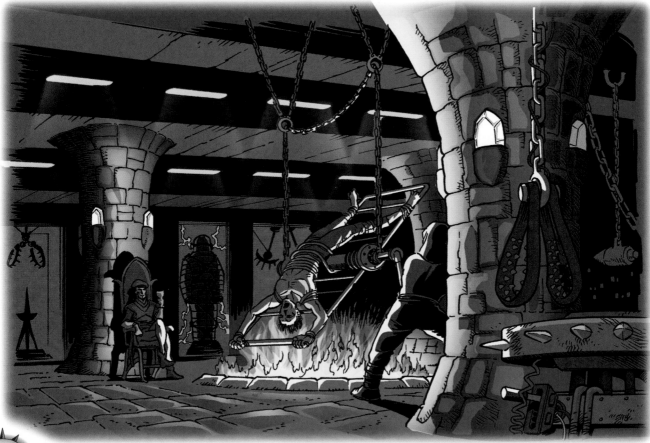

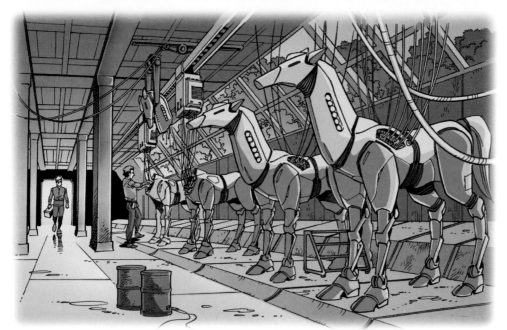

STABLES

Notice something different about these horses? Yep, they're mecha horses—mechanized creatures. The best thing about the mecha stable is that you don't have to clean up any manure. As in all stables, the horses are lined up in a row, but they don't need dividing walls between them because mechanized horses don't get spooked. They remain motionless until switched on. Instead of groomers, programmers attended to the horses. Cables leading from the horses to an energy source provide the required recharging. Note the overhead tracks, which are used to replace parts.

ARENA

This is the where the knights practice their combat skills, and where the fat cats and landed gentry sit and watch for their own amusement. Sometimes, practice drills give way to all-out battles and even challenges, which can result in a fight to the death. Most often, however, it's a place to hone one's skills. The fighters have serious weapons and are bound together at the ankles by a cord. They also face other obstacles, such as a precarious drop if they take one careless step off those elevated platforms.

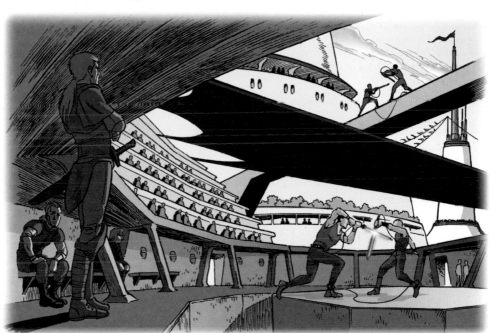

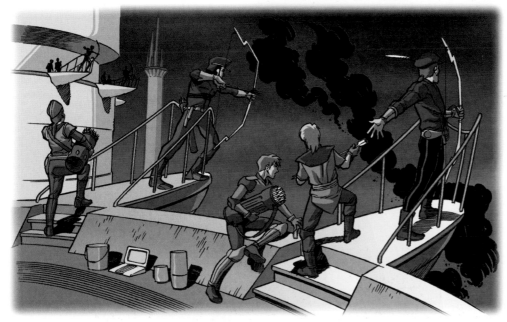

DEFENSIVE POSTS

The fighting platforms, or perches, on top of the castle are the last line of defense before the castle walls are breached. The archers fire down at the enemy soldiers in the front lines (not into the middle of the crowd). Many archers will also become casualties and fall off the perches as they die (it's always more dramatic to fall off a perch as you die than to crumple to the ground where you're standing). Note the squires, feeding arrows to the archers. If an archer is hit, the squire will stand up to take his place and, if he's a good shot, a new hero knight will be born.

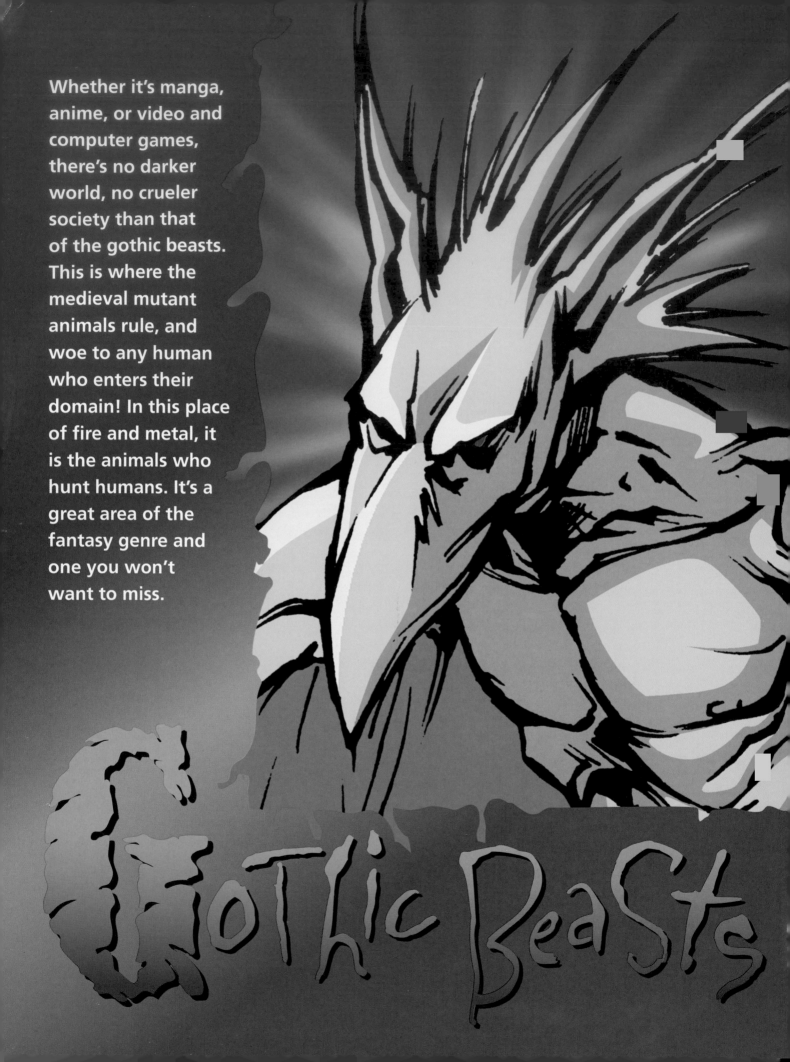

Whether it's manga, anime, or video and computer games, there's no darker world, no crueler society than that of the gothic beasts. This is where the medieval mutant animals rule, and woe to any human who enters their domain! In this place of fire and metal, it is the animals who hunt humans. It's a great area of the fantasy genre and one you won't want to miss.

Gothic Beasts

The most successful character designs for beasts are those that have borrowed elements from one specific animal, rather than being a mishmash of several different ones. Beast characters are also all *anthropomorphized,* which means that they've been given human characteristics and form, even though they retain animal elements, such as the head, fur, claws, and, sometimes, the tail. The posture should also be humanlike. You can take any animal—provided it isn't warm and fuzzy—give it human posture and a suit of armor, and turn it into a gothic creature.

Here, the animal influence was the buffalo. The extraordinarily heavy head of the buffalo requires the support of massive neck and shoulder muscles, which give the buffalo a brutish appearance—perfect for a guard character. The deep-set eyes and the horns create a mysterious look. The hooves can be flexible to mimic hands. Although the hooves are small on real buffalo, they need to be exaggerated on the goth buffalo, because the beast stands upright and clutches things. Tiny hands on big brutes are, well, funny—and you don't want your beast to look funny.

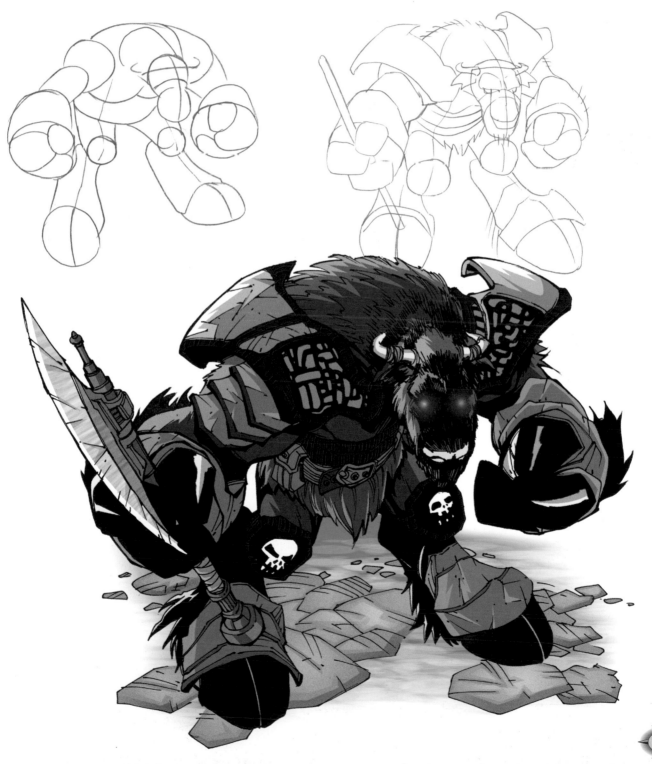

Frills Are In This Season

The most severe-looking reptile, aptly called the frilled lizard, has a frill running around its head. Aside from the head, tail, and claws, the entire body is human in form. Only the neck has been eliminated, because a long neck would look too human. You can create your own version and retain more of the lizard's original form, if you prefer. But lizards have short legs and long bodies—not impressive stuff when they're standing upright. Given wiry, human bodies, they become lightning-fast attackers with a crazed look.

The armor here is atypical, more of the mecha variety than the medieval type. Mecha, remember, is mechanical stuff that has a power source to increase the strength of the wearer; it also allows more freedom of movement.

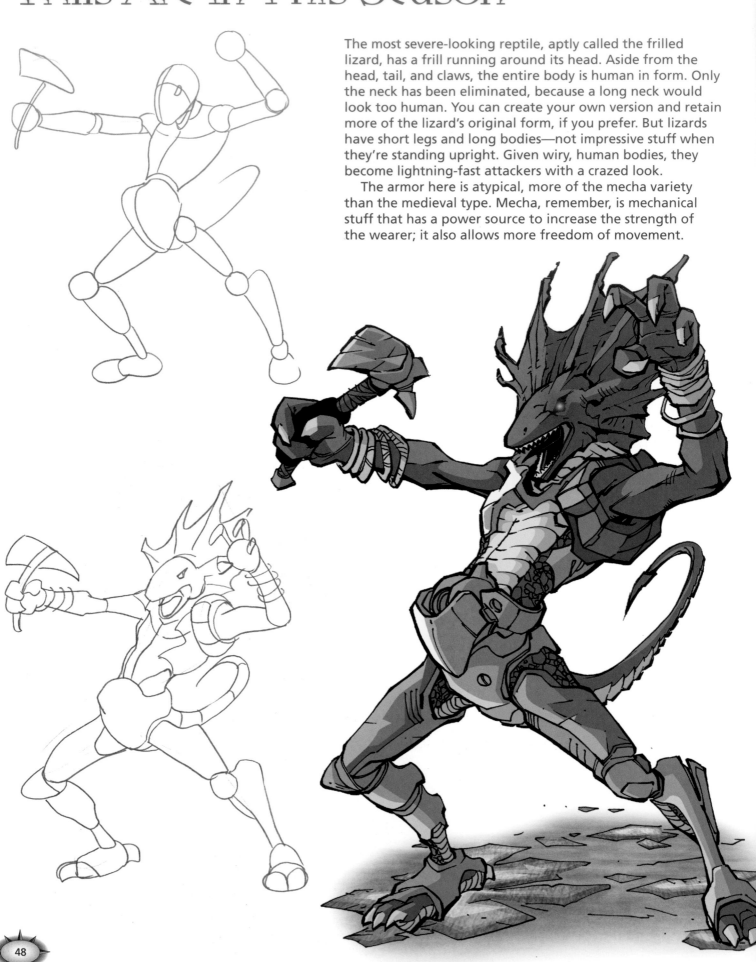

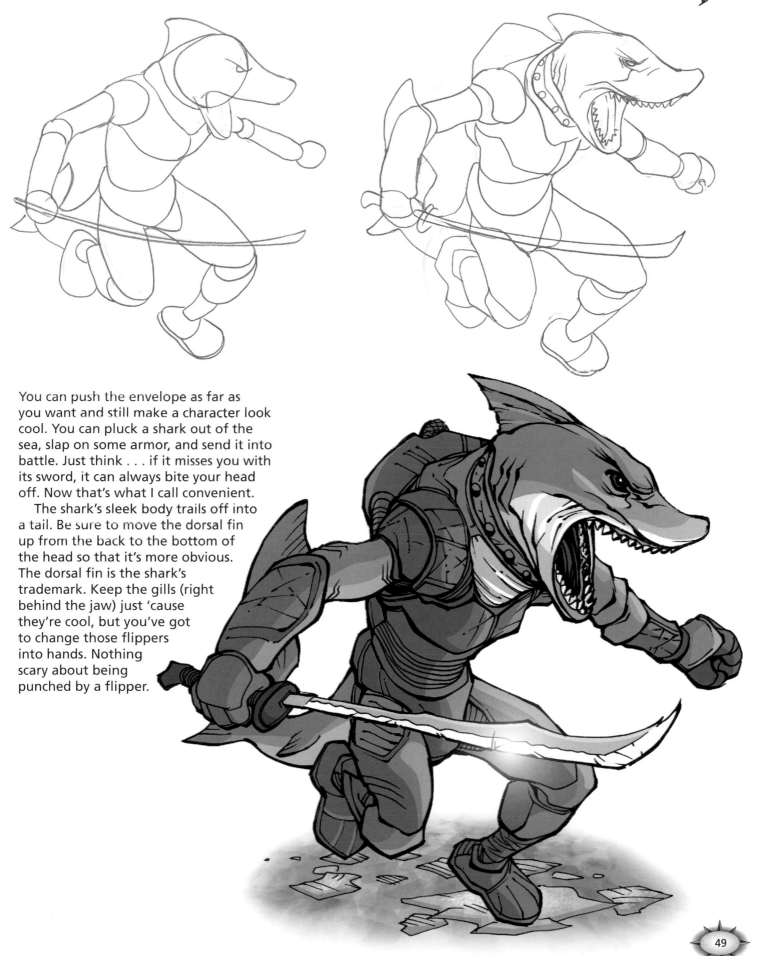

You can push the envelope as far as you want and still make a character look cool. You can pluck a shark out of the sea, slap on some armor, and send it into battle. Just think . . . if it misses you with its sword, it can always bite your head off. Now that's what I call convenient.

The shark's sleek body trails off into a tail. Be sure to move the dorsal fin up from the back to the bottom of the head so that it's more obvious. The dorsal fin is the shark's trademark. Keep the gills (right behind the jaw) just 'cause they're cool, but you've got to change those flippers into hands. Nothing scary about being punched by a flipper.

Your Local Warlord

The warlords of this netherworld trade in human flesh. Here, scores of people inhabit the dank, lower quarters of the castles, chained and shackled, performing backbreaking labor. The animal inspiration for these warlords was the rhinoceros.

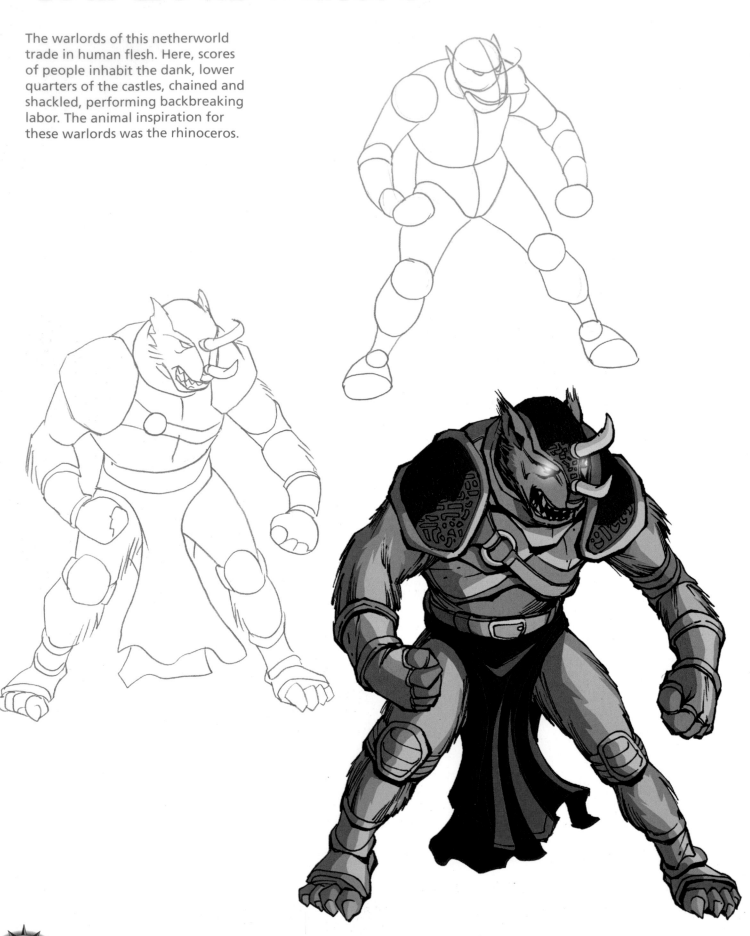

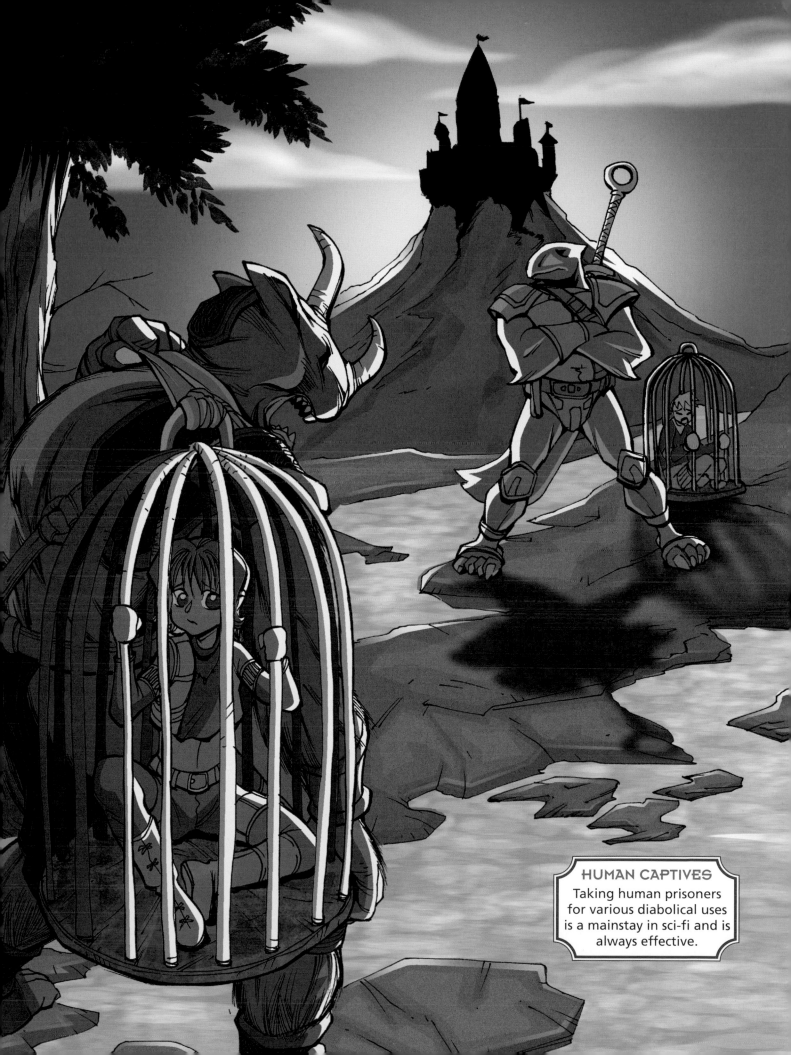

HUMAN CAPTIVES
Taking human prisoners for various diabolical uses is a mainstay in sci-fi and is always effective.

Who's Afraid of the Big Bad Wolf?

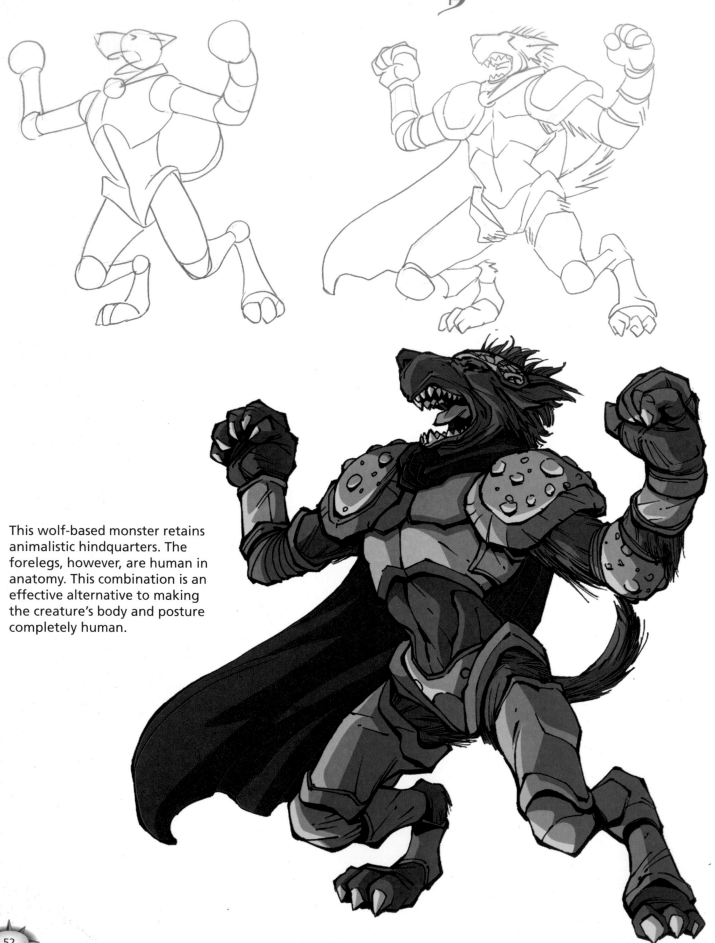

This wolf-based monster retains animalistic hindquarters. The forelegs, however, are human in anatomy. This combination is an effective alternative to making the creature's body and posture completely human.

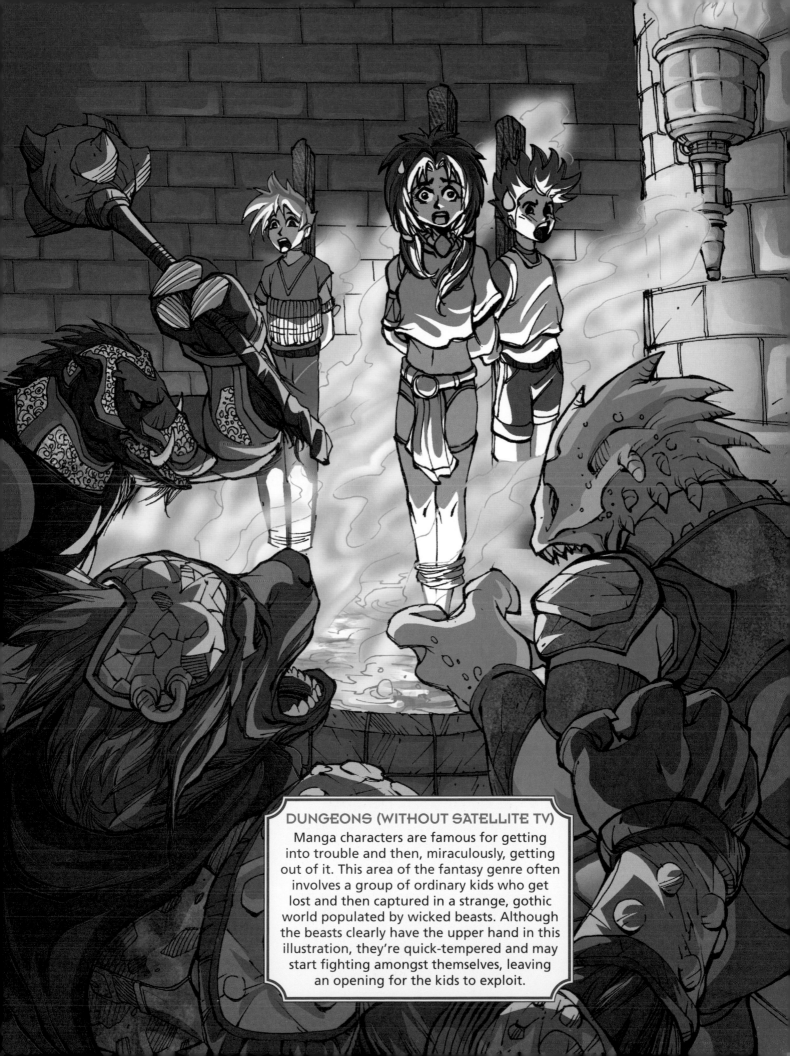

DUNGEONS (WITHOUT SATELLITE TV)

Manga characters are famous for getting into trouble and then, miraculously, getting out of it. This area of the fantasy genre often involves a group of ordinary kids who get lost and then captured in a strange, gothic world populated by wicked beasts. Although the beasts clearly have the upper hand in this illustration, they're quick-tempered and may start fighting amongst themselves, leaving an opening for the kids to exploit.

Guess Who's for Dinner?

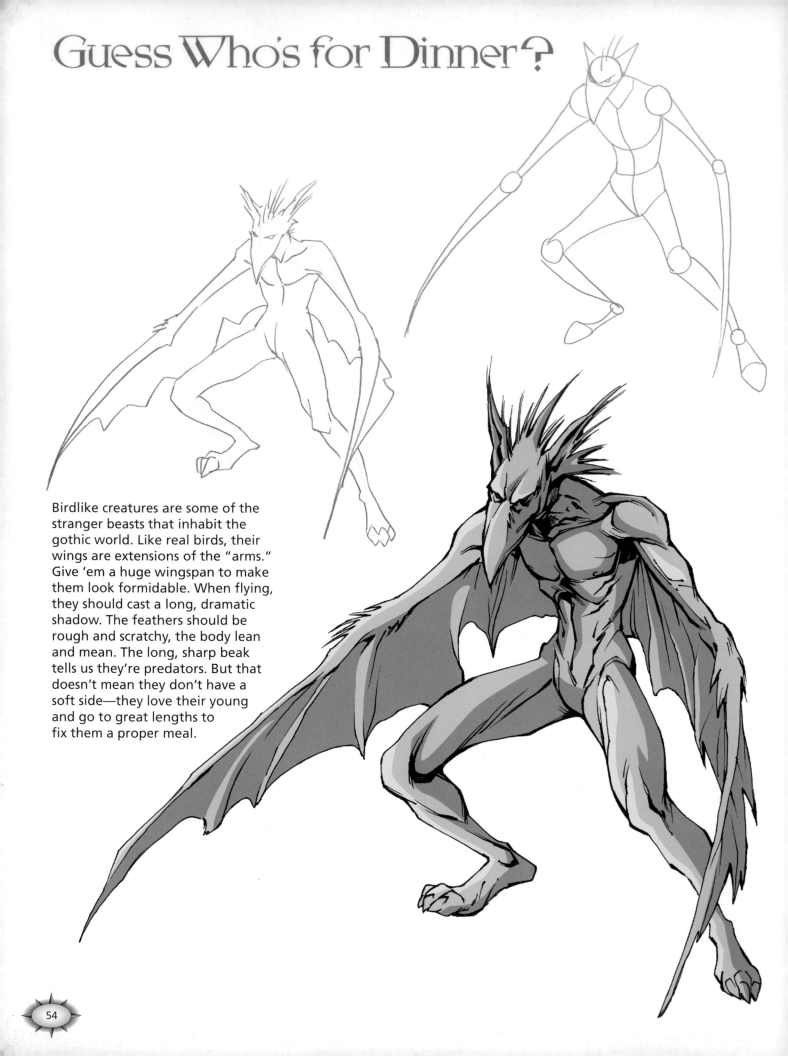

Birdlike creatures are some of the stranger beasts that inhabit the gothic world. Like real birds, their wings are extensions of the "arms." Give 'em a huge wingspan to make them look formidable. When flying, they should cast a long, dramatic shadow. The feathers should be rough and scratchy, the body lean and mean. The long, sharp beak tells us they're predators. But that doesn't mean they don't have a soft side—they love their young and go to great lengths to fix them a proper meal.

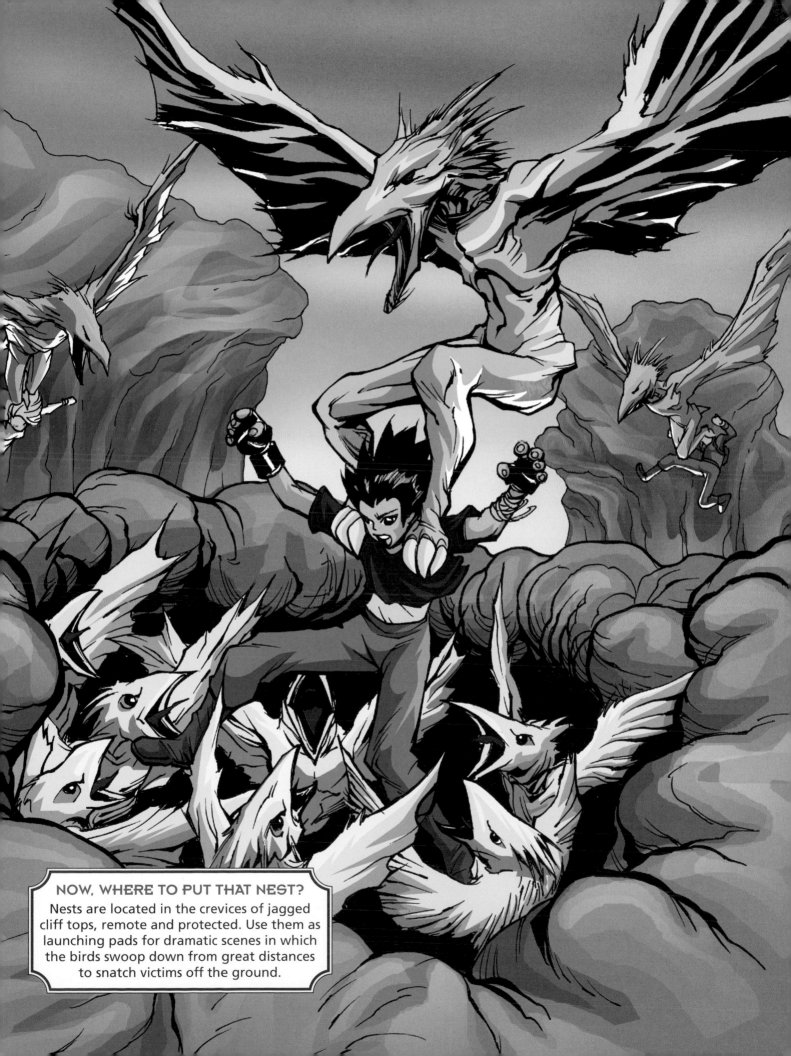

NOW, WHERE TO PUT THAT NEST?

Nests are located in the crevices of jagged cliff tops, remote and protected. Use them as launching pads for dramatic scenes in which the birds swoop down from great distances to snatch victims off the ground.

It's Not Easy Being...

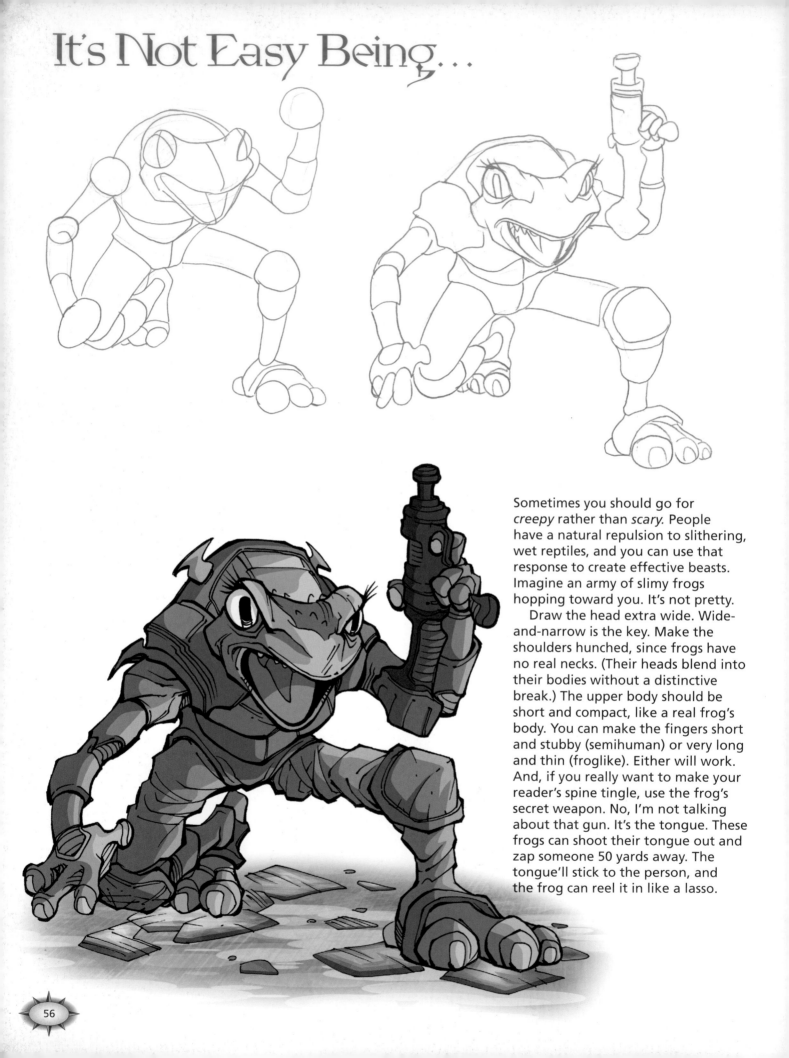

Sometimes you should go for *creepy* rather than *scary*. People have a natural repulsion to slithering, wet reptiles, and you can use that response to create effective beasts. Imagine an army of slimy frogs hopping toward you. It's not pretty.

Draw the head extra wide. Wide-and-narrow is the key. Make the shoulders hunched, since frogs have no real necks. (Their heads blend into their bodies without a distinctive break.) The upper body should be short and compact, like a real frog's body. You can make the fingers short and stubby (semihuman) or very long and thin (froglike). Either will work. And, if you really want to make your reader's spine tingle, use the frog's secret weapon. No, I'm not talking about that gun. It's the tongue. These frogs can shoot their tongue out and zap someone 50 yards away. The tongue'll stick to the person, and the frog can reel it in like a lasso.

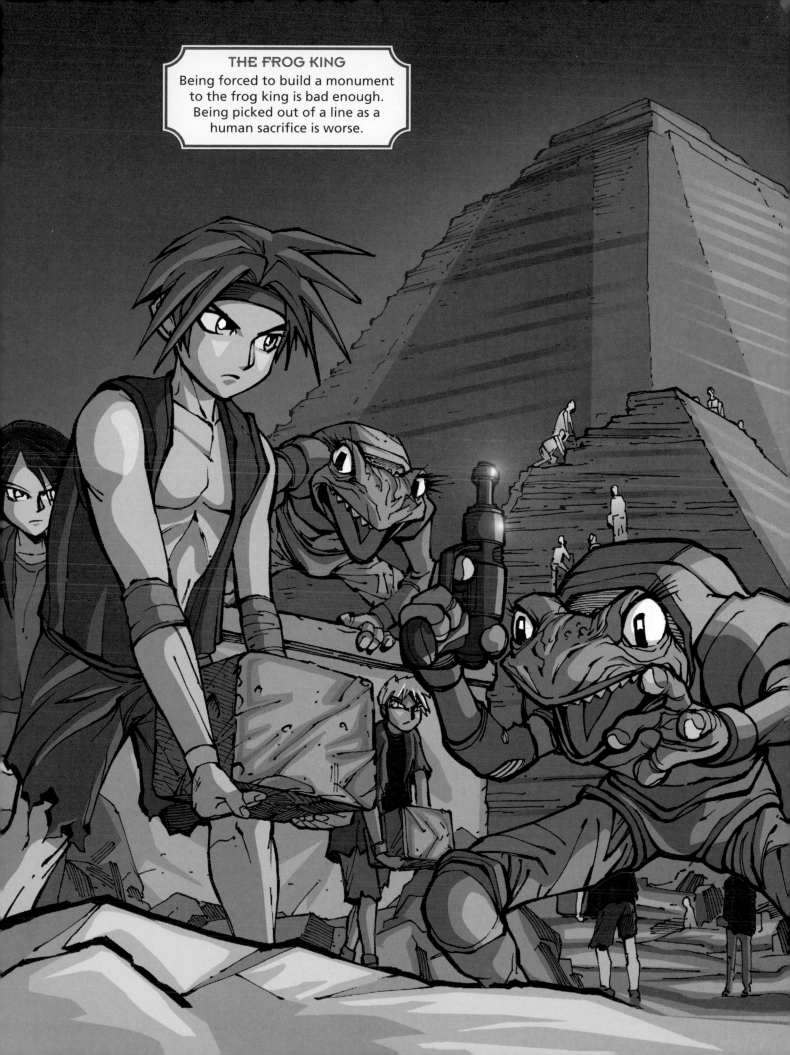

THE FROG KING

Being forced to build a monument to the frog king is bad enough. Being picked out of a line as a human sacrifice is worse.

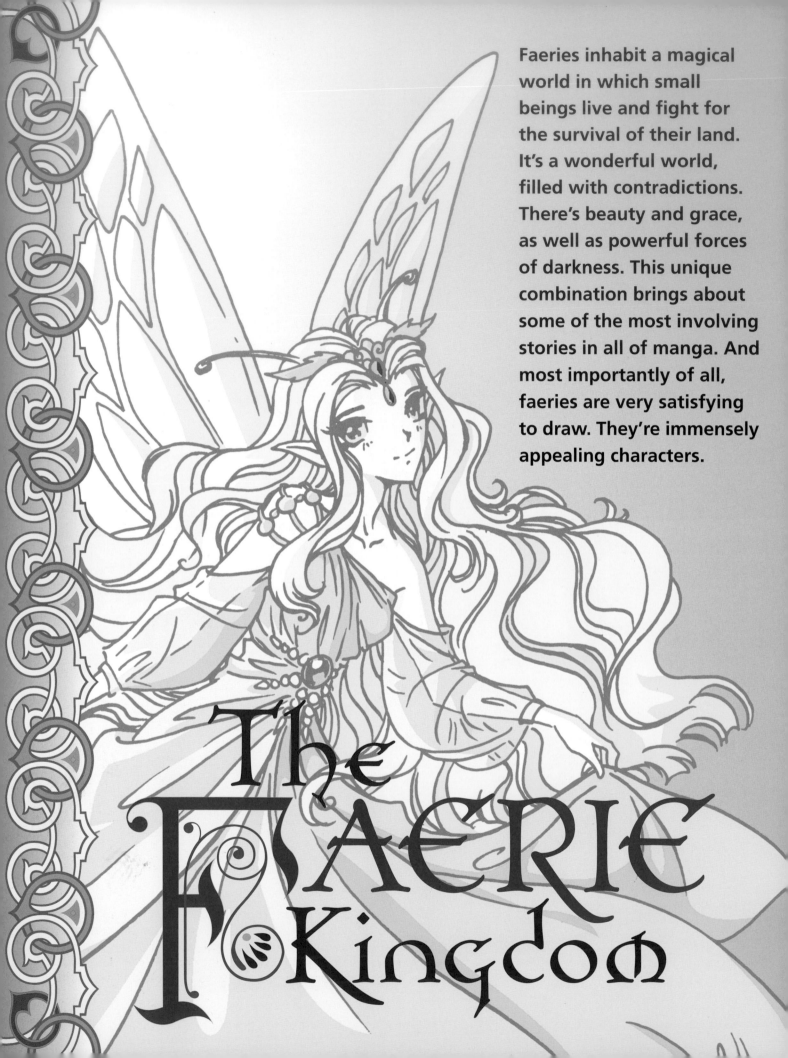

Faeries inhabit a magical world in which small beings live and fight for the survival of their land. It's a wonderful world, filled with contradictions. There's beauty and grace, as well as powerful forces of darkness. This unique combination brings about some of the most involving stories in all of manga. And most importantly of all, faeries are very satisfying to draw. They're immensely appealing characters.

The Faerie Kingdom

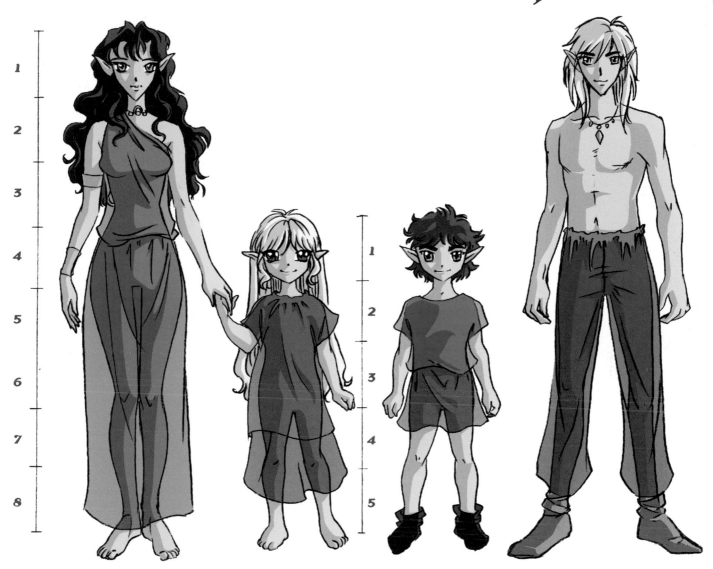

FIGURE PROPORTIONS

Adult faeries are drawn at 8 units or "8 heads tall," as artists call it. So, they're fairly long characters. By contrast, toddler faeries are only 5 heads tall, which means that they're more compact (and cuter). Artists don't have much use for measurements like 6' tall or 5' 9", which don't tell you anything about the proportions of a figure when you're drawing it. Artists use the head as a basic unit of measurement. For example, if you look to the lines next to the characters, you'll see that each unit is equal in size to a character's head.

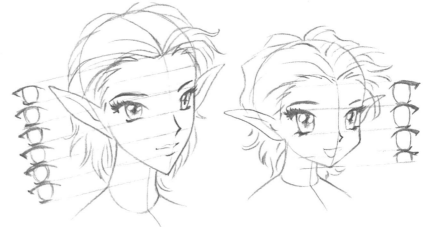

HEAD PROPORTIONS

You can measure the proportions of the head by using the eye as the unit of measurement. Adult heads are 6 eyes long (from the chin to the crown of the forehead), while toddler heads are only 3½ eyes long. This means that a toddler's eyes take up a much larger proportion of the face than do those of an adult.

Young Faeries: Male...

A faerie isn't just a human with funny ears. There are other adjustments you need to make to create these magical beings. Like 12-year-old kids, faeries are drawn about 6½ heads tall. However, they are slimmer and lighter than humans. Their hair is wilder, and their faces are slightly thinner and longer. You already know about the ears, but you can also add antennae and insect wings. Being creatures of nature, many manga faeries go around barefoot. And their clothes should look like stuff you would have gotten at a thrift shop in Robin Hood's day.

Faerie hair is naturalistic. It never looks combed.

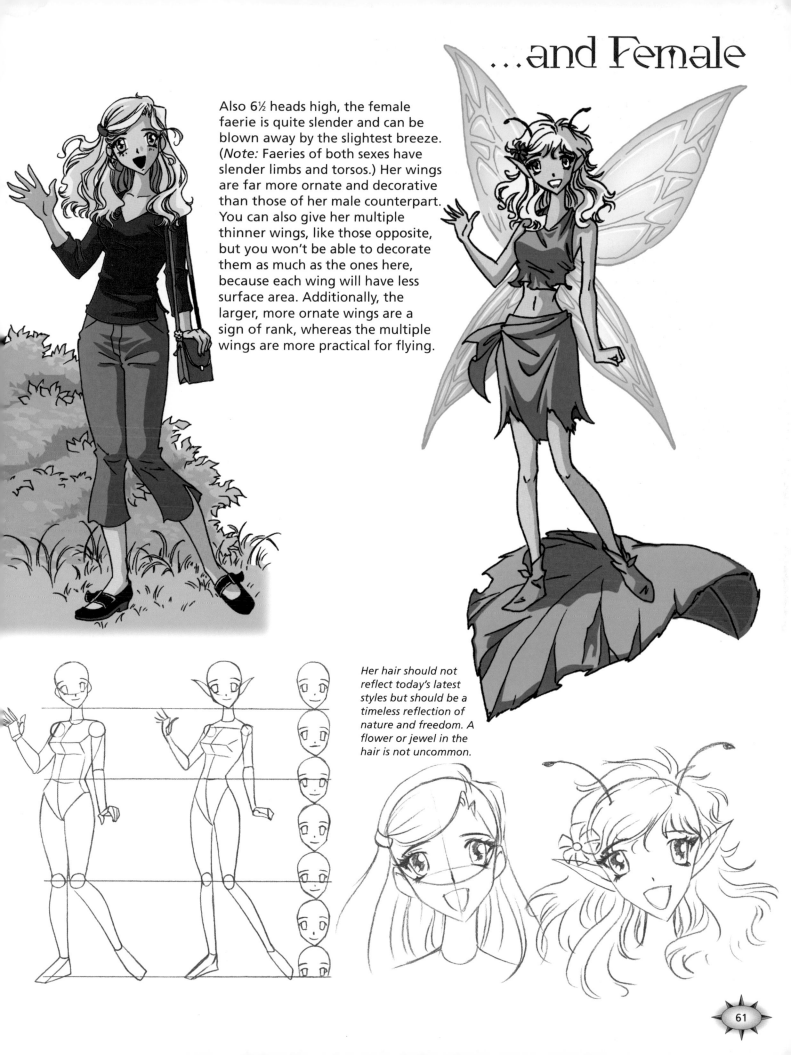

Also 6½ heads high, the female faerie is quite slender and can be blown away by the slightest breeze. (*Note:* Faeries of both sexes have slender limbs and torsos.) Her wings are far more ornate and decorative than those of her male counterpart. You can also give her multiple thinner wings, like those opposite, but you won't be able to decorate them as much as the ones here, because each wing will have less surface area. Additionally, the larger, more ornate wings are a sign of rank, whereas the multiple wings are more practical for flying.

Her hair should not reflect today's latest styles but should be a timeless reflection of nature and freedom. A flower or jewel in the hair is not uncommon.

The Young Faerie Head: Male...

To start, draw the top of the head (the skull) and the bottom of the head (the jaw) as two separate masses stuck together. The line down the middle of the form is called the *center line* and is used by artists to keep things symmetrical on both sides of the face. Draw it lightly and erase it later. Draw the eyes very wide apart to emphasize the roundness of the face, a quality that people associate with youth and innocence and that is naturally appealing to readers. The chin is always narrow, and comes to a point—a sign of elegance. The ears are long and, at the top, always, *always* trail off at a 45-degree angle, never straight up and down, which would make them look like devil's ears.

Note that the far eye becomes narrower as it recedes around the far side of the face. This is important for drawing faerie eyes in a 3/4 view. Since the eyes are set so far apart, the far eye must appear to get thinner in width in this angle. If the eyes are drawn in equal size and shape, the roundness of the face will be lost on the audience, and the drawing will look incorrect. By distorting the far eye, you create the illusion that the eye is on a round surface in much the same way as a ship sailing away from you, over the horizon, gets smaller. Of course, this isn't the case when drawing faeries in a front view or profile, because both of those are flat, head-on views.

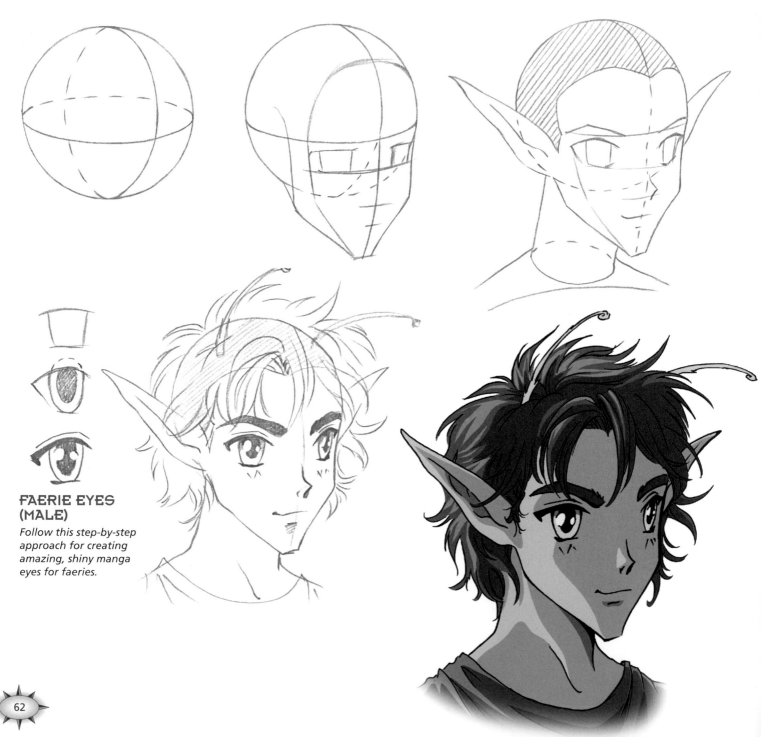

FAERIE EYES (MALE)

Follow this step-by-step approach for creating amazing, shiny manga eyes for faeries.

...and Female

While the male faerie head is subtle and gentle, the female's is even more refined and elegant. Her jawline is smoother and doesn't cut as strong an angle from the ear to the chin. The outline of her face, from her forehead down to her chin, is also marked by gentle curves. The neck is thin and supple. The eyes are positioned wide apart and get a generous helping of lashes. The hair is long and wavy.

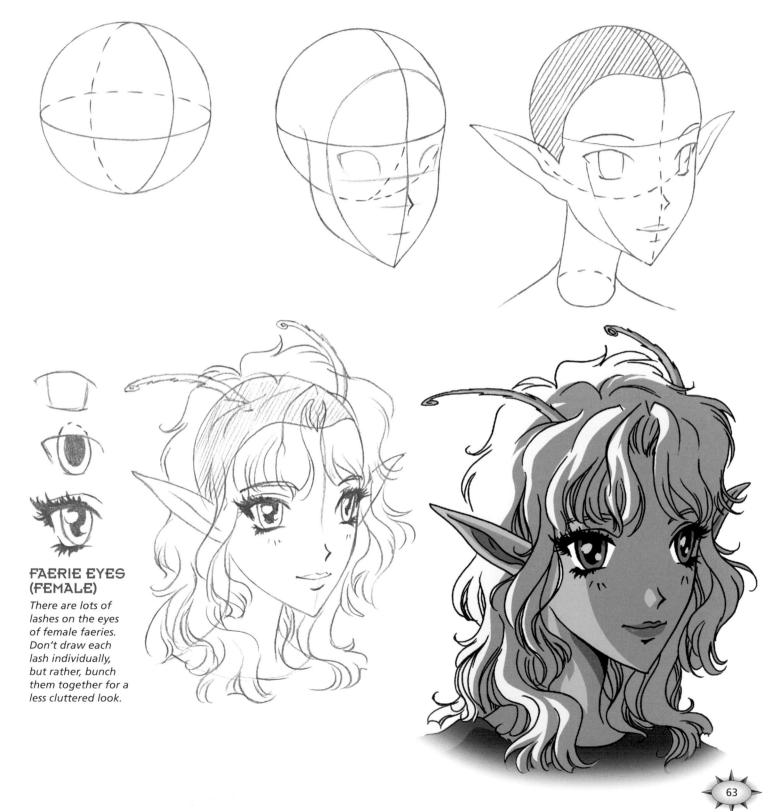

FAERIE EYES (FEMALE)

There are lots of lashes on the eyes of female faeries. Don't draw each lash individually, but rather, bunch them together for a less cluttered look.

Head Tilts

Since faerie faces are unusually subtle, it helps to get some hints for drawing the head at various angles. By practicing these head tilts, you'll be able to draw these characters more intuitively. If you reach a point at which you don't get a pose right, go back to the previous construction step—rather than looking to the finished drawing—to see where you went wrong.

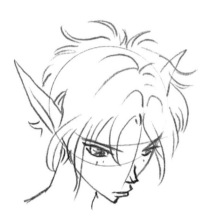

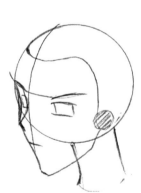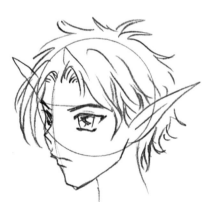

HEAD TILTS

FAERIE EYES

A few variations.

FAERIE EARS

You can come up with a great variety of ears, but I wouldn't use too many varieties in a single group of faeries. The ear type is what distinguishes one group of faeries from another.

Faeries vs. Elves

The basic rule to go by is: Faeries have wings and elves don't. Faeries also may have antennae, whereas elves never do. And, faeries can be very tiny in size, while elves, though small, are not so tiny that they can be held in the palm of the hand like faeries. This means that faeries are much more elusive creatures.

As the larger of the two beings, an elf can hold a fairy in the palm of her hand.

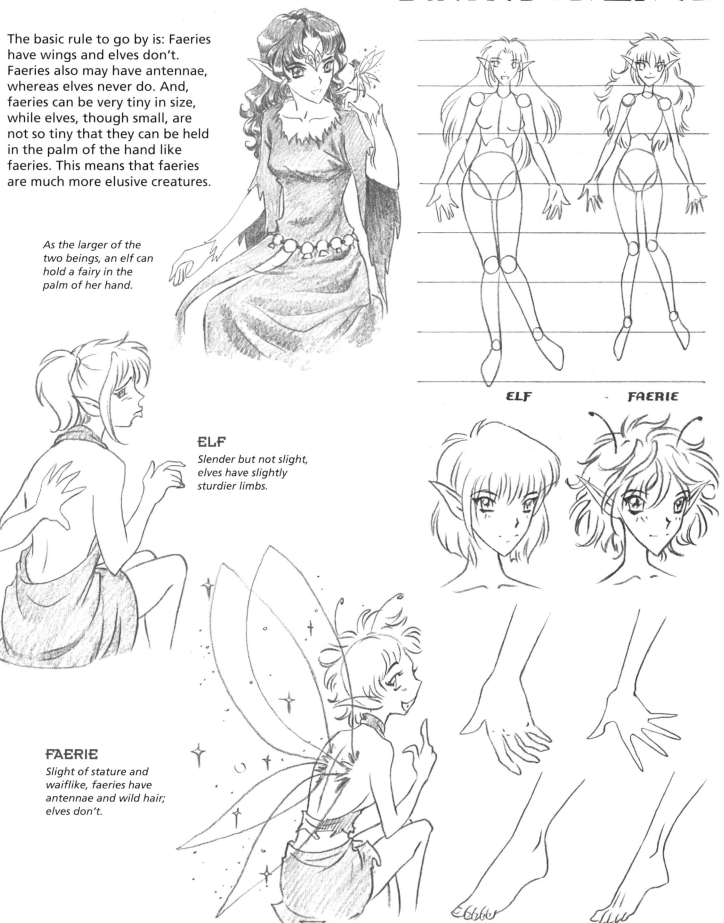

ELF · FAERIE

ELF
Slender but not slight, elves have slightly sturdier limbs.

FAERIE
Slight of stature and waiflike, faeries have antennae and wild hair; elves don't.

Faeries in Full Dresses

One of the most rewarding parts of drawing is creating a variety of interesting characters, each with his or her own personality. The next few pages show a variety of faerie characters, each with step-by-step instructions.

Although faeries are forest creatures, casual and carefree in appearance, they can be attired more formally—in beautiful dresses and gowns, which make them look even more magical. When drawing a full dress, make sure it catches the wind and billows. The fabric should bunch and crease where the figure bends. It should also crease at points where the clothes are pulled together, such as the belt and shoulder areas. The creases should radiate outward from these stress points. The clothes should never be tight, but always loose and flowing. Also, the longer the dress, the longer the character's hair should be.

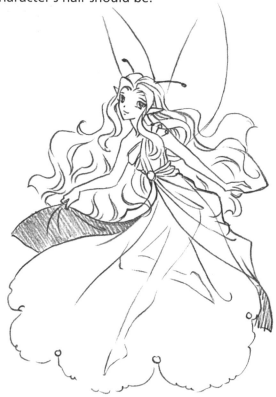

A NOTE ABOUT DRAWING CLOTHES

It's a wise practice to sketch out the entire body before adding the dress, even if the dress will ultimately obscure part of the figure, such as the legs in the example here. If you can't draw the entire figure correctly first—without the dress—sketching a dress over a sub-par figure won't hide the drawing's weakness.

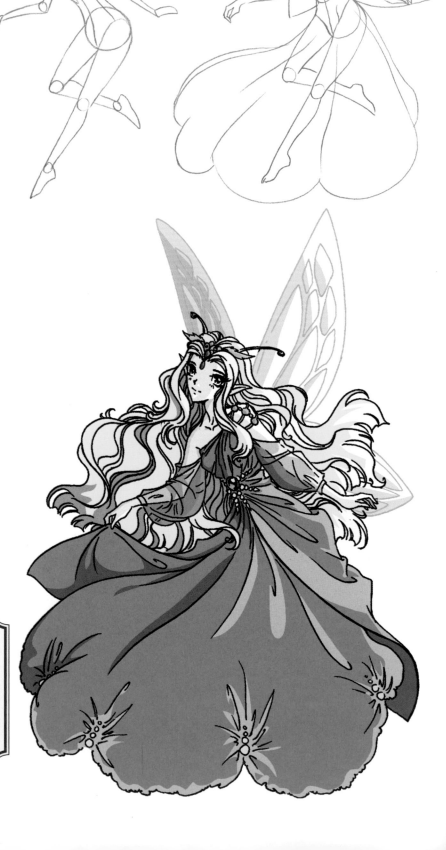

Faerie Prince

All faerie royals usually have ornate wing designs.
The men often wear capes, as well. Instead of
carrying a hawk on his forearm, the faerie prince
has a fictionalized version of a monarch butterfly.
There's nothing intrinsically unique about the prince's
face as compared to other male faeries his age. It's
the crown, heavily jeweled necklace, high boots,
and such that bestow on him his air of distinction.

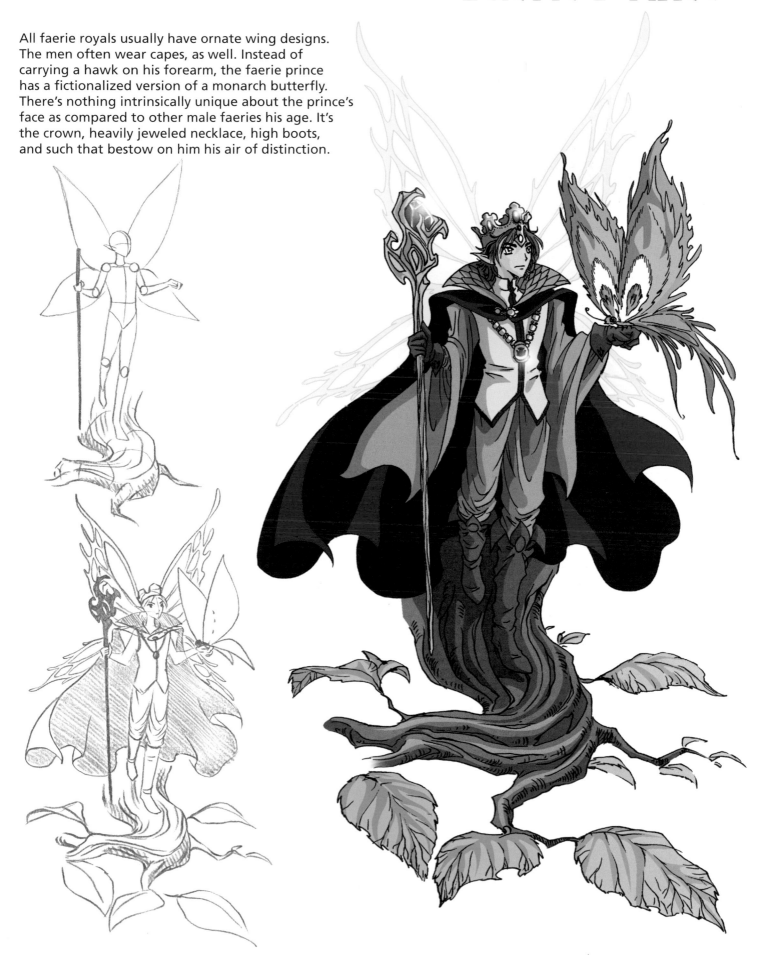

Faerie Queen

The matriarch of the faerie kingdom sits on her thrown, which is really the petals of a flower. Her commanding posture reinforces her status: She sits upright, erect, always seeing and surveying her domain. As you can see by her open face and large eyes, she's a kind queen. Her headpiece, ornate wings, high collar, long sleeves, jewels, and scepter with amulet are the hallmarks of royalty.

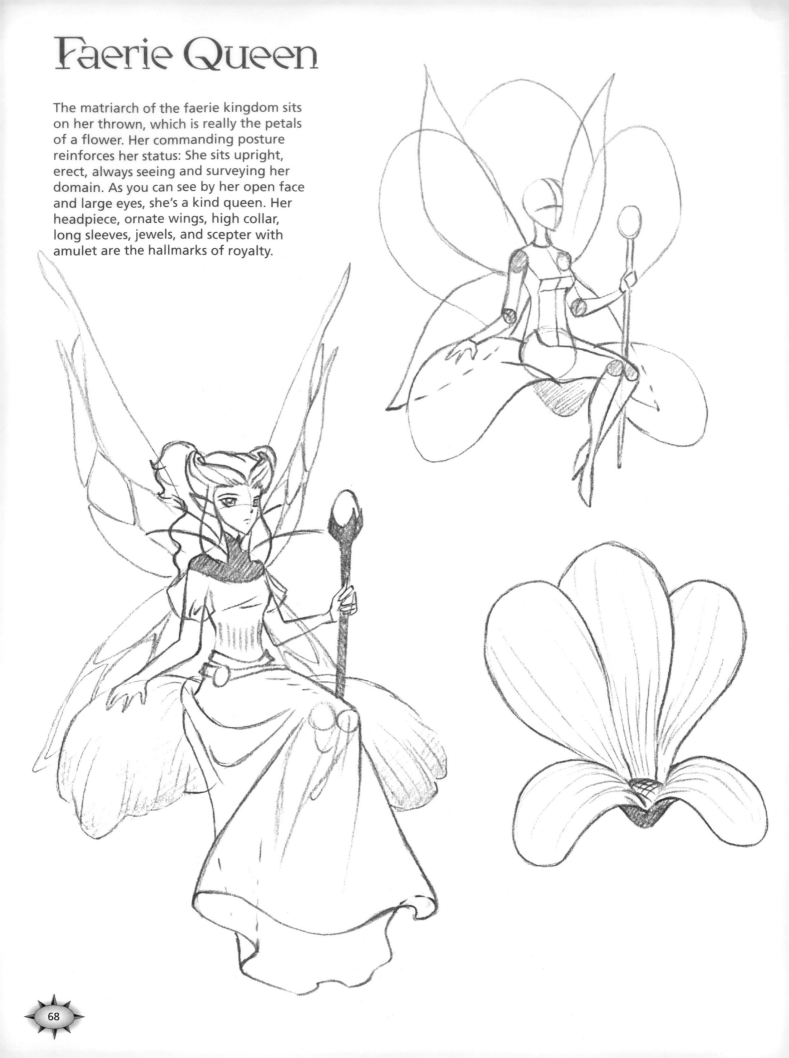

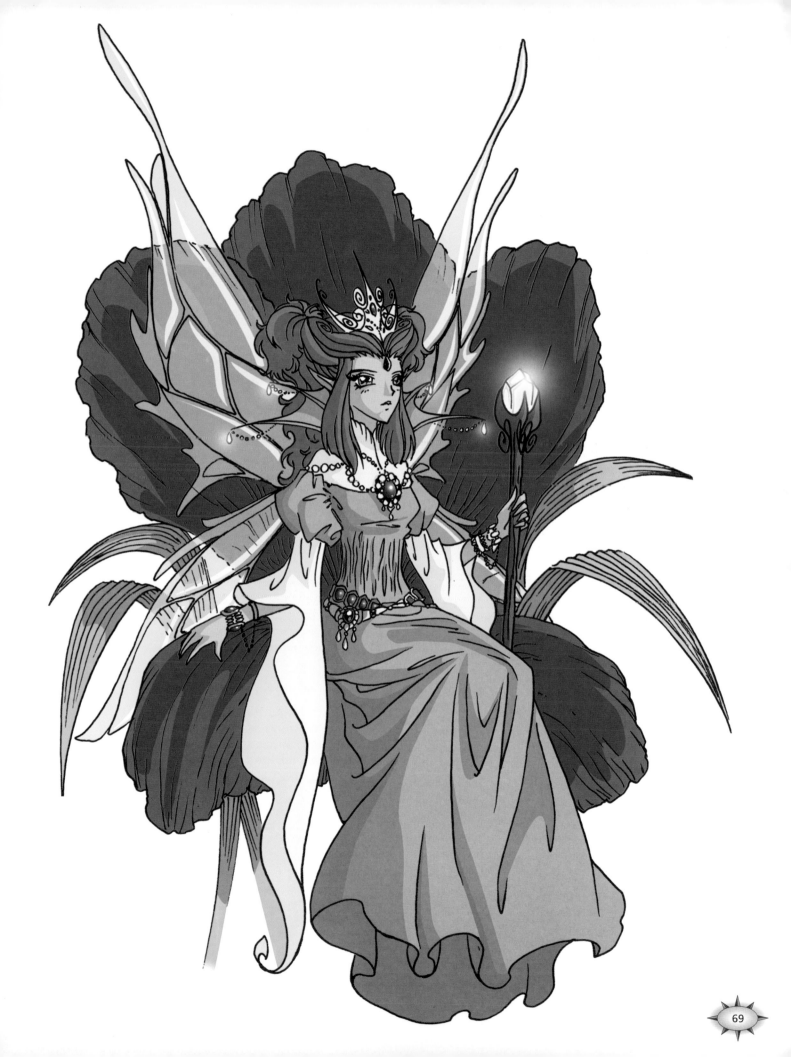

Faerie Dragon

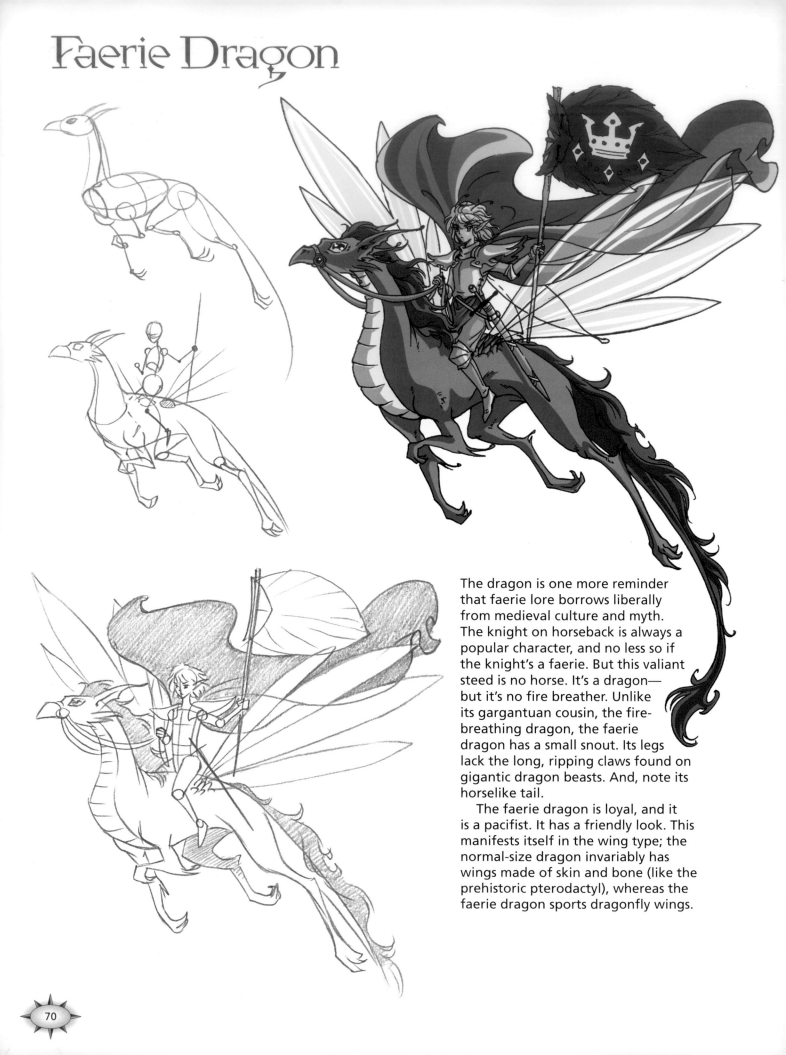

The dragon is one more reminder that faerie lore borrows liberally from medieval culture and myth. The knight on horseback is always a popular character, and no less so if the knight's a faerie. But this valiant steed is no horse. It's a dragon—but it's no fire breather. Unlike its gargantuan cousin, the fire-breathing dragon, the faerie dragon has a small snout. Its legs lack the long, ripping claws found on gigantic dragon beasts. And, note its horselike tail.

The faerie dragon is loyal, and it is a pacifist. It has a friendly look. This manifests itself in the wing type; the normal-size dragon invariably has wings made of skin and bone (like the prehistoric pterodactyl), whereas the faerie dragon sports dragonfly wings.

The tale of King Arthur has The Lady of the Lake, and today's *mangakas* (manga artists) have water faeries in their adventures. Being closely connected to the forces of nature, the water faerie can cause currents, ripples, and the tides to form and do her bidding. She can appear out of the water and return again, leaving no trace, no wake in her path. She can be either a friend or a foe of those who would travel by boat, ferry, or raft.

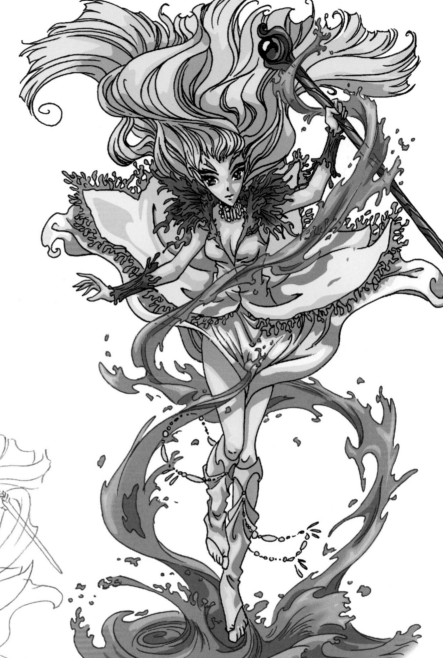

FAERIE/HUMAN RELATIONS

Faeries can never have romantic involvements with humans. So, you end up with the natural tug between, for example, a human man and a faerie woman, separated, always, by the fact that they must inhabit two different worlds. And, don't let the small size of the females fool you; female manga faeries are attractive ladies. When drawing an attractive faerie, remember that just because she's small doesn't mean she should have short proportions. She can have fairly long, attractive legs and still be thumb size.

Faerie Mermaid

Characteristic of the faerie mermaid is her long, flowing hair, which is accentuated all the more by its graceful movement through the water currents. Typically, the mermaid has some sort of a low-cut top to cover her torso, which leaves her shoulders, arms, and neck bare. The bottom half of the figure is purely aquatic and unclothed. She has a flowing fin at the end of her lower half and translucent side fins off her hips.

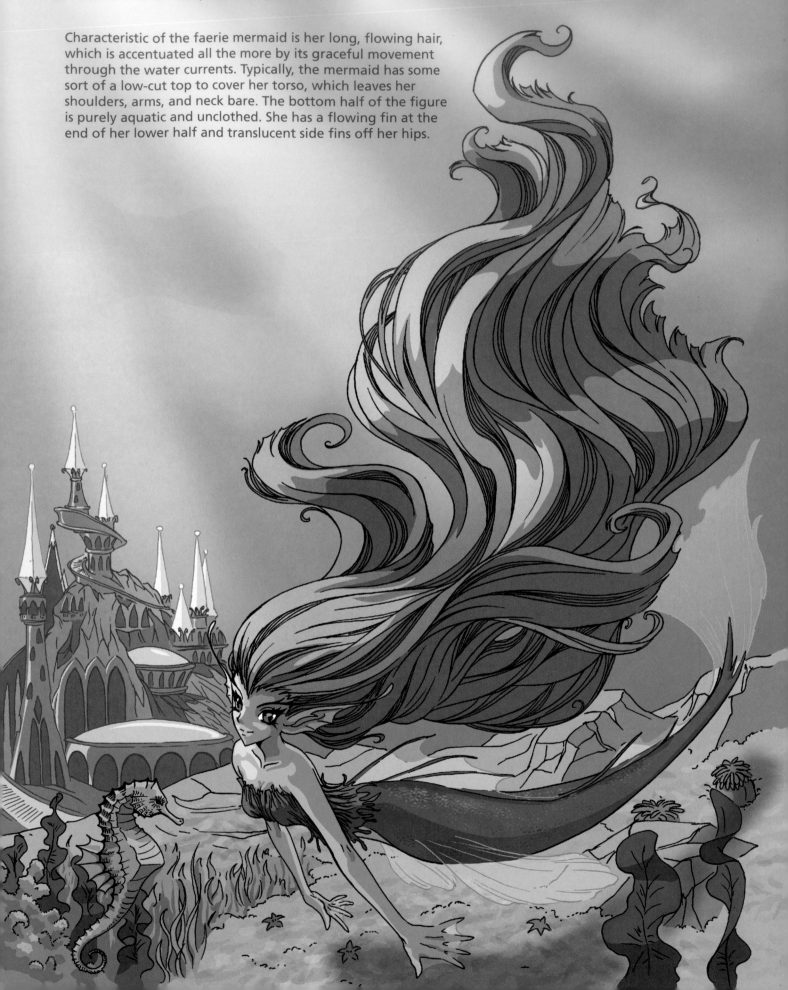

Flamekeeper Faerie

All of nature's primal elements—earth, wind, water, and fire—can be assigned to a particular faerie for safekeeping and control. Mastering these forces takes lifelong study that must remain secret and out of enemy hands. Whoever controls fire can use it to light a house in winter, add warmth, or destroy an entire forest and all the magical creatures within it.

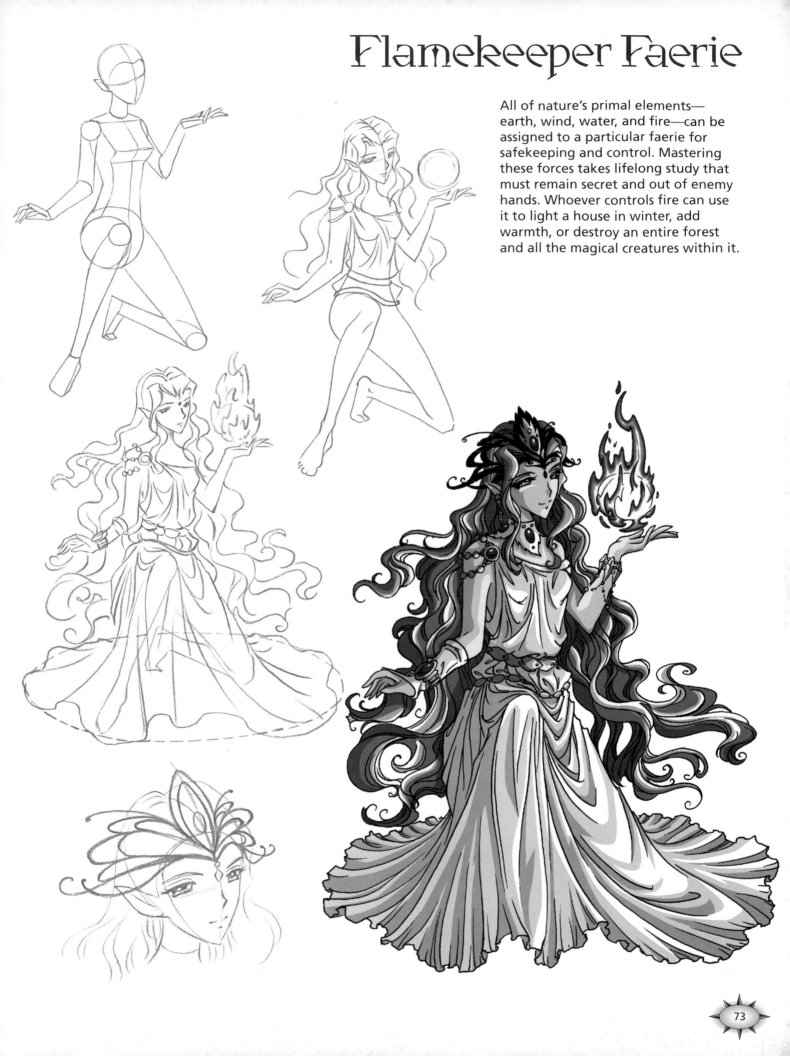

Windkeeper Faerie

You cannot see the wind, only the effects it has on the environment. Therefore, it's important to sprinkle some windswept foliage around the windkeeper faerie. Her garment is also windblown in an elegant manner, with many delicate folds and creases. Her ears are feathered, a motif borrowed from the helmet of Mercury, the Roman god who served as messenger to the other gods.

As noted on page 66, it's always a good idea to sketch out the entire figure before clothing it, but it's especially important for this character as the outline of her legs is delineated by the folds and creases in her clothing.

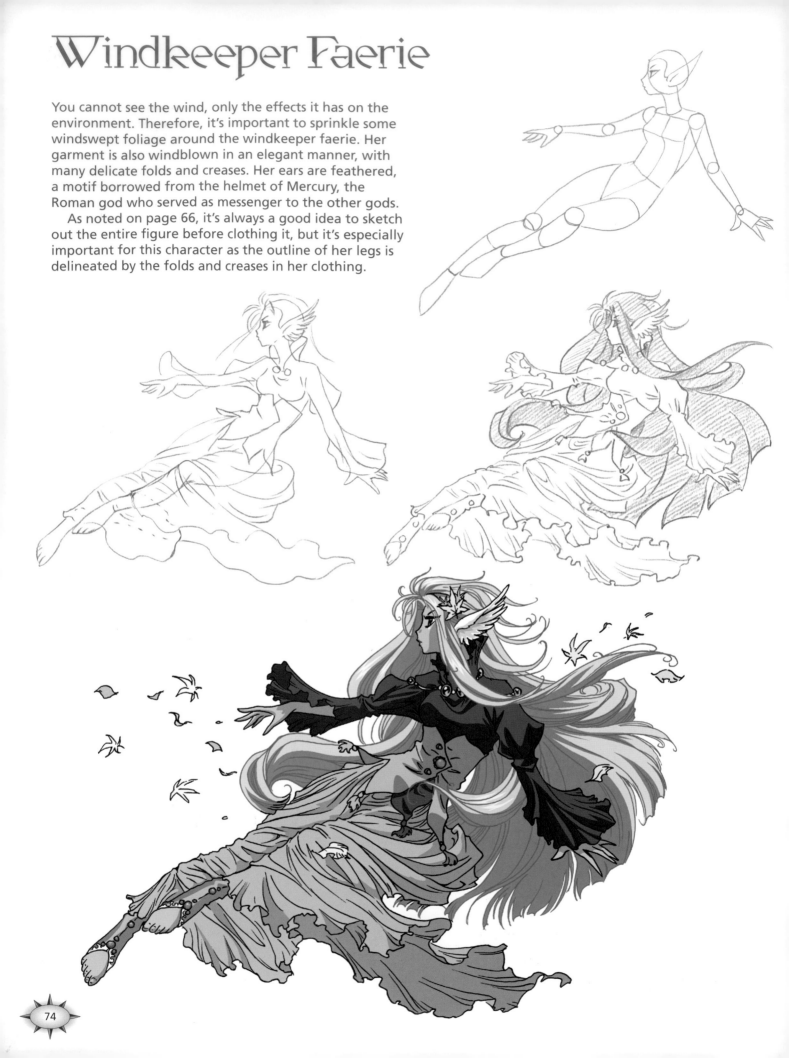

Ethereal Beings

Cousins of faerie characters are the ethereal beings—beings of light, magic, and grace. They are dramatic, mysterious, even mystical. Call them the new-age manga. They appear suddenly, like a vision, and can leave just as quickly. They're noted for their elegant appearance. Humans on special quests often seek guidance from these beings.

They can appear in almost any manga genre, be it medieval, faerie, or sci-fi. You can have one of these ethereal beings show up as a serene, mystical knight in medieval times, for example. In each genre, ethereal beings should be costumed appropriately for the time period. However, they should appear as spectral images, almost translucent, filled with an omniscient aura and an otherworldly tranquility. When these beings fight, as they sometimes do, they're the most difficult characters to defeat in all of manga. Their defenses are perfect, their attacks effortless.

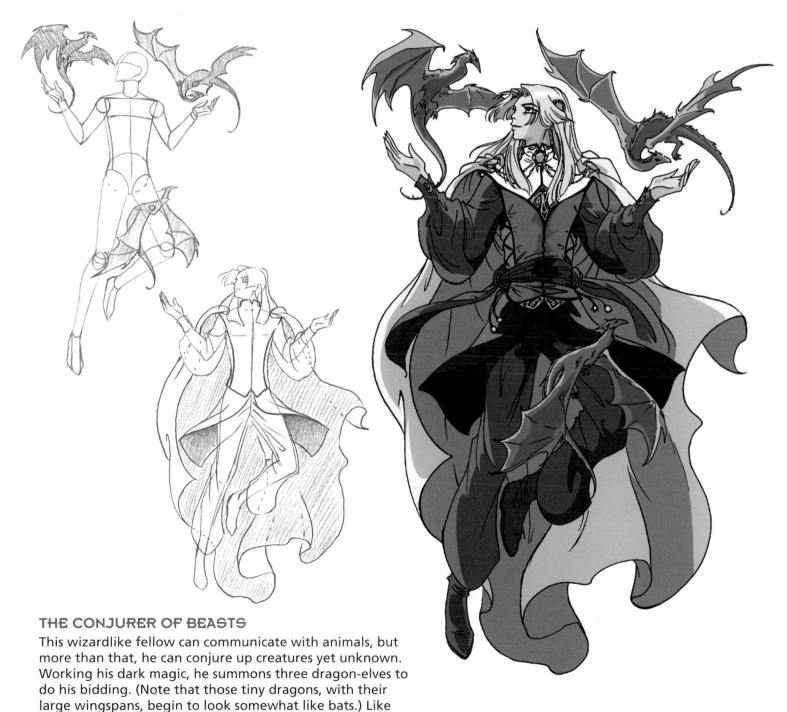

THE CONJURER OF BEASTS

This wizardlike fellow can communicate with animals, but more than that, he can conjure up creatures yet unknown. Working his dark magic, he summons three dragon-elves to do his bidding. (Note that those tiny dragons, with their large wingspans, begin to look somewhat like bats.) Like most wizards, he has long flowing hair, a cape, and billowing sleeves. He straddles the fence between good and evil.

BEING OF LIGHT

Light is a great device for showing a character's magical qualities. The reader instantly senses that whoever controls the light is imbued with special powers.

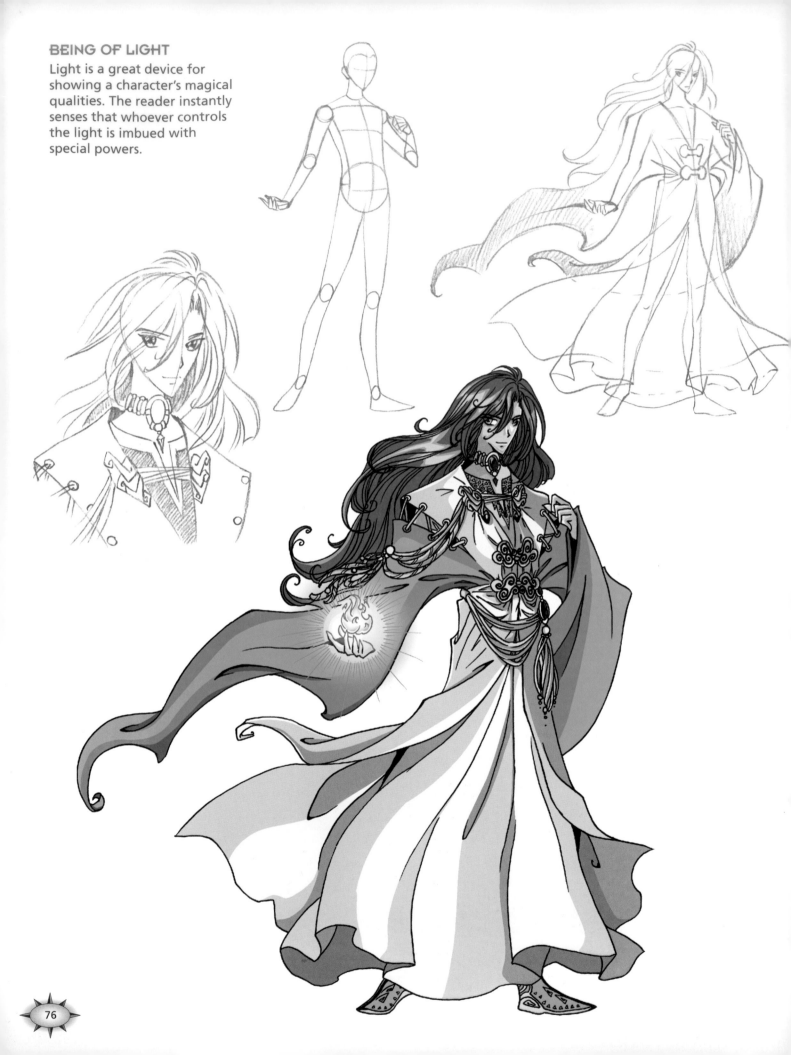

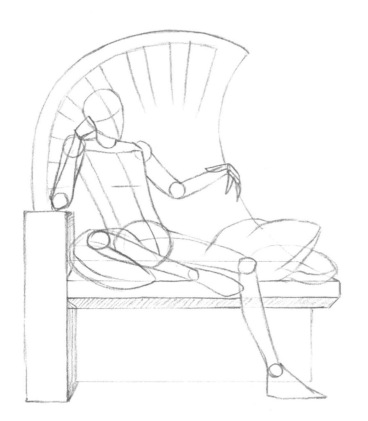

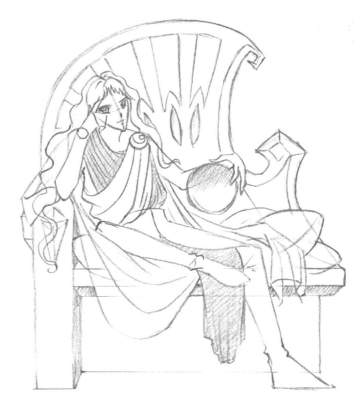

ETHEREAL BEINGS AT REST

The Greek gods had to rest after expending their energies, so perhaps, ethereal beings also require a place to rest and reflect. You can create a special place for these beings to dwell and receive visitors. The resting place might be a throne, several columns, a garden, or even a bench. When designing a chair, throne, bench, or bed, it may help to first select a theme. The influence in this case is a seashell, which you can see in the back of the bench. As you begin to define the theme, you can add so many flourishes that the original influence is no longer apparent. That's perfectly okay. You don't have to convey your original idea to the reader. Its purpose is to help you, as an artist, establish a framework—a starting point from which to create.

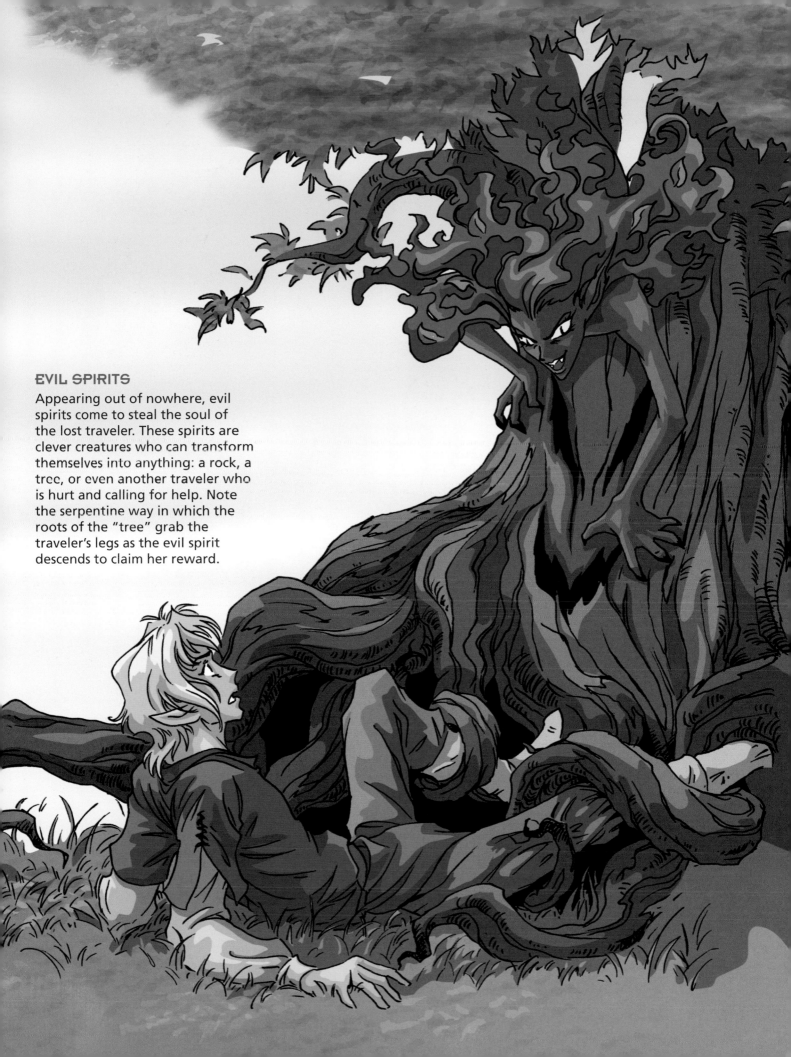

EVIL SPIRITS

Appearing out of nowhere, evil spirits come to steal the soul of the lost traveler. These spirits are clever creatures who can transform themselves into anything: a rock, a tree, or even another traveler who is hurt and calling for help. Note the serpentine way in which the roots of the "tree" grab the traveler's legs as the evil spirit descends to claim her reward.

Ogres, Trolls, and Hermits

Not everything can be serene and light, otherwise life would get pretty dull. Ogres, trolls, and hermits provide some needed variety in the faerie world. Here's the shorthand on how to remember who is who: Ogres are big and bad; trolls are little and bad; and hermits can be bad or good, depending on their mood, which is mercurial.

In some fantasy stories, dwarfs are cast as supporting characters. I strongly discourage the use of this term and of these characters in the fantasy genre. Dwarfism is a medical condition, unlike the characteristics of ogres, trolls, and hermits, which are completely fictional. Enlightened people do not exploit the medical conditions of others for novelty appeal.

OGRE

Ogres and big, monsterlike beings typically have bulbous oversized eyes, a small nose, pointy ears, and pointy fingernails. The forehead is big, but the rest of the face is narrow. Accentuate the cheekbones on the ogre (and on all evil characters) by making them wide, and give him sunken cheeks. Tattered clothes and a thick belt give the ogre a brutish look. His club can be plain or spiked, like a mace, and make those shoulders big, like melons.

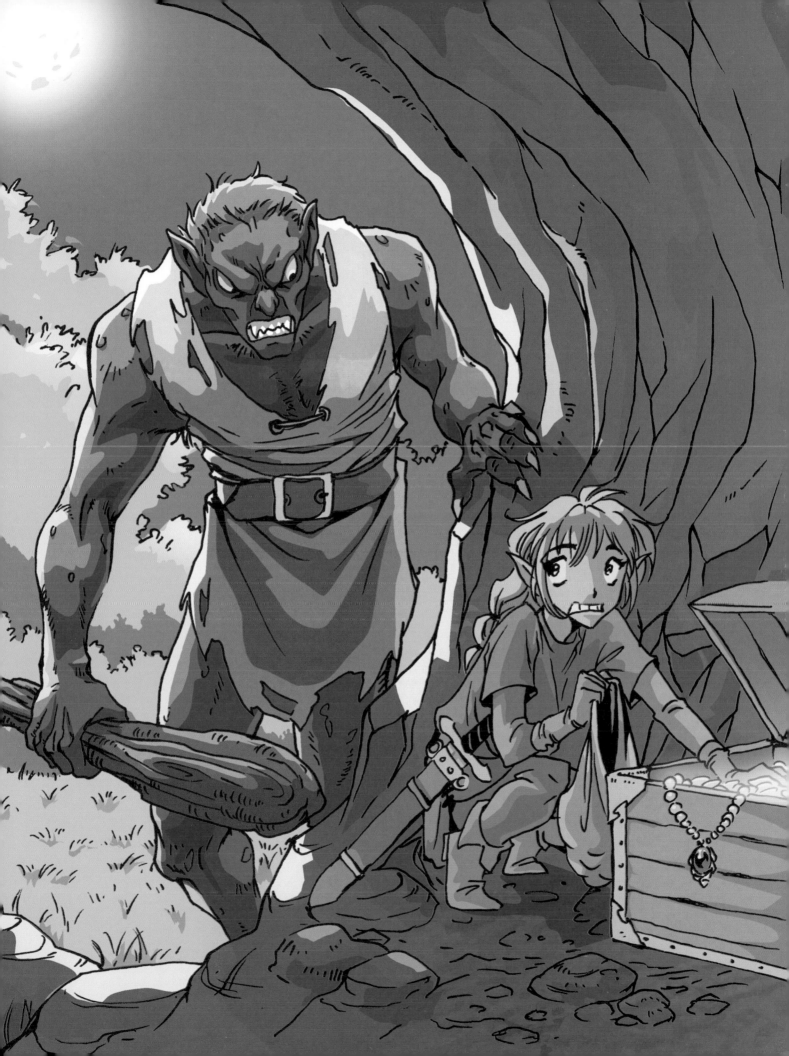

TROLL

Trolls live under bridges. Why they think this is a good idea beats me. But hey, I'm not a troll. For some reason, once a troll sits under a bridge, he doesn't like anyone else to cross it. And usually, the bridge is the only way across to a very important place. So the troll and the traveler have to go to conflict resolution therapy—either that, or you fight the troll.

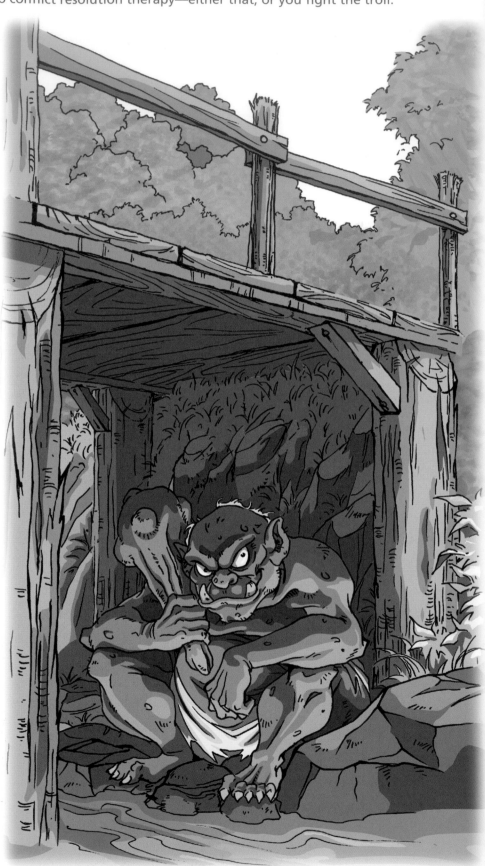

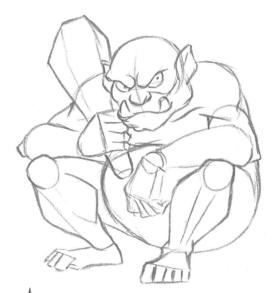

HERMIT

Hermits are secretive characters who live apart from the world. They often have special skills that place them in demand—and therein lies the drama. Just when you really need one, the hermit won't see any visitors. So you've got to plead your case in the most persuasive way. The hermit is an industrious, talented craftsman. Due to his solitary lifestyle, he doesn't care about his appearance. He lets his beard, hair, and eyebrows grow wildly long.

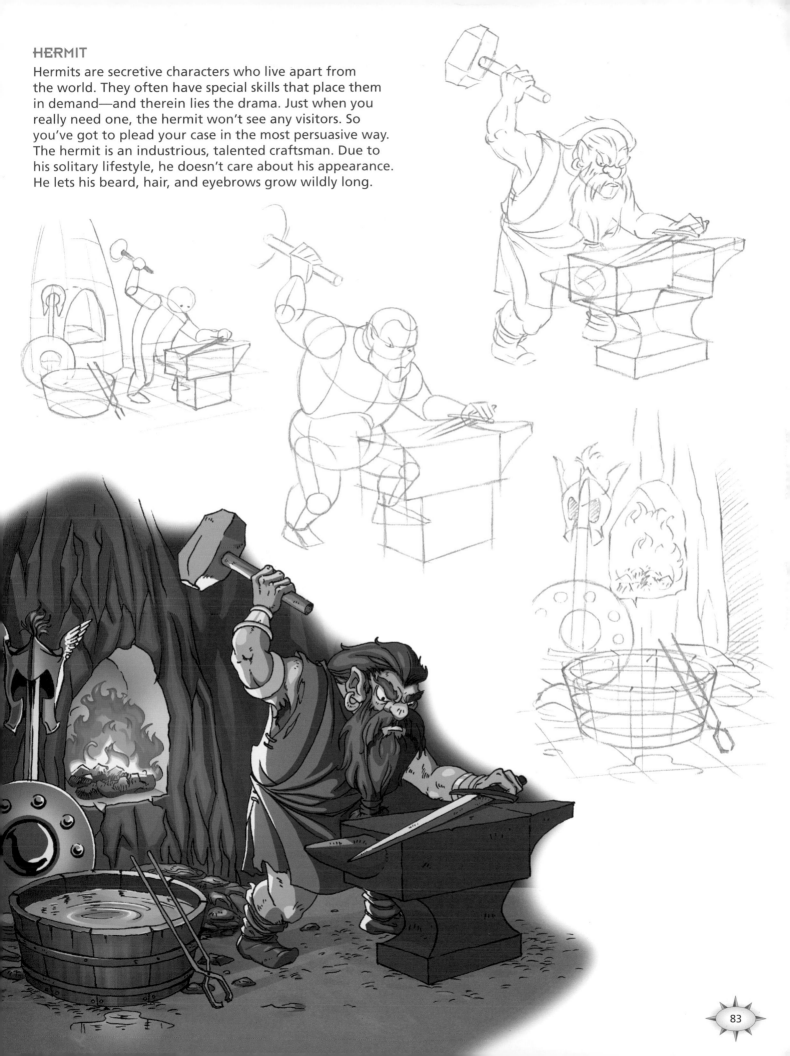

WARRIOR WOMEN OF MANGA

No book on the fantasy genre would be complete without a section on the alluring warrior women of the fantasy realm. They run the gamut from sexy villains to fearless fighters and even goddesslike creatures. Attitude is very important for female warriors, who must be confident and alluring. Also, the costume is paramount in defining the role the character plays. Of course, all female warriors should be appealing and attractive.

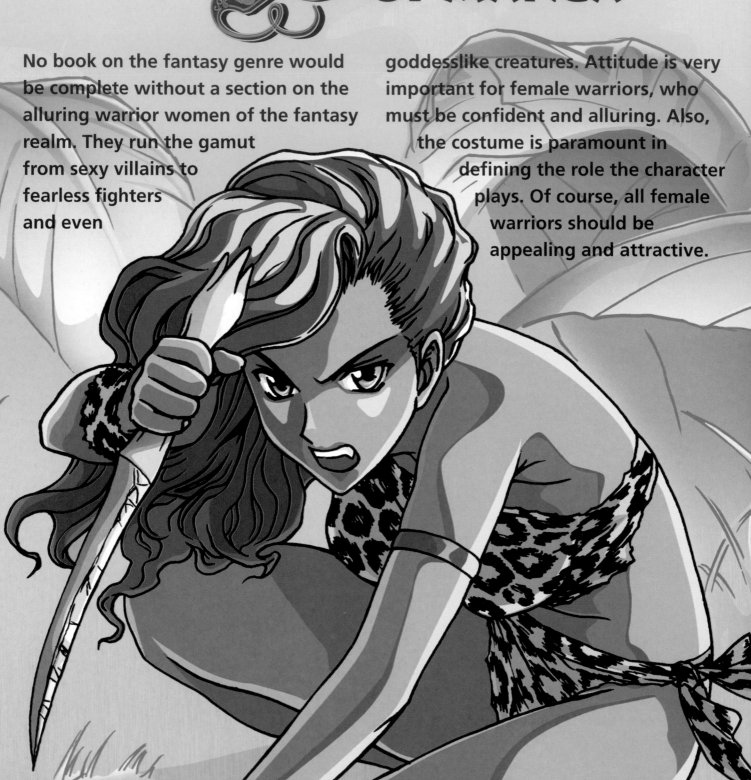

Fantasy Warrior

In manga, you often find that the toughest fighters are the best looking. So it is with this fearless fighter. Your task is to show enough of the body through the costume to get the audience to notice her figure.

The dramatic rotation of her upper body makes this pose stand out. If both her torso and her hips were facing forward, the image would lose its impact. Twisting, bending, stretching, and leaning make a dramatic pose. To draw someone charging forward, as this character does, position the upper body out in front, past the legs. Note that the bent leg obscures most of the lower leg and foot on that limb.

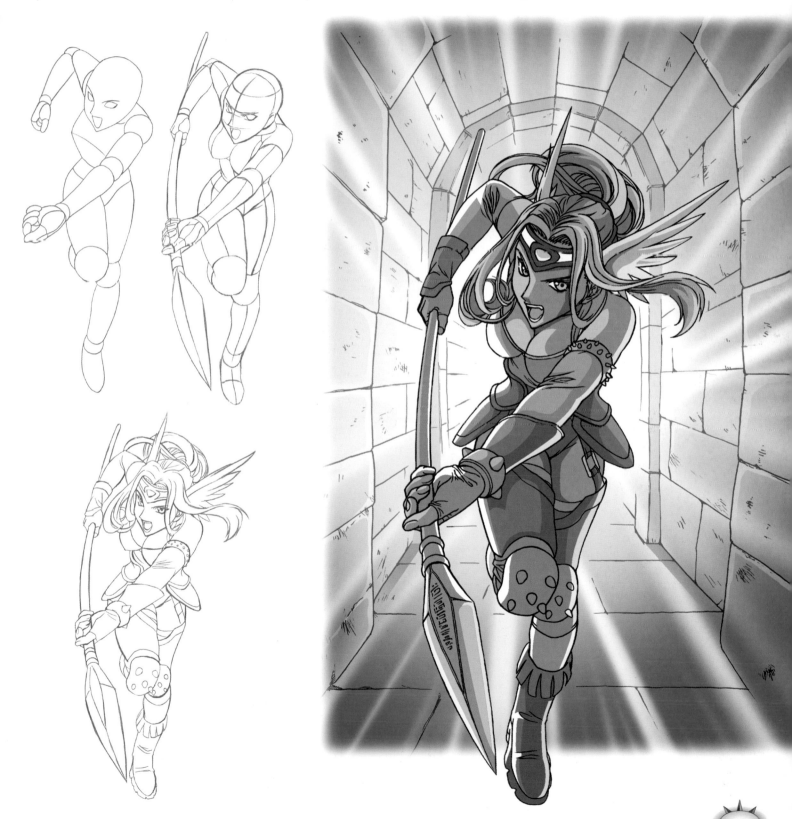

Lady of Darkness

With her leather outfit, claw-tipped wings, and blade, she's a diabolical dazzler. A good rule of thumb when drawing evil, winged women is: Feather wings are for good gals, featherless (skin) wings are for bad gals. Wicked ladies, whether they have wings or not, also wear extra-long boots and gloves, which make them more alluring. In addition, the more evil she is, the prettier she should be. It adds an element of drama when the hero meets up with her: He can't decide whether to fight her or ask her on a date!

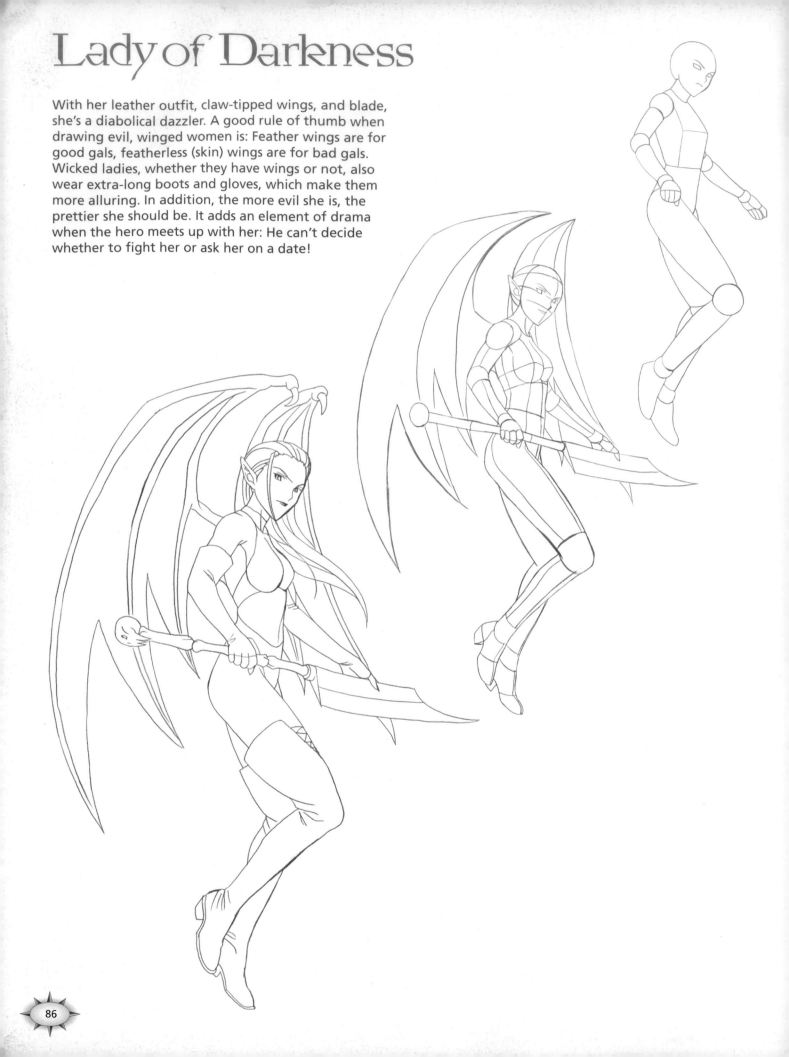

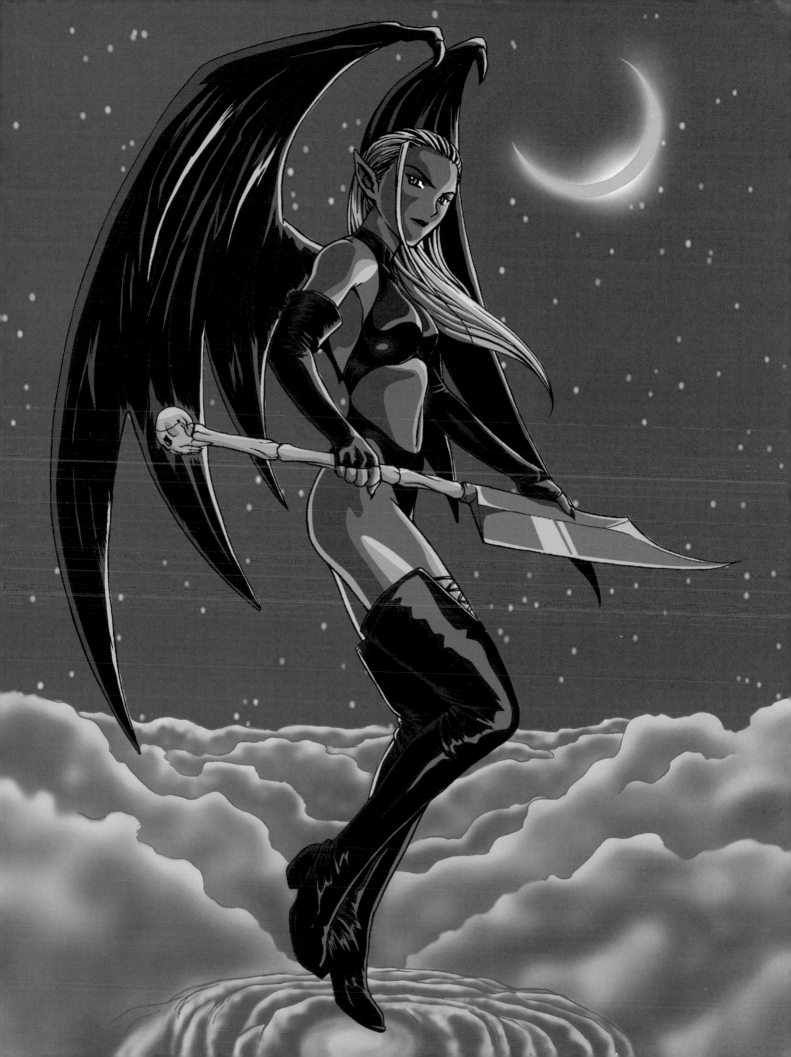

Female Warlock

With piercing eyes and a commanding presence, the female warlock summons the forces of nature to do her bidding. The short cape is less pretentious than a long, flowing gown. She's faerie, no doubt about that (which we can tell from the ears and one-piece outfit with a belt in the middle), but the headpiece with the pendant hanging between the eyes lets us know that she has a special relationship to magic. In addition, the gloves, staff, thigh cuff, and cape lead us to only one conclusion: She is a knower of magic and its mysterious ways.

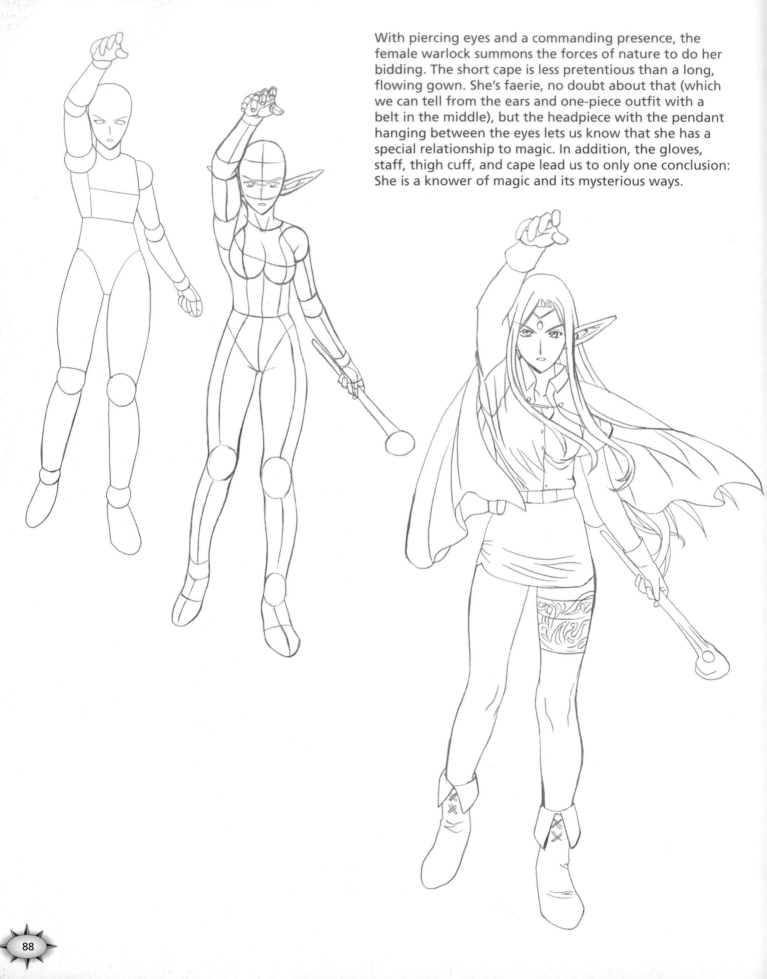

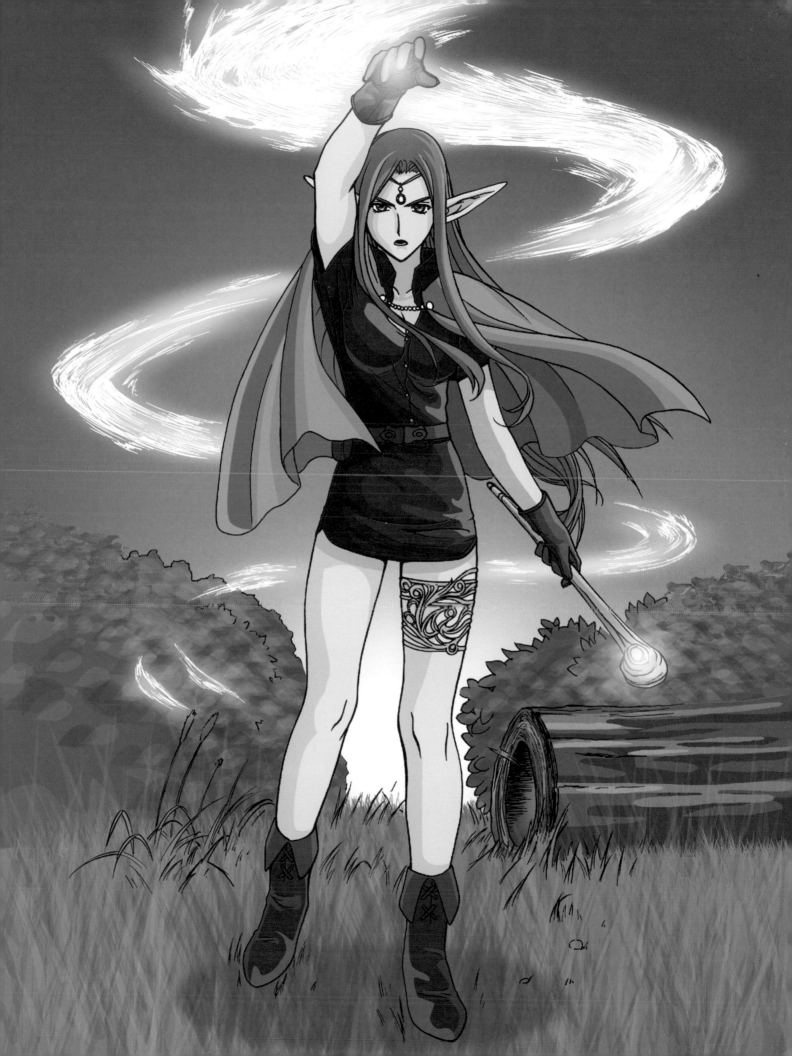

Angelic Soldier

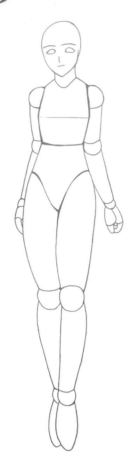

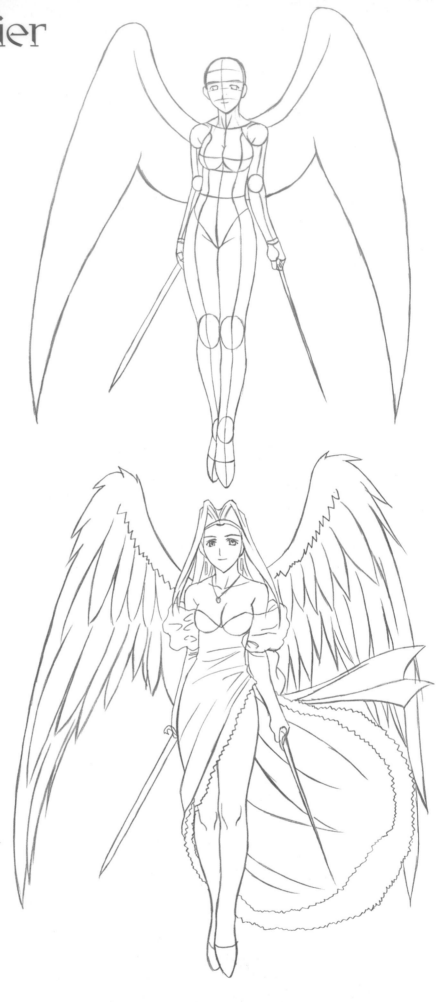

Manga characters are sometimes visited by visions of supernatural beings who present themselves as a teacher, warrior, or messenger. The feathered wings are a sure sign that she is good. Another indication of her decency is how her hair falls *away* from her face, rather than dipping over one eye.

This doesn't mean, however, that she is at all times peaceful. The righteous fight for what they believe in, and if she does not fight, she will offer her assistance to those who do—provided they're fighting for justice.

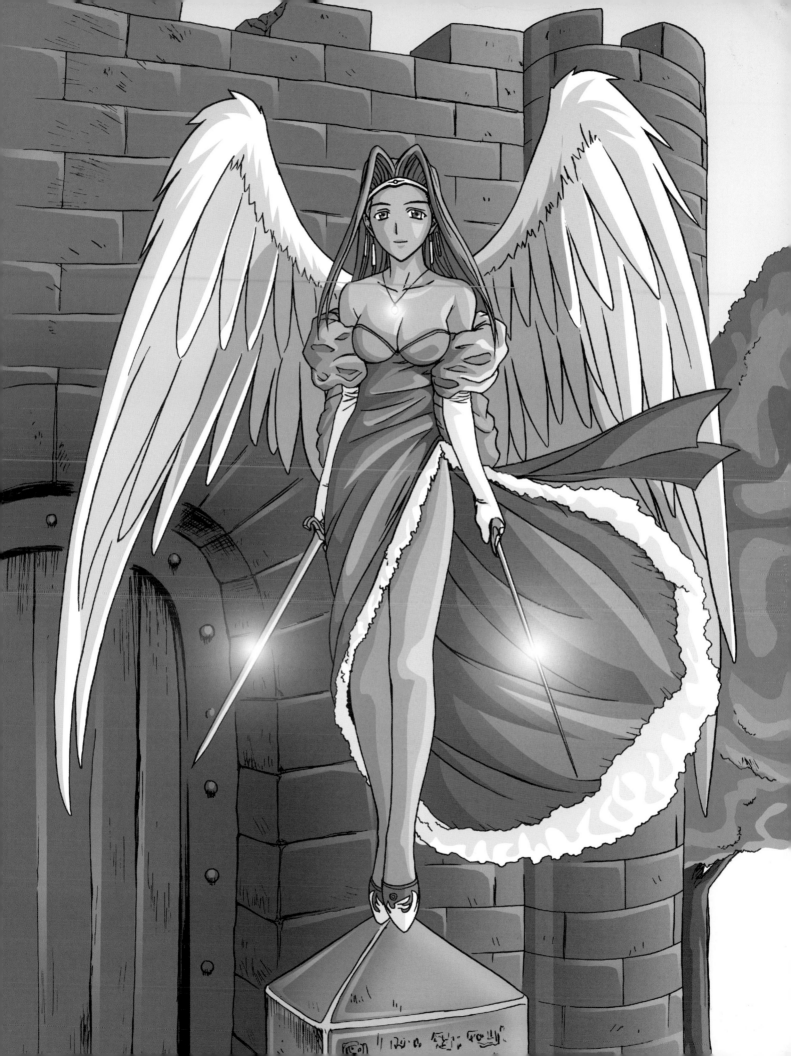

Faerie Adviser

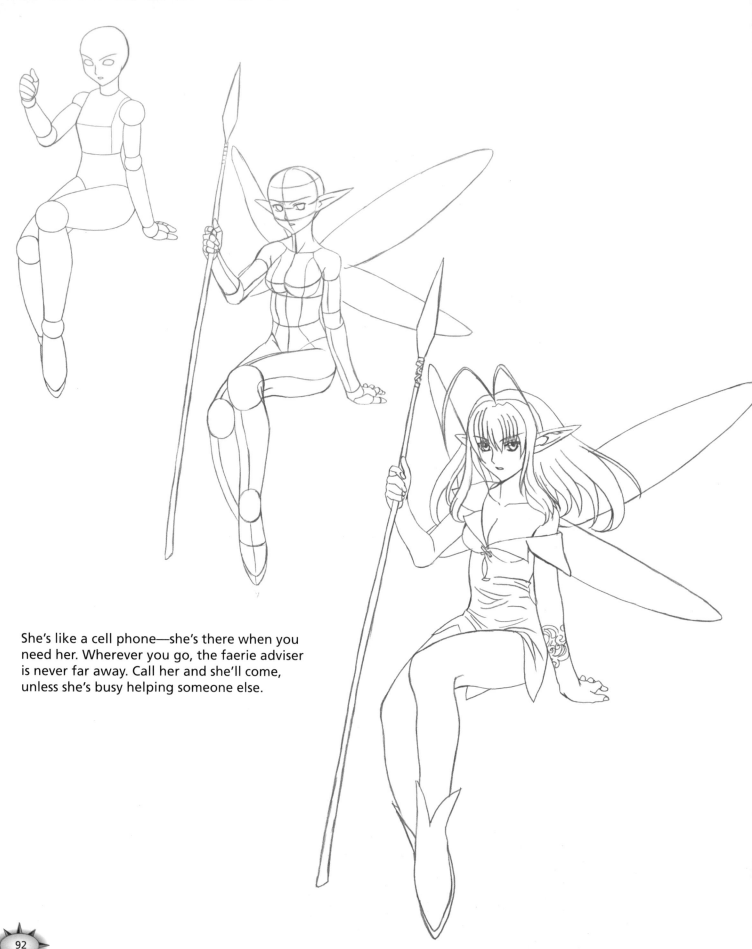

She's like a cell phone—she's there when you need her. Wherever you go, the faerie adviser is never far away. Call her and she'll come, unless she's busy helping someone else.

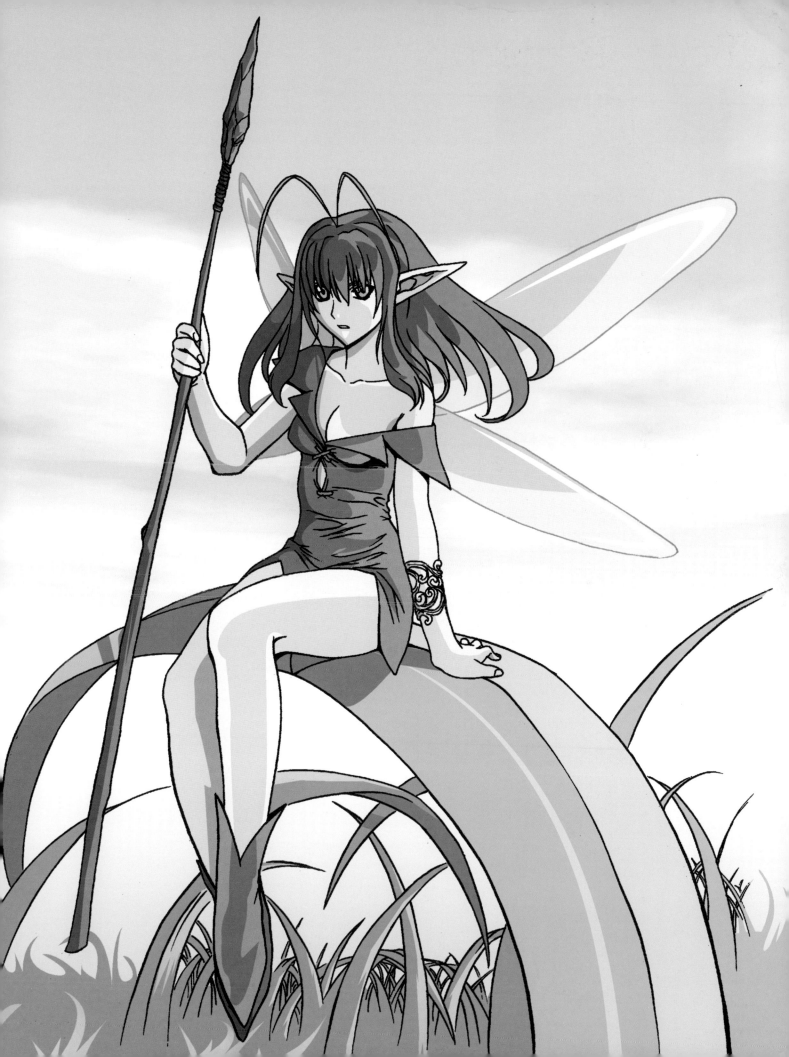

Sci-Fi Bruiser

How do you make a woman appear incredibly strong but still attractive? Give her wide shoulders, but not the bulky arms of bodybuilders. Wide shoulders, combined with a slender waist, always make for an appealing look in comics, where strength and beauty go together. (This drop-dead gorgeous avenger has enough power to hurl a dozen men over her head.) Also, give her glamorous clothes: flaring shoulders, a sultry high collar, and those ornamental straps.

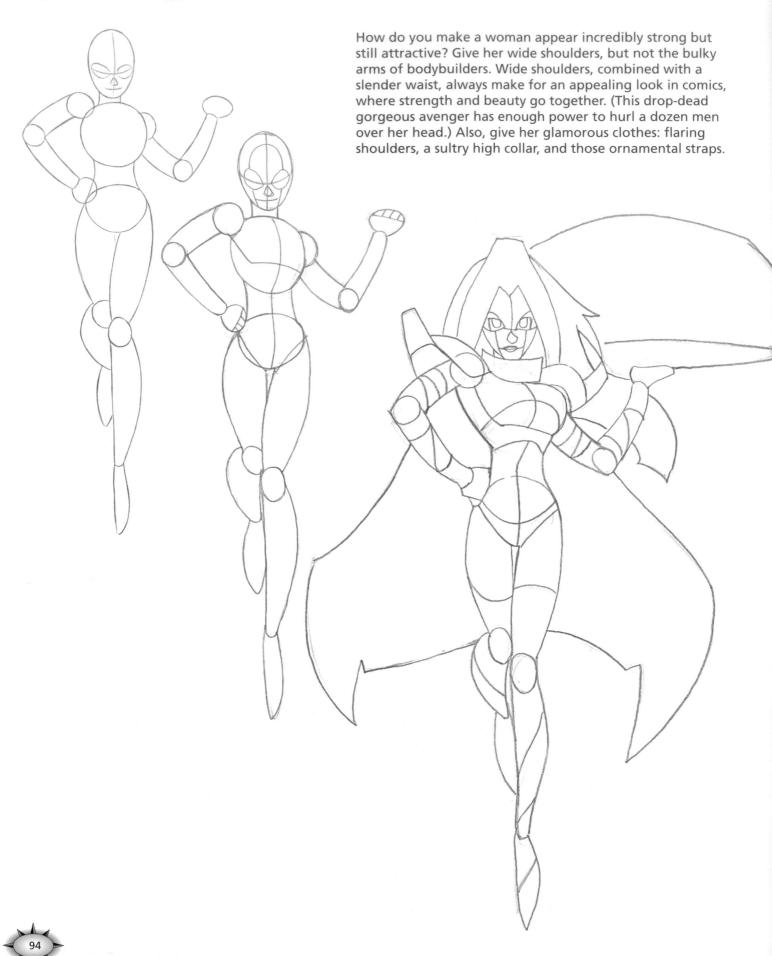

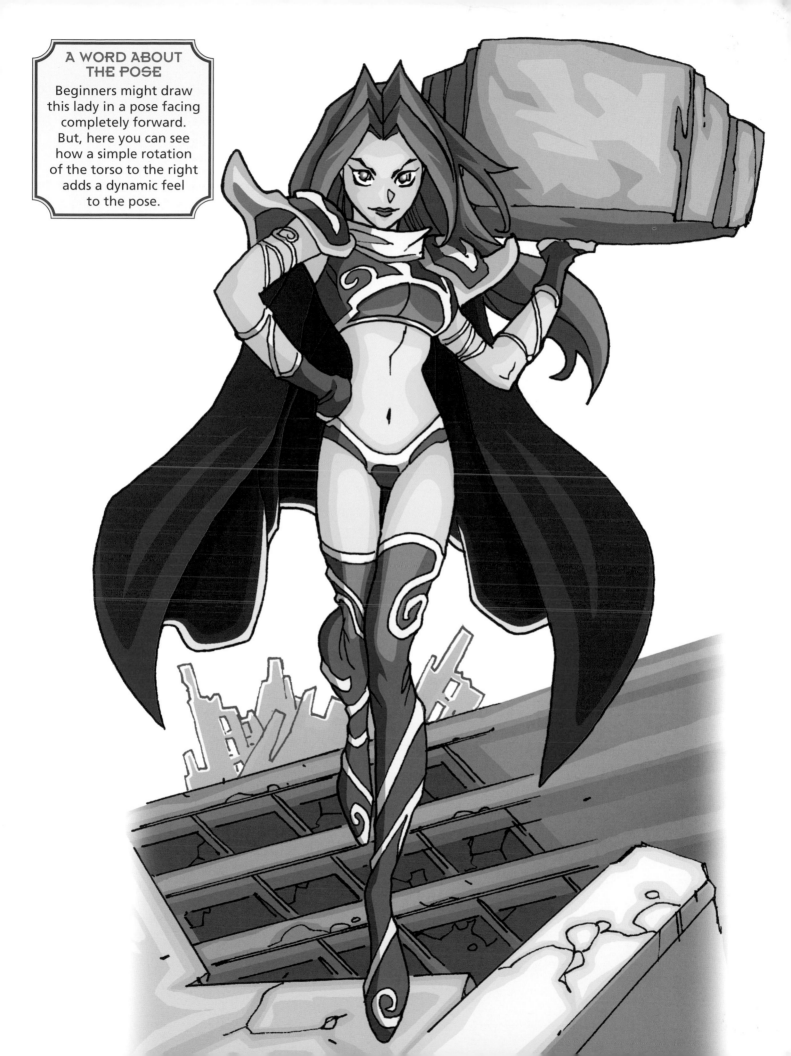

A WORD ABOUT THE POSE

Beginners might draw this lady in a pose facing completely forward. But, here you can see how a simple rotation of the torso to the right adds a dynamic feel to the pose.

Primitive Warrior

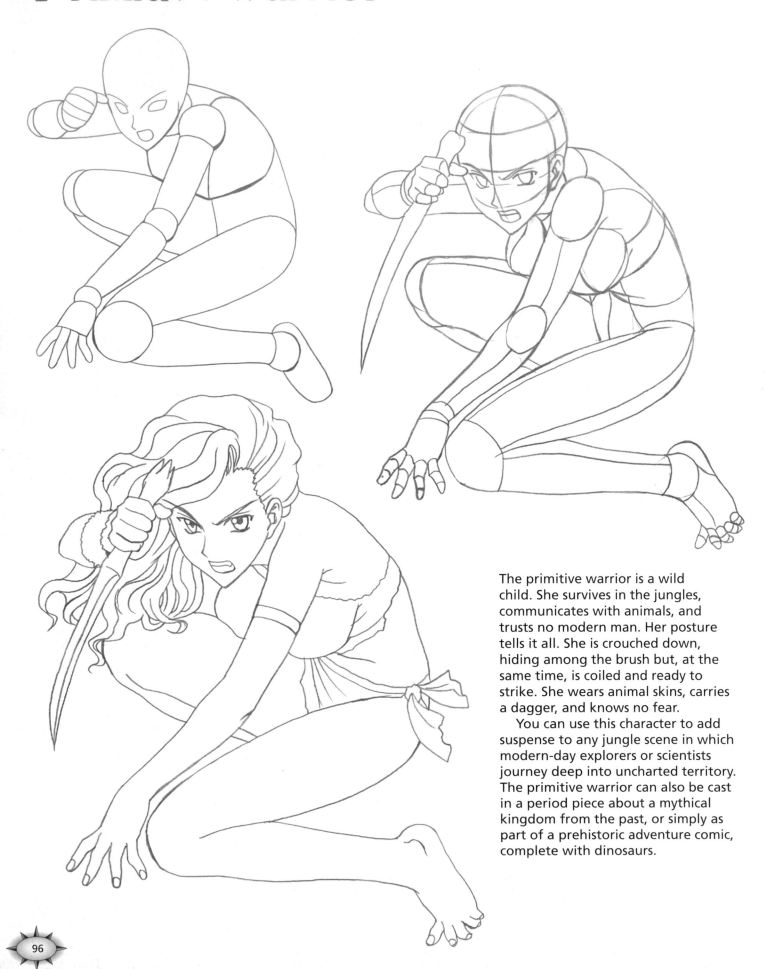

The primitive warrior is a wild child. She survives in the jungles, communicates with animals, and trusts no modern man. Her posture tells it all. She is crouched down, hiding among the brush but, at the same time, is coiled and ready to strike. She wears animal skins, carries a dagger, and knows no fear.

You can use this character to add suspense to any jungle scene in which modern-day explorers or scientists journey deep into uncharted territory. The primitive warrior can also be cast in a period piece about a mythical kingdom from the past, or simply as part of a prehistoric adventure comic, complete with dinosaurs.

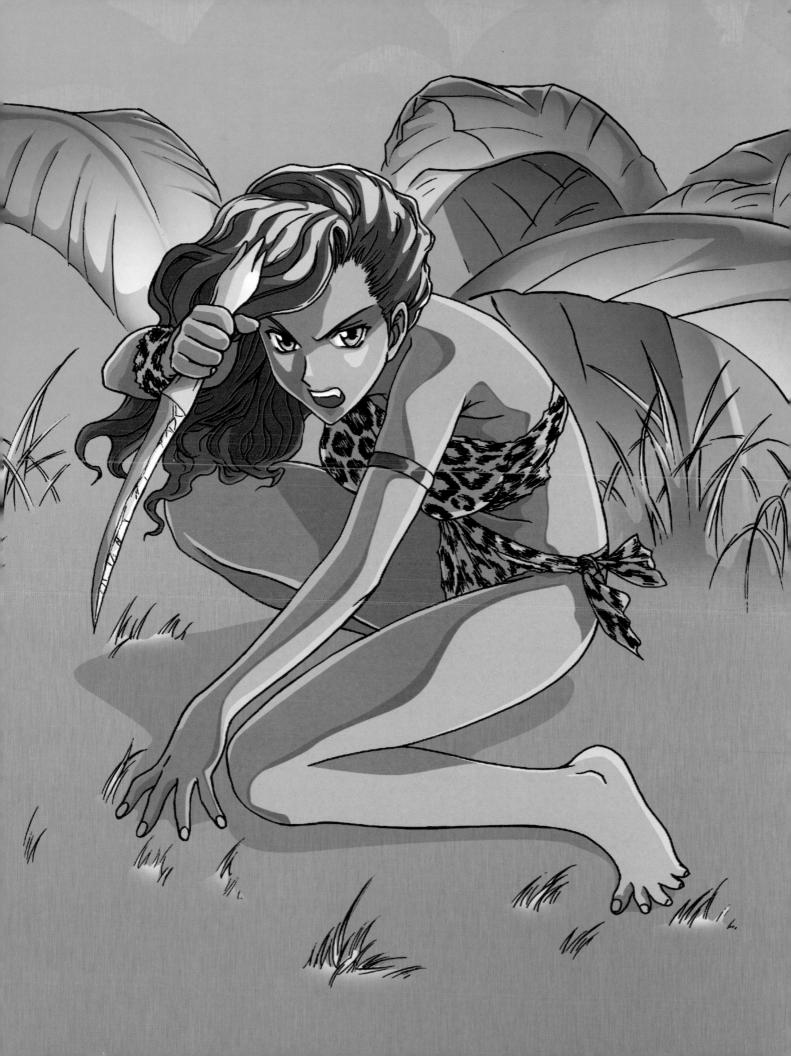

SCIENCE FICTION

When we talk about science fiction, we're talking about a time in the future when new technologies make weapons much more devastating, other races from other worlds are battling for the domination of Earth, and society has moved way beyond the creature comforts of its own planet and is now pushing the boundaries of the galaxy. Sci-fi characters are very intense. They have to be. They're always in a struggle for the very survival of their planet.

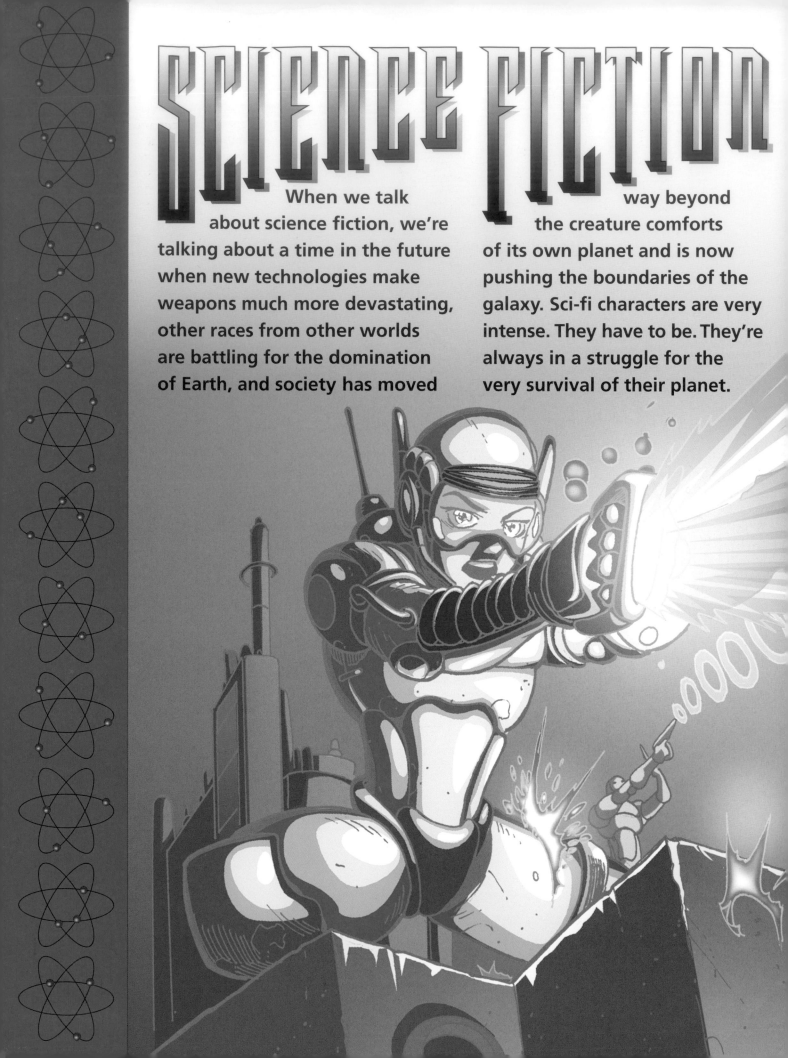

Choosing a Sci-fi Costume

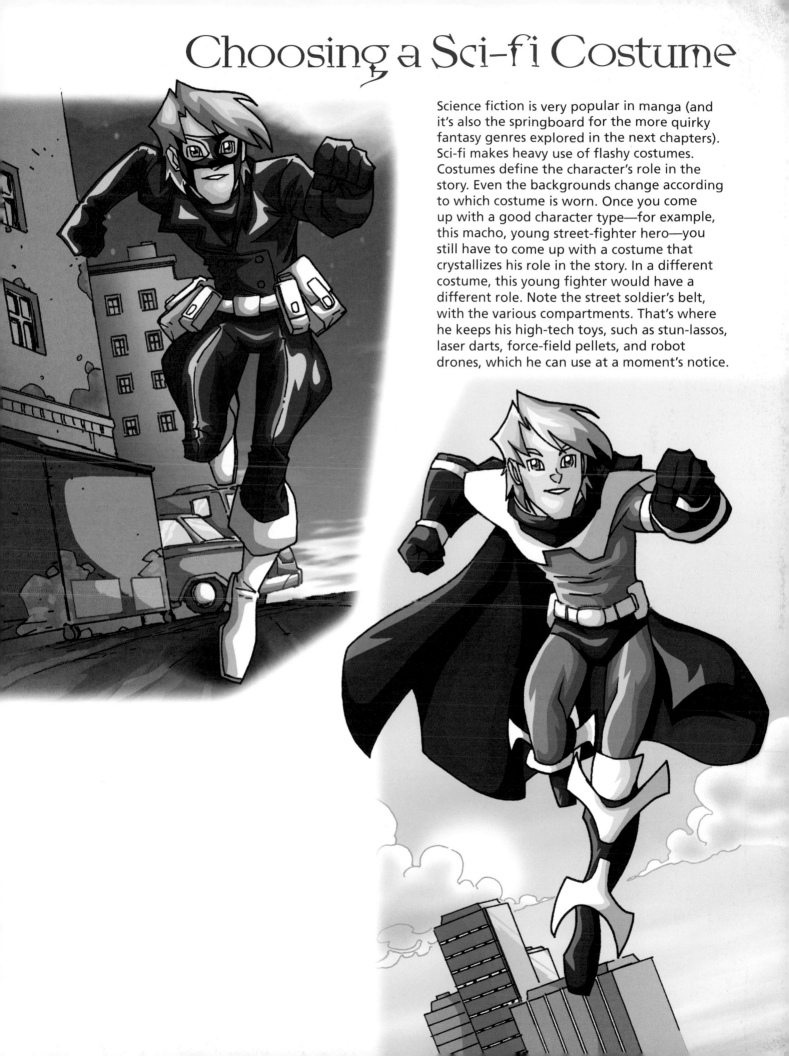

Science fiction is very popular in manga (and it's also the springboard for the more quirky fantasy genres explored in the next chapters). Sci-fi makes heavy use of flashy costumes. Costumes define the character's role in the story. Even the backgrounds change according to which costume is worn. Once you come up with a good character type—for example, this macho, young street-fighter hero—you still have to come up with a costume that crystallizes his role in the story. In a different costume, this young fighter would have a different role. Note the street soldier's belt, with the various compartments. That's where he keeps his high-tech toys, such as stun-lassos, laser darts, force-field pellets, and robot drones, which he can use at a moment's notice.

Alien Commander

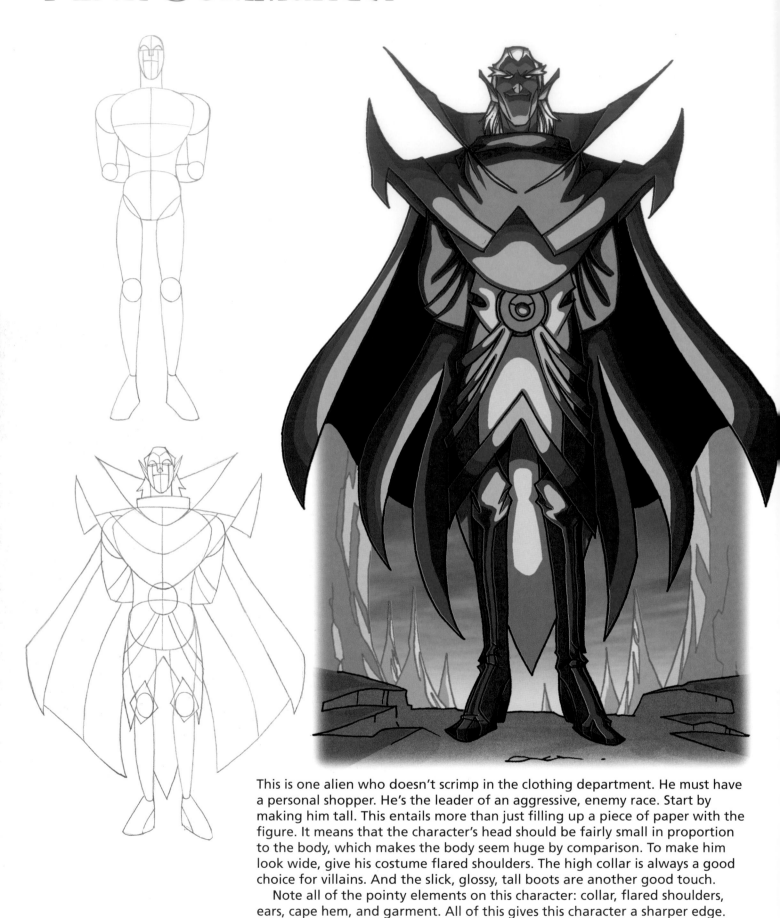

This is one alien who doesn't scrimp in the clothing department. He must have a personal shopper. He's the leader of an aggressive, enemy race. Start by making him tall. This entails more than just filling up a piece of paper with the figure. It means that the character's head should be fairly small in proportion to the body, which makes the body seem huge by comparison. To make him look wide, give his costume flared shoulders. The high collar is always a good choice for villains. And the slick, glossy, tall boots are another good touch.

Note all of the pointy elements on this character: collar, flared shoulders, ears, cape hem, and garment. All of this gives this character a sharper edge.

Earth Admiral

Perhaps he's outgunned, but darn it, he's going to take some of those blasted aliens down with him! In contrast to the alien's sleek, almost elegant appearance, the Earth ship commander is round and thick, with bushy hair—he's a seasoned, tough, bear of a guy. As the good guy, his high collar isn't nearly as severe as that of the alien. Rather than having a sharp theme to his costume, his overall look is square. Square is an "honest" shape. Triangles and points are for bad guys.

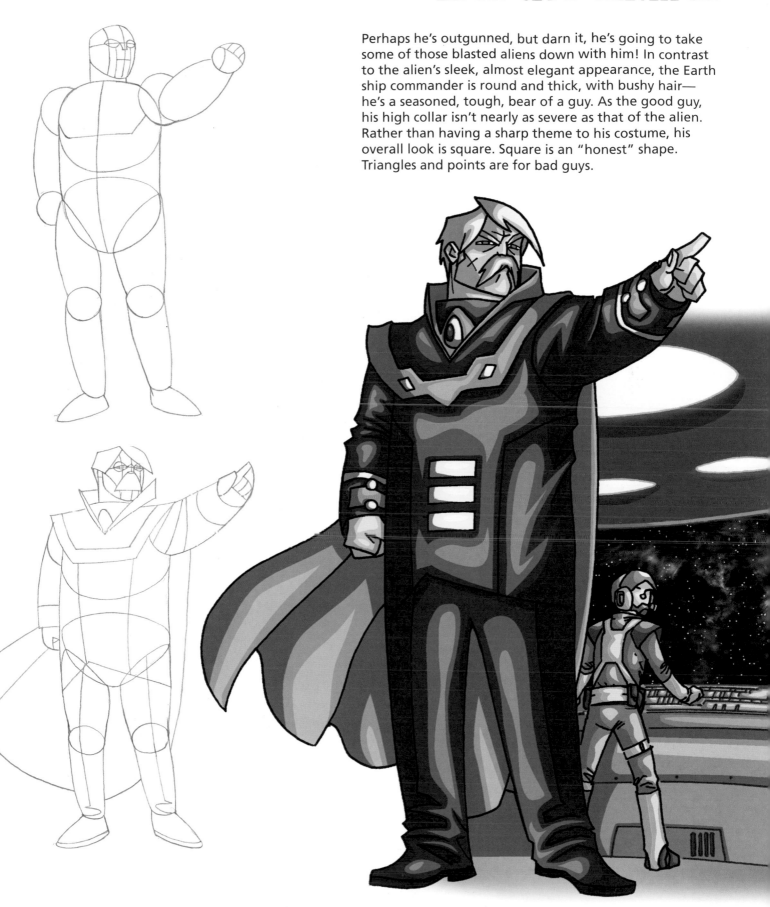

Earth Pilots: Male ...

Pilots have the most intricate costumes, because they often require hook-ups to mainframe computers in their cockpit controls. The outfits are formfitting so that they can function in the tight environment of the cockpit.

All pilots are trim and athletic looking. Their hair is carefree and can be parted in the middle for a cool look. The bottoms of the boots share a striking resemblance to today's high-end athletic shoes. The problem with young male fighter pilots is that their lanky frames are unimpressive. But you can easily compensate for that by giving them some high-tech shoulder pads.

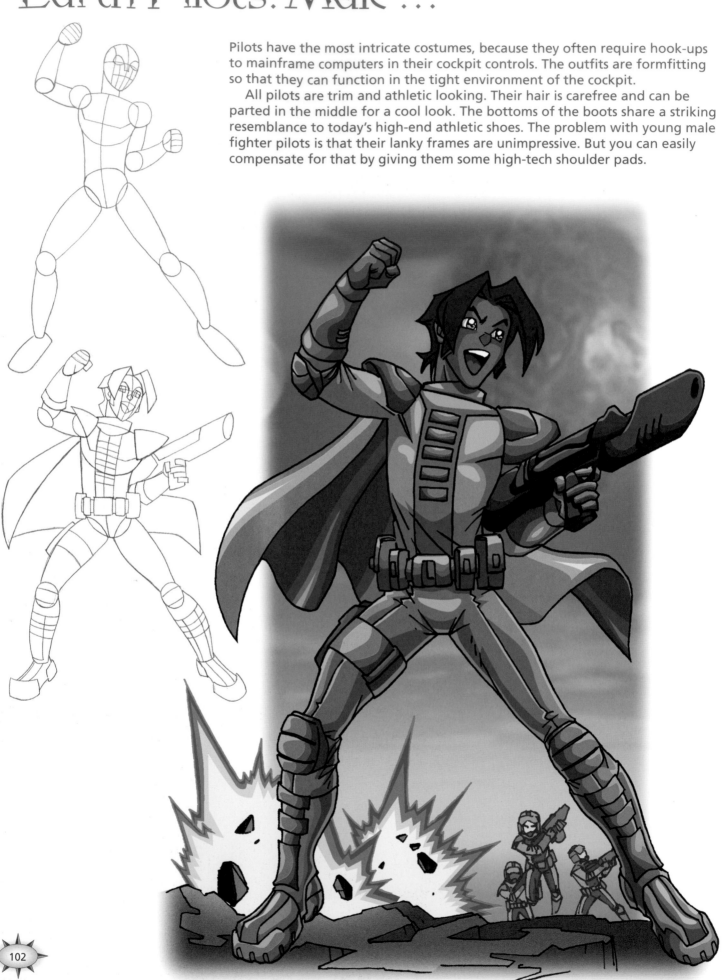

FORESHORTENING

This typical manga pose gives us the opportunity to explore a technique called *foreshortening.* Note how the arm holding the weapon falls somewhere between a side pose and a front pose, resulting in a 3/4 position. In this position, the arm has a shortened appearance. This shortened appearance is foreshortening. To successfully illustrate foreshortening in this type of pose, it's very important to draw and define the interior parts of the arm. This will help the eye compensate for the arm's shortened length. So, make sure you clearly draw the arm band around the forearm. Continuing up the arm, you should also draw the elbow area and clearly define the area where the upper arm connects to the shoulder. Looking at the finished drawing, you can see how all of these points along the way—the anatomical landmarks—help us recognize the form of the arm despite the fact that it has been shortened.

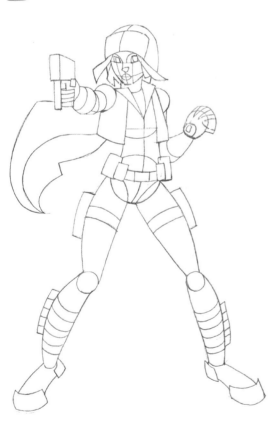

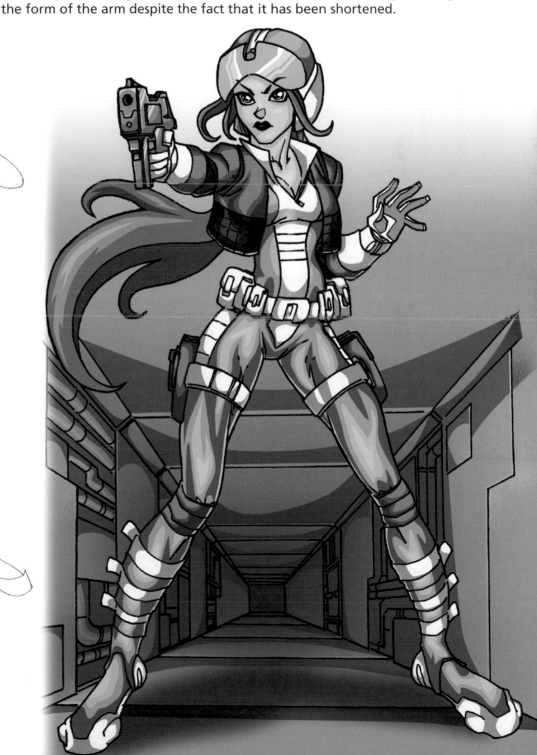

The Stowaway

Every good story needs a funny sidekick, even in the oh-so-serious world of science fiction. Funny sidekicks are often young and short, but they can also be slim, chubby, human, animal, mutant, or alien. And, there are all different kinds: Some are very physical, meaning they do a lot of visual gags and bits with their bodies; others are very talkative and enthusiastic; and then there are the ones who are curious, whimsical, and even magical or enchanted. You can even have a sidekick that's a robot. This sidekick—a little stowaway—is wearing the 23rd-century version of ripped jeans and a T-shirt.

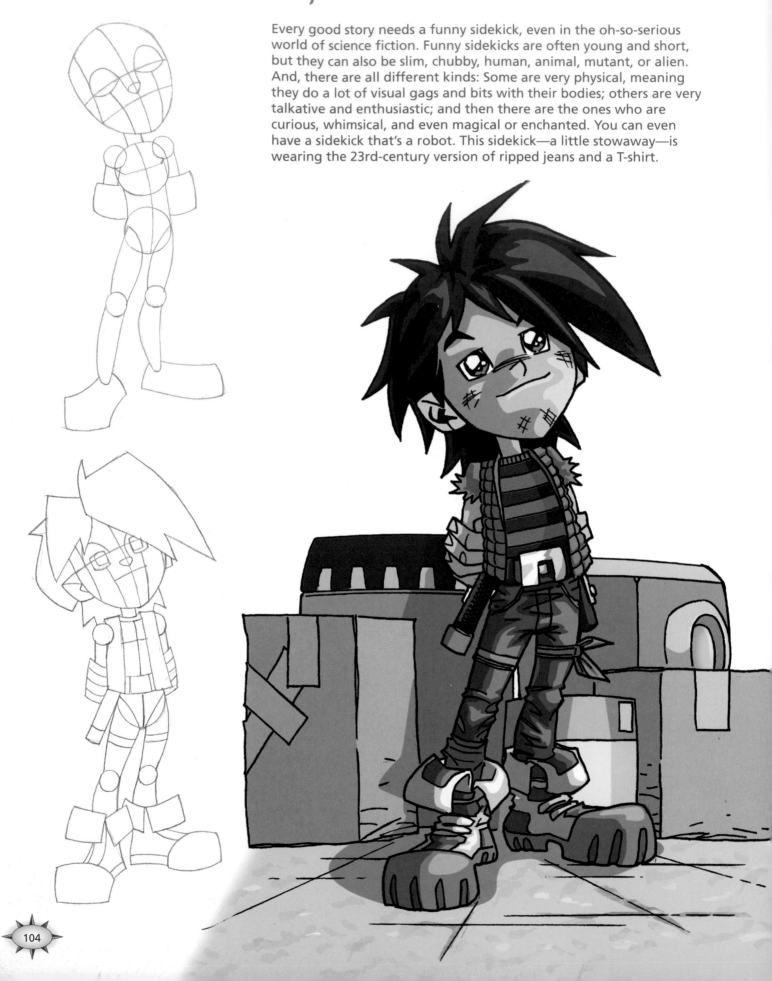

Alien Troop Leader

Humanoid in appearance, the alien troop leader is still very much a different species. But, if you make him too different—you know, crawling along on 16 legs with 14 eyes—then he can't fire a gun or give chase. The great fight scenes wouldn't occur. Remember that, at its core, sci-fi is still just cops and robbers in high-tech suits. By giving the creature a modified human form, you can have all the cool fight scenes you want. You do, however, still need to give the audience what I call the *tip-off*—the thing that lets them know this isn't a person, it's a creature. For this alien troop leader, the tip-off is the extra-long neck with armor plates on the back.

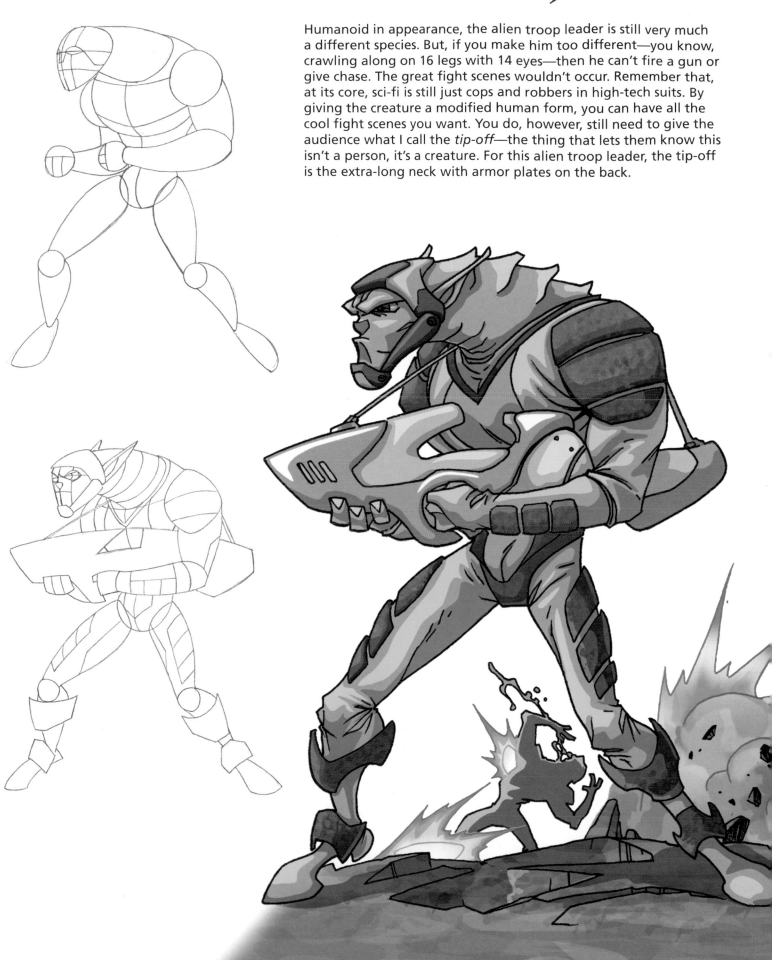

Don't Touch Me, Slimy!

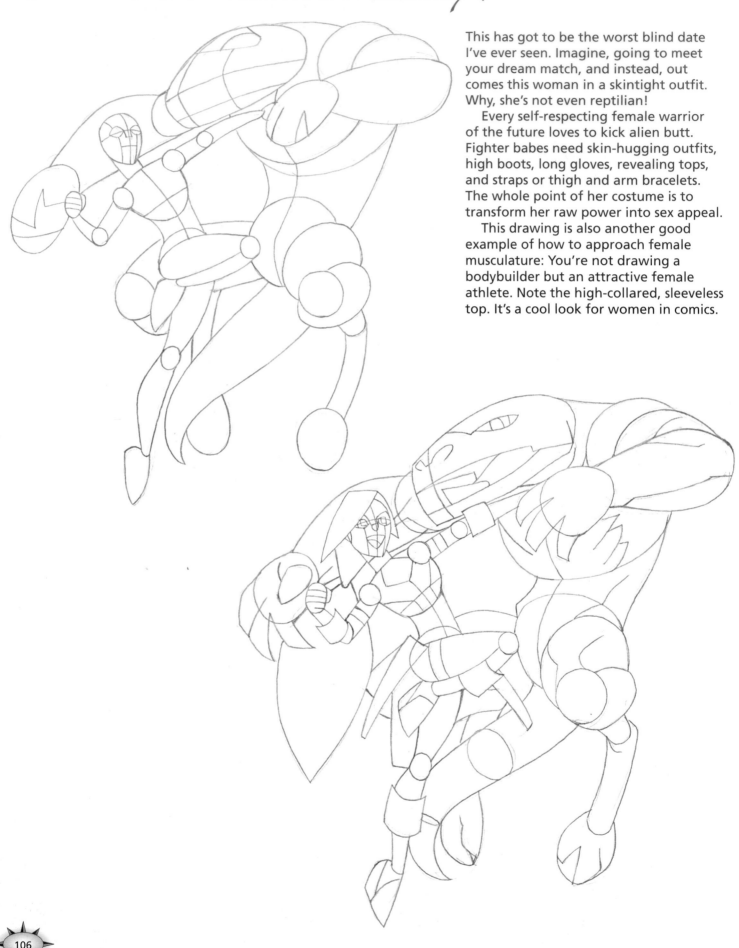

This has got to be the worst blind date I've ever seen. Imagine, going to meet your dream match, and instead, out comes this woman in a skintight outfit. Why, she's not even reptilian!

Every self-respecting female warrior of the future loves to kick alien butt. Fighter babes need skin-hugging outfits, high boots, long gloves, revealing tops, and straps or thigh and arm bracelets. The whole point of her costume is to transform her raw power into sex appeal.

This drawing is also another good example of how to approach female musculature: You're not drawing a bodybuilder but an attractive female athlete. Note the high-collared, sleeveless top. It's a cool look for women in comics.

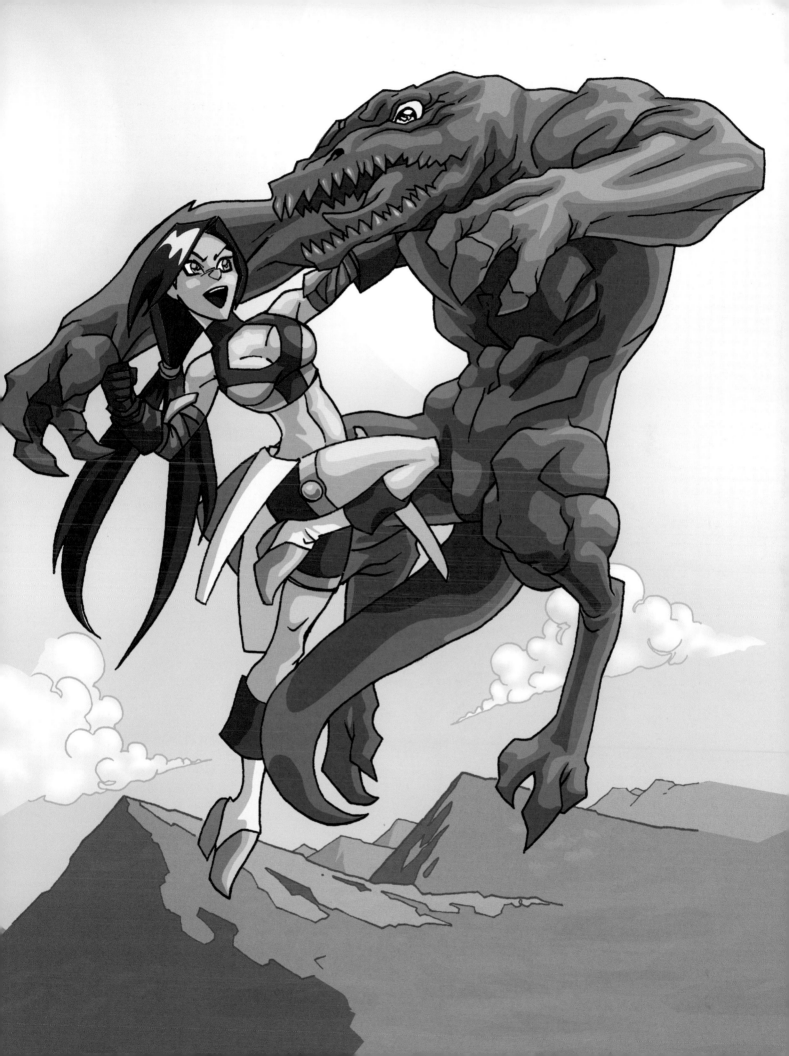

Power Kids

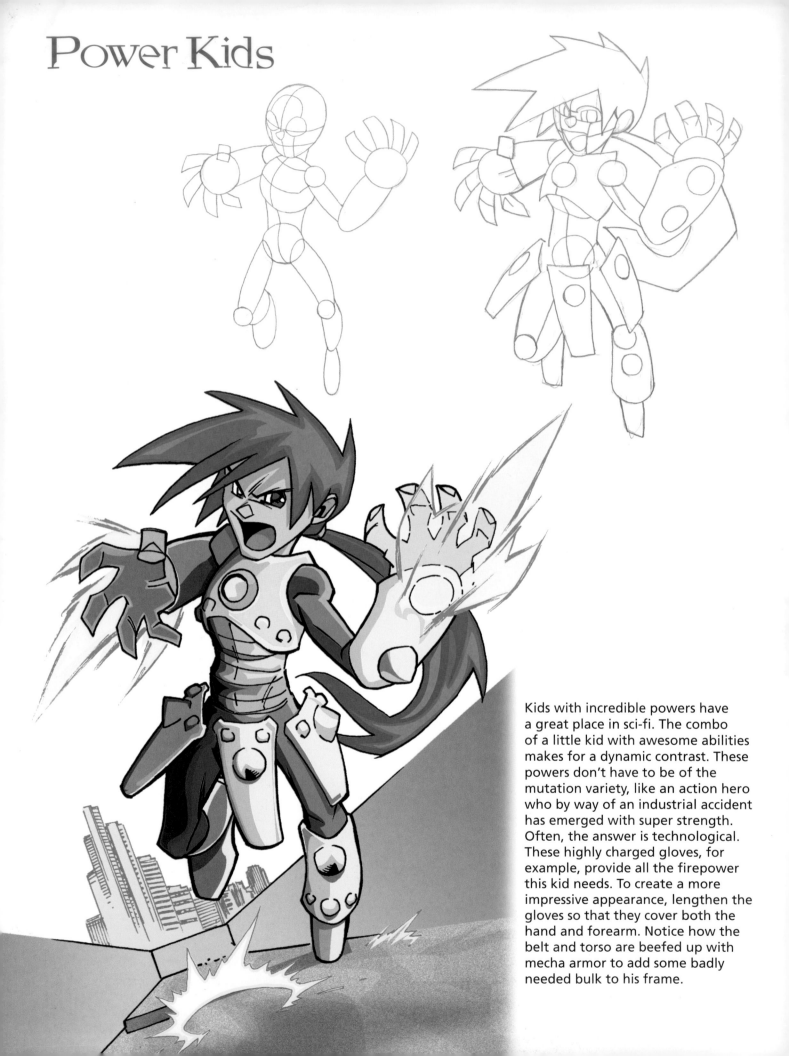

Kids with incredible powers have a great place in sci-fi. The combo of a little kid with awesome abilities makes for a dynamic contrast. These powers don't have to be of the mutation variety, like an action hero who by way of an industrial accident has emerged with super strength. Often, the answer is technological. These highly charged gloves, for example, provide all the firepower this kid needs. To create a more impressive appearance, lengthen the gloves so that they cover both the hand and forearm. Notice how the belt and torso are beefed up with mecha armor to add some badly needed bulk to his frame.

Winged Warrior

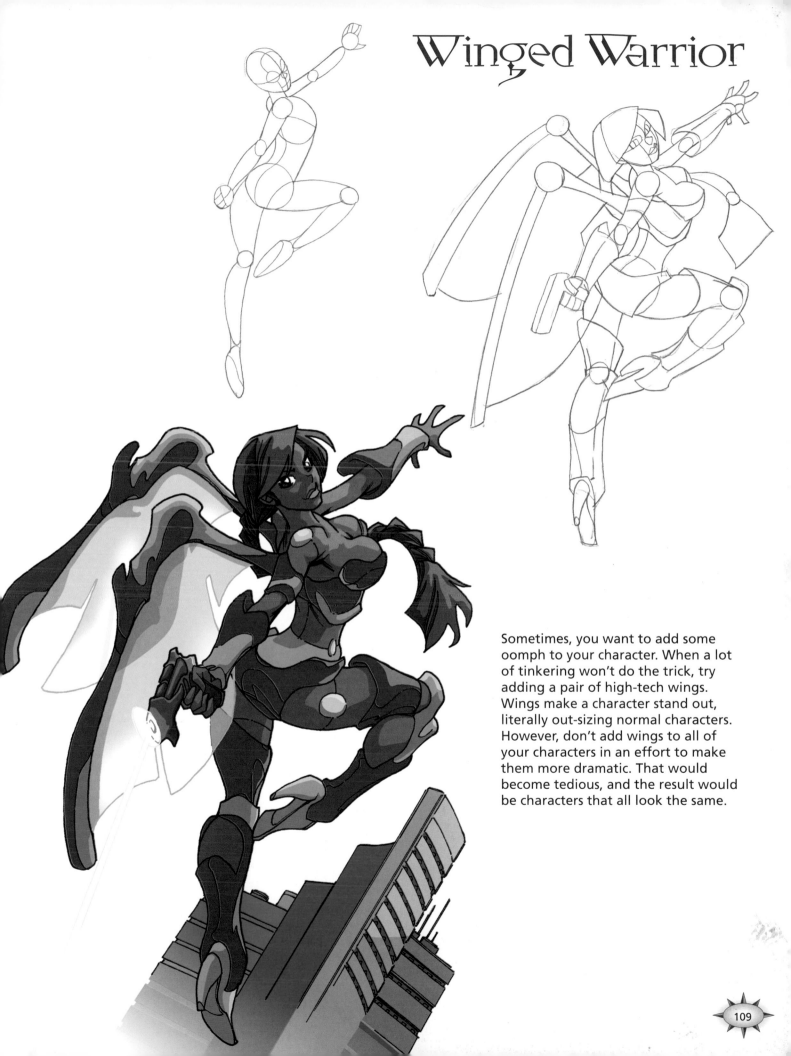

Sometimes, you want to add some oomph to your character. When a lot of tinkering won't do the trick, try adding a pair of high-tech wings. Wings make a character stand out, literally out-sizing normal characters. However, don't add wings to all of your characters in an effort to make them more dramatic. That would become tedious, and the result would be characters that all look the same.

Special Effects for Science Fiction

You can draw the coolest weapons in the world, but the scene won't come alive until the blast from the gun strikes something and we see the *kick of the explosion.* That's the cool part—when the blast hits something and explodes. There are a variety of futuristic gun blasts possible, and each results in a different explosive impact.

THREE POPULAR BLAST EFFECTS

Whether it's a ray beam or a projectile, the weapons of the future shoot energy. Sometimes a beam of energy may gush out of a rifle like water out of a hose. At other times, the energy is emitted in more discreet packets. Each blast has its own shape. And don't overlook the small, distinct blast effect that often occurs at the nozzle of the gun.

PULSE

The pulses travel in oval shapes, getting longer as they come nearer. And, as they come nearer, they rotate in toward the target, making them extremely difficult to avoid and giving them a really cool animation effect.

BURSTS

The burst is a straightforward packet of intense energy, much narrower than the pulse and with erratic shapes. Bursts are speed-lined. They don't rotate but pump off in rapid succession. They can be part of a blistering attack.

RAY BEAM

Old reliable but never out of fashion, the ray beam widens out as it travels to its destination. It starts with zigzag lines but smoothes out to straight lines as it proceeds on course.

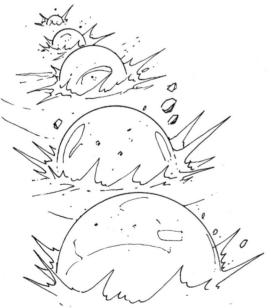

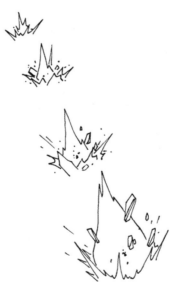

PULSE RESULTS

Half-domes with shines and explosive debris.

BURST RESULTS

Flaming ditches carved out of the ground.

RAY BEAM RESULTS

A seared line rips through the ground where the beam hits.

Pulses and Bursts in Action

You can best see how cool the special effects are when you view them in context. Special effects are at the foundation of sci-fi scenes, and not merely an afterthought. Sometimes, the effects are scene-stealers.

This scene is a great illustration of two styles of weaponry effects: pulses and bursts. The far aircraft (in the background) shoots energy pulses from twin guns. One gun finds its mark and causes significant damage to one wing of the fleeing craft (in the foreground). The fleeing craft is also on the prowl, rapid-firing a series of bursts that rake the ground, destroying everything in their path.

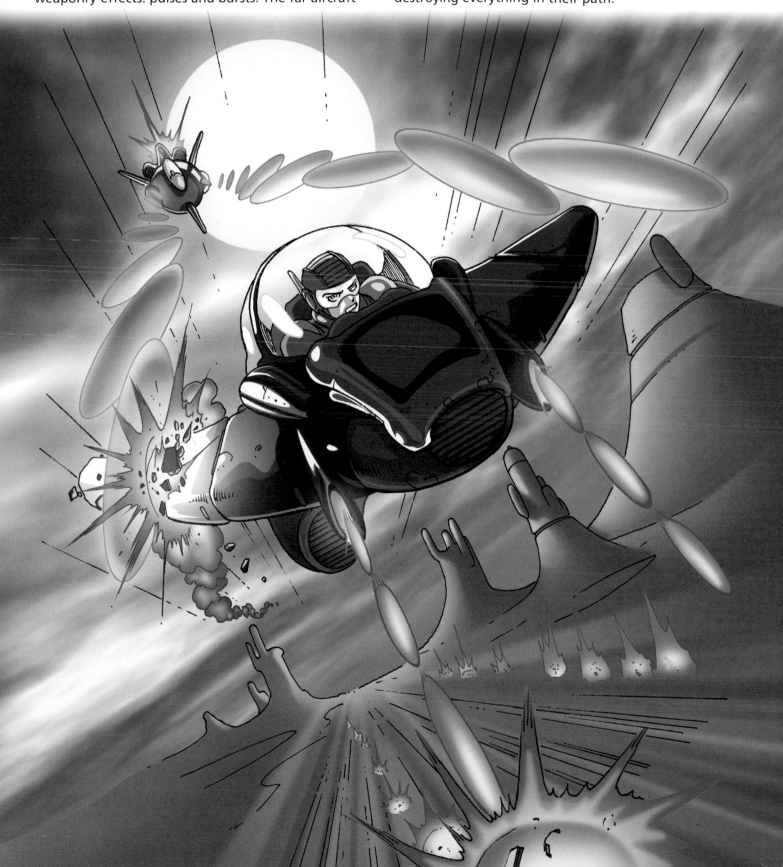

Dodging Fire in an Air Tank

Not every scene needs to show something getting hit by enemy fire. Sometimes, you add drama by showing the pulses, bursts, or blasts flying past their targets. It heightens the suspense. Note the large pulses flying by this air tank, accompanied by streaks. These streaks are very important as they convey speed and fill in blank spaces in the drawing. Note that there don't need to be flames coming from the air tank jets—provided that we see the effects of those jets on the ground, violently kicking up dirt and debris.

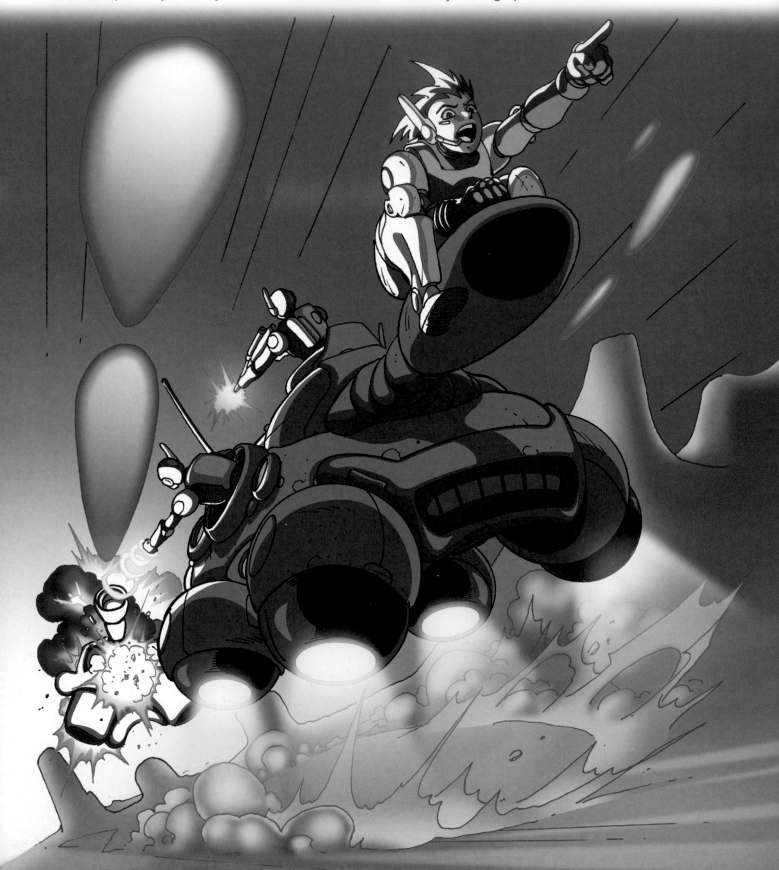

Firepower Step by Step

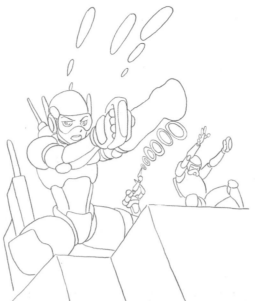

In this example, the figure is firing a ray beam. There's a slight zigzag blast at the gun's nozzle. (Always put a blast effect at the nozzle of the gun.) Pulses and streaks go like crazy overhead—it's a real war scene. Additionally, there's one more special effect in use to create a real sense of action: In the lower right of the page, below the soldier firing the ray gun, there are blast impact marks from shots that have ricocheted off the cement barricade. It makes the scene look alive, like it's happening *right now,* and it indicates that the action is not one-sided—this character is firing weapons but is also being fired at.

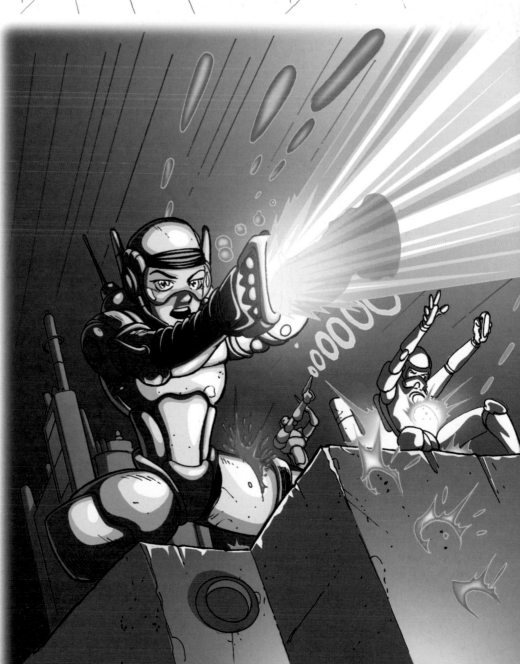

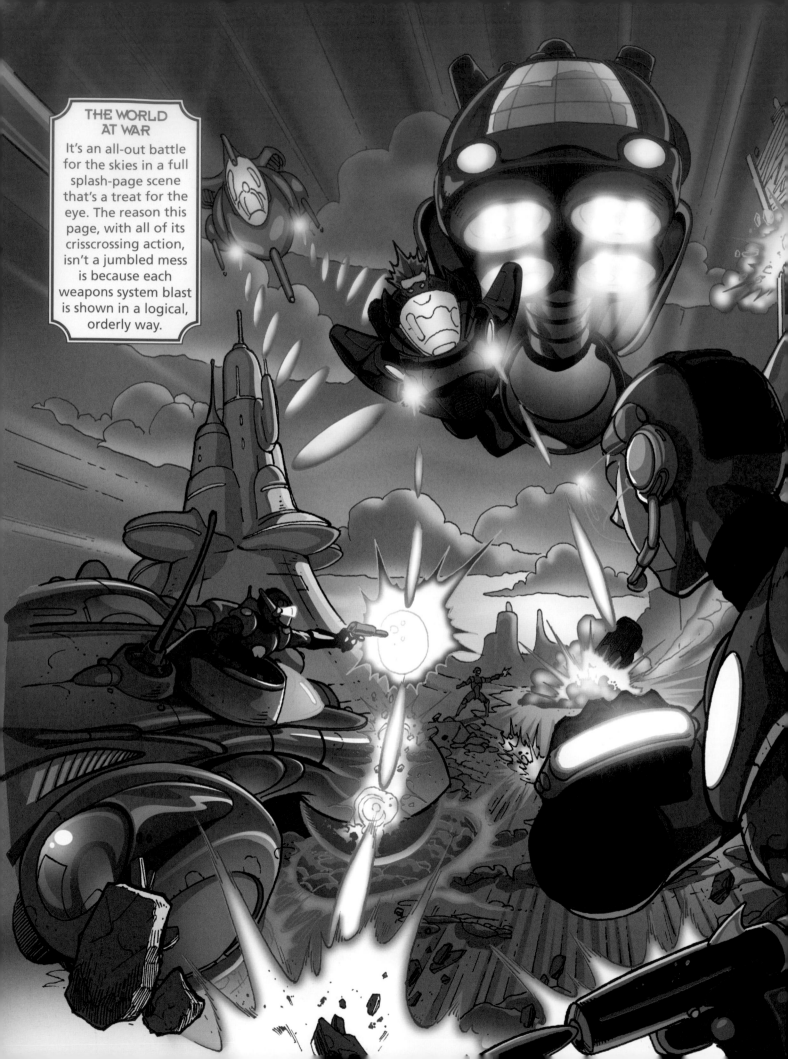

THE WORLD AT WAR

It's an all-out battle for the skies in a full splash-page scene that's a treat for the eye. The reason this page, with all of its crisscrossing action, isn't a jumbled mess is because each weapons system blast is shown in a logical, orderly way.

Science Fantasy

Another strong genre in manga and anime is science fantasy, which is a large subset of science fiction. Science fantasy takes the sci-fi format—the futuristic settings, alien races, and spacecraft—and inserts into that a cast of fantasy characters. These fantasy characters are often portrayed as royal aliens who come from a faraway planet kingdom. The entire cast is made up of nobles. Even though they're an alien race, their appearance is close to human. They're often cast as the good guys. They navigate their spaceships through the treacherous areas of the universe, battling ugly, primitive aliens bent on their destruction.

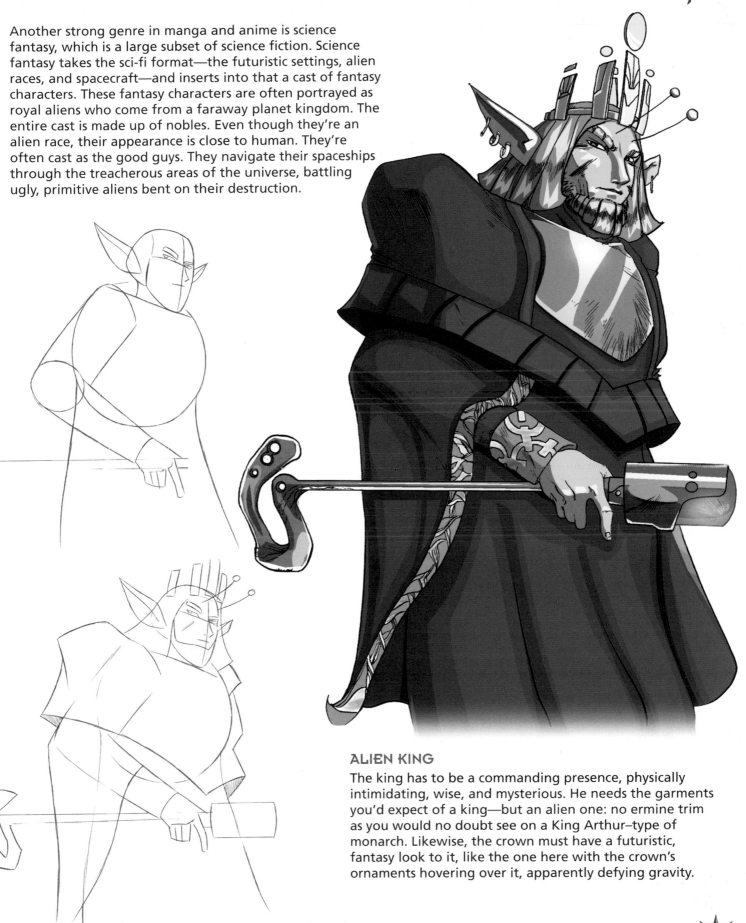

ALIEN KING

The king has to be a commanding presence, physically intimidating, wise, and mysterious. He needs the garments you'd expect of a king—but an alien one: no ermine trim as you would no doubt see on a King Arthur–type of monarch. Likewise, the crown must have a futuristic, fantasy look to it, like the one here with the crown's ornaments hovering over it, apparently defying gravity.

EVIL DUKE

In every family, there's always an outcast. When it's a royal family, it's even worse. There's always someone trying to claw his way to the throne, and he'll stop at nothing to do it, even if that means secretly plotting with his enemies to destroy his own people! This ruthless character should be someone who isn't in direct line to the throne so that he knows he'll never get to be king on his own. He should have pointy features, with a cunning smile, and be quite fond of the better things in life. He doesn't have a barrel chest, which would convey a sense of heroism; rather, his posture shows a slightly curved back, which is a less forthright stance.

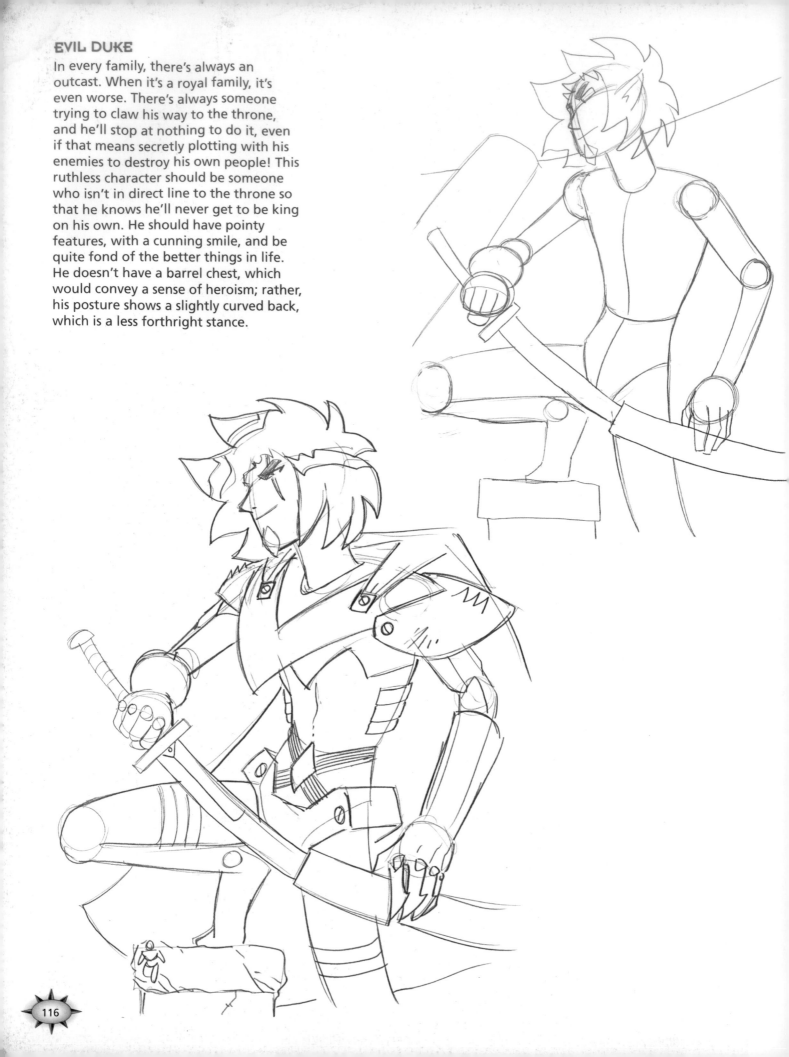

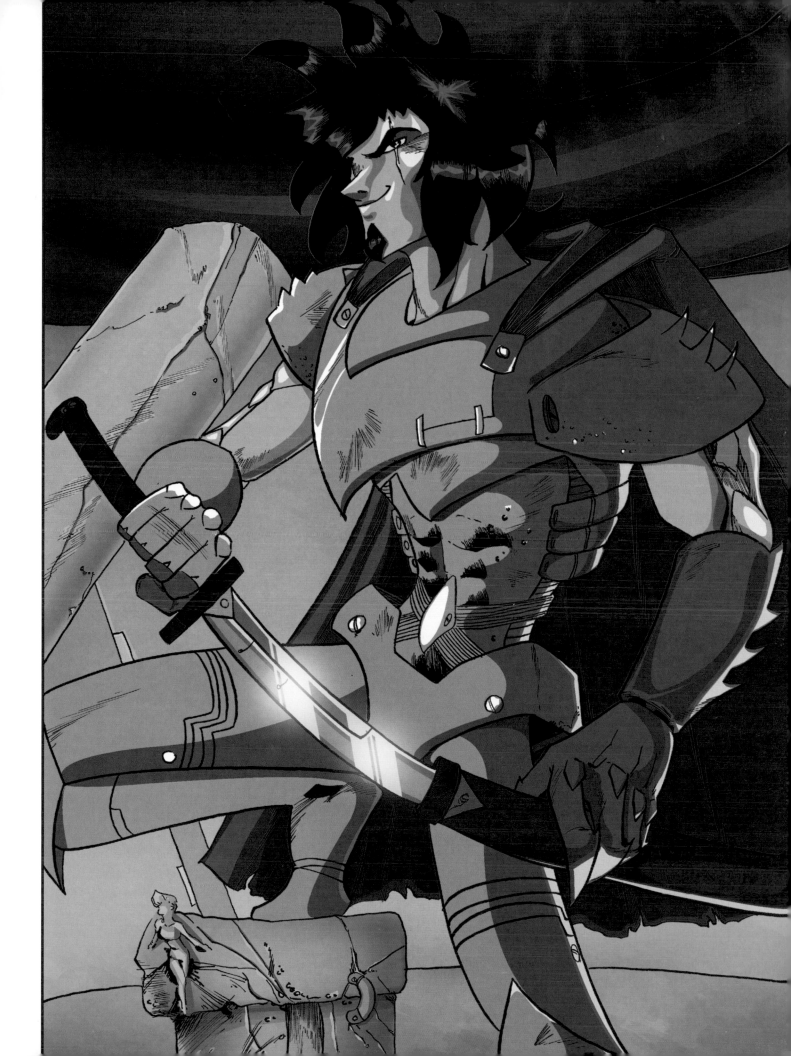

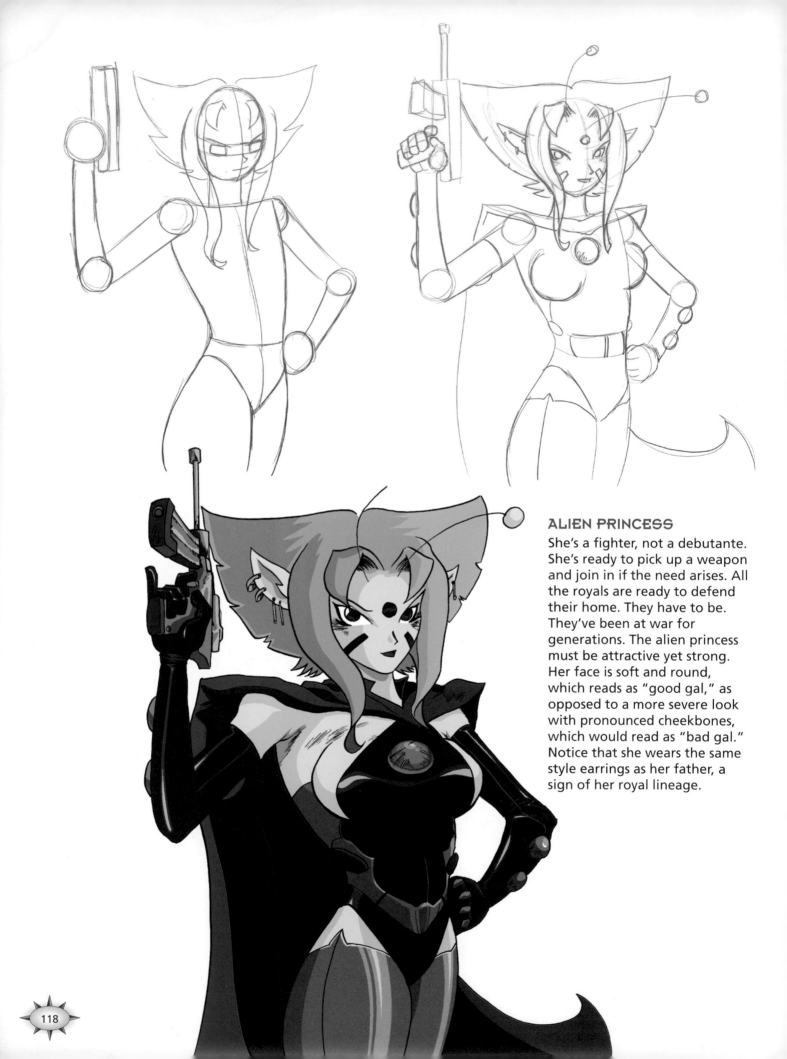

ALIEN PRINCESS

She's a fighter, not a debutante. She's ready to pick up a weapon and join in if the need arises. All the royals are ready to defend their home. They have to be. They've been at war for generations. The alien princess must be attractive yet strong. Her face is soft and round, which reads as "good gal," as opposed to a more severe look with pronounced cheekbones, which would read as "bad gal." Notice that she wears the same style earrings as her father, a sign of her royal lineage.

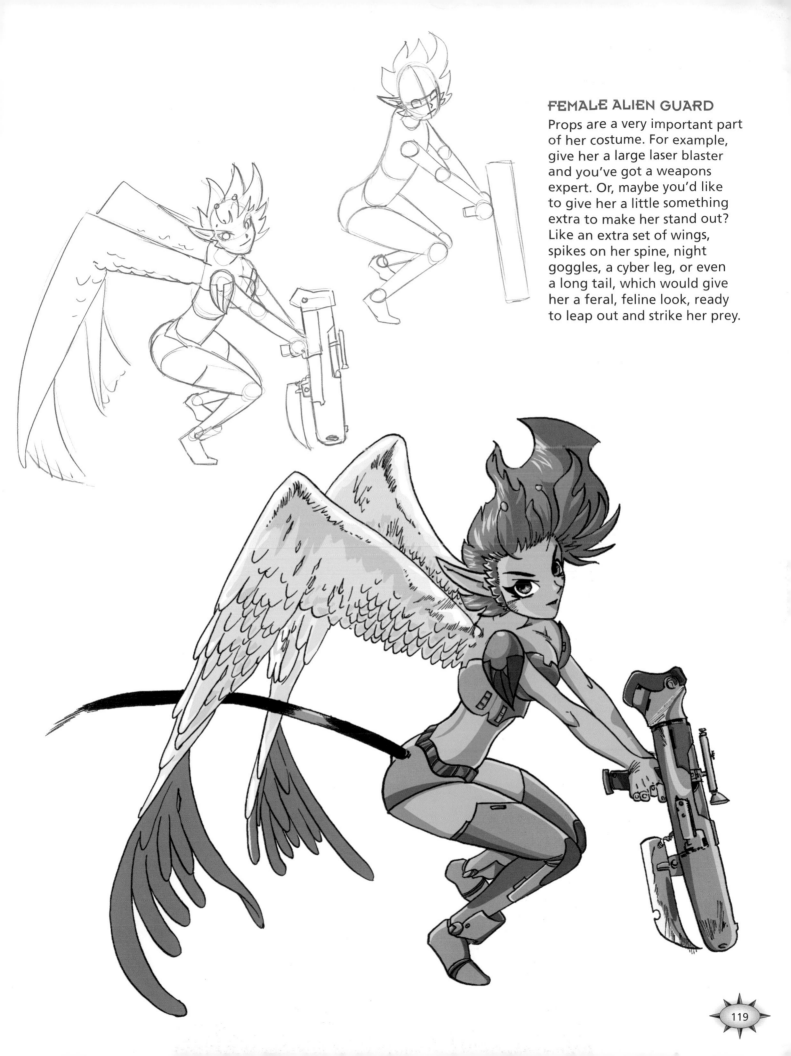

FEMALE ALIEN GUARD

Props are a very important part of her costume. For example, give her a large laser blaster and you've got a weapons expert. Or, maybe you'd like to give her a little something extra to make her stand out? Like an extra set of wings, spikes on her spine, night goggles, a cyber leg, or even a long tail, which would give her a feral, feline look, ready to leap out and strike her prey.

MALE ALIEN GUARD

Like a knight in armor, this futuristic warrior is suited up in a mecha outfit that can take lots of punishment. Remember, these guards are always on the front lines, stopping the enemies at the gate. Give them athletic builds, but draw the attacking barbarians as bulky brutes. Guards are often engaged in fierce, prolonged fight scenes, which readers and audiences love! The barbarians should outnumber the guards. Each guard may have to kill half a dozen barbarians in a fight scene in which the barbarians are trying to board their ship. These plot themes parallel the medieval tales of invading armies of knights storming the castle walls.

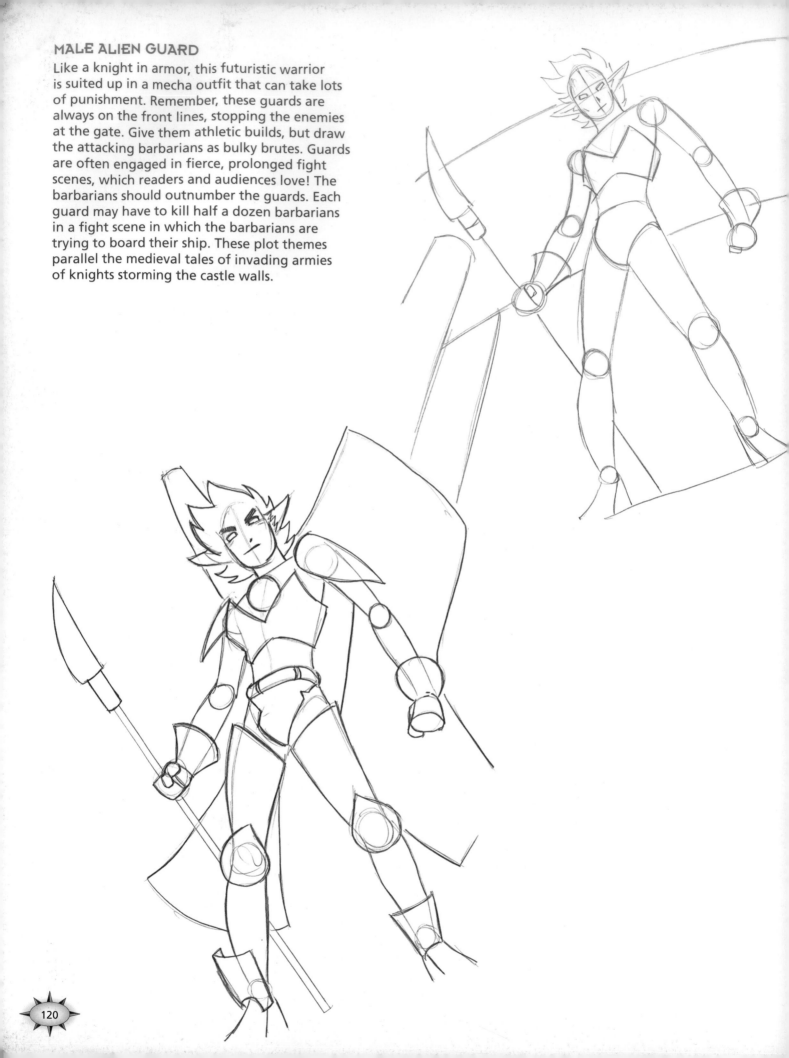

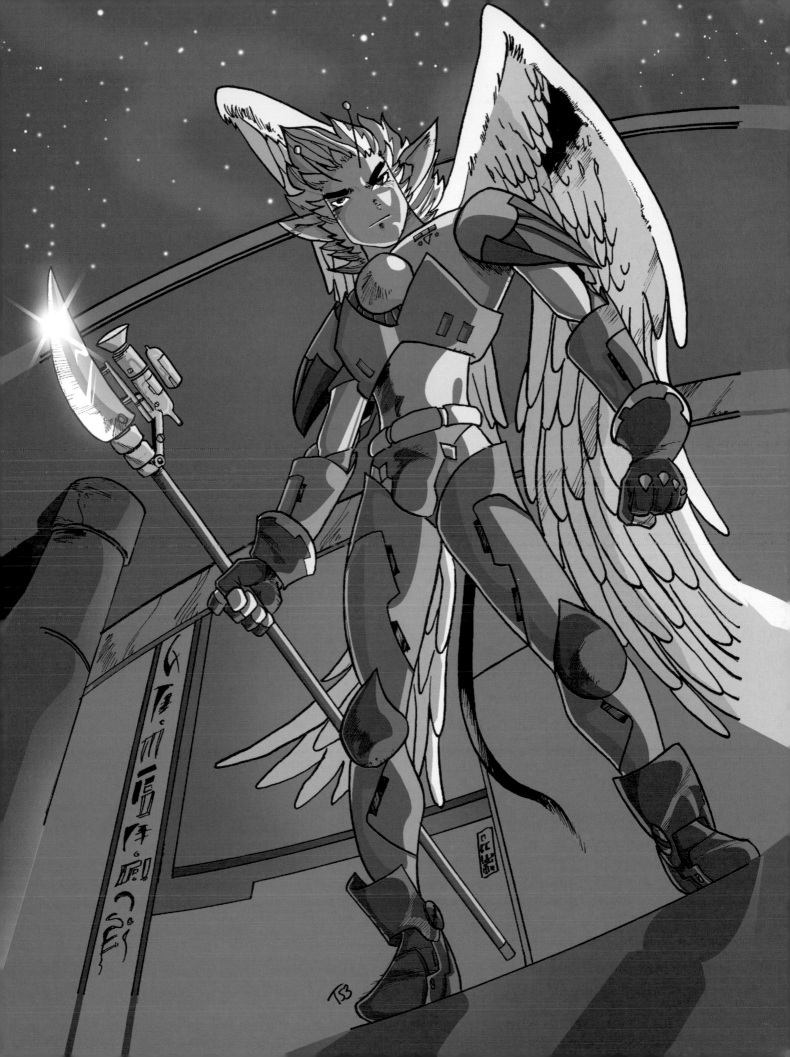

Fantasy isn't all joy and light, my friends. It's also a genre that boasts some of the most wicked creatures you can imagine, creatures that can chew you up like a miniature cocktail wiener. You're about to enter a place of darkness and pure evil, where humans tread at their peril. It's a terrible place, a place worse than being home-schooled by your big sister. I am talking *bad*. It puts the "Mwa-ha" in "Mwa-ha-ha!"

MONSTERS

Demon Monster

This master of the underworld makes a great character. Standard options include horns, a masklike face, and the robe of a high priest from an ancient civilization. This particular version is fashioned after a primitive evil god, the type that would rise from an ancient temple and devour a human sacrifice. Add a serpentine collar around his neck and under his arms. The high collar gives him that high priest look. Note the double set of horns on the collar and hanging from the face. And don't waste your time cracking jokes to demons. It just ticks them off.

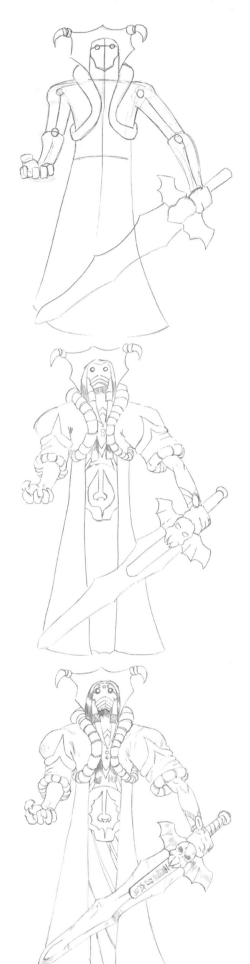

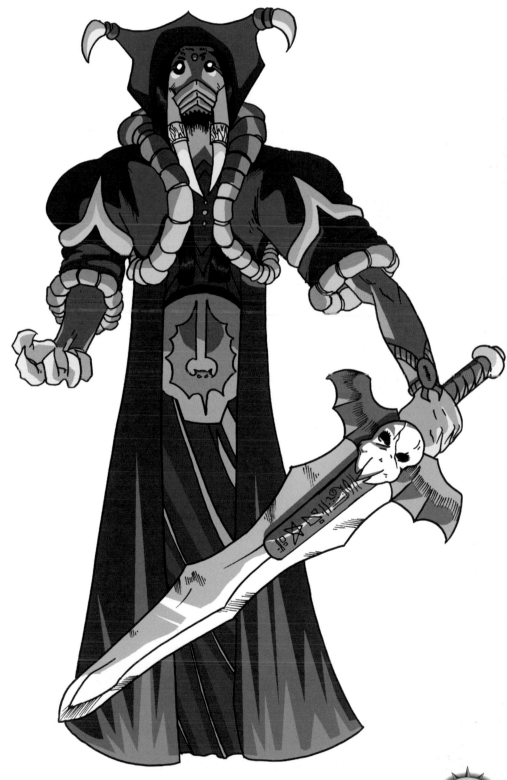

A NOTE ABOUT COLOR

Anime (Japanese animation) is always done in color. Much *manga* (Japanese comics)—on which anime is based—is done in black and white. You can get a wide range of gray tones using only black and white. However, American audiences always prefer color. Still, there are many interesting effects you can get without color. And in this section you'll see some good examples of it.

Here's an Eyeful

Disembodied eyeballs always creep people out. If you're going to all the trouble of drawing a giant, drippy eye, you might as well go all the way. So, for arms and legs, stick on some squid tentacles (and suckers). This fella hovers above the ground, which means he's an extra-terrestrial (as opposed to those Earthly eye monsters you see hanging out downtown). Monster visitors from other planets are always evil. Believe me, there's no such thing as an alien monster with a heart of gold. You can draw Mr. Eyeball any size you like, but it's only when you add humans to the picture that you truly see the scale of this creature here. He's immense! Watch this neat trick he has learned: juggling humans!

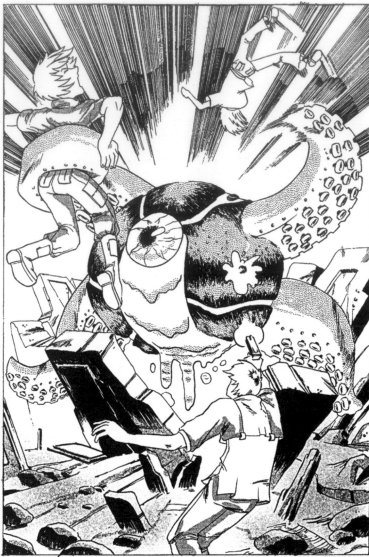

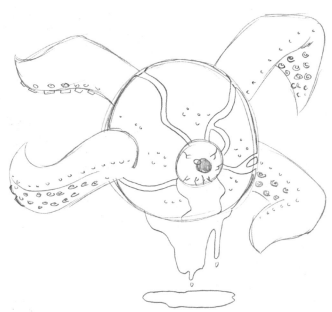

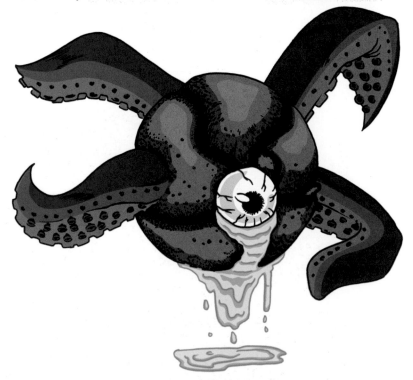

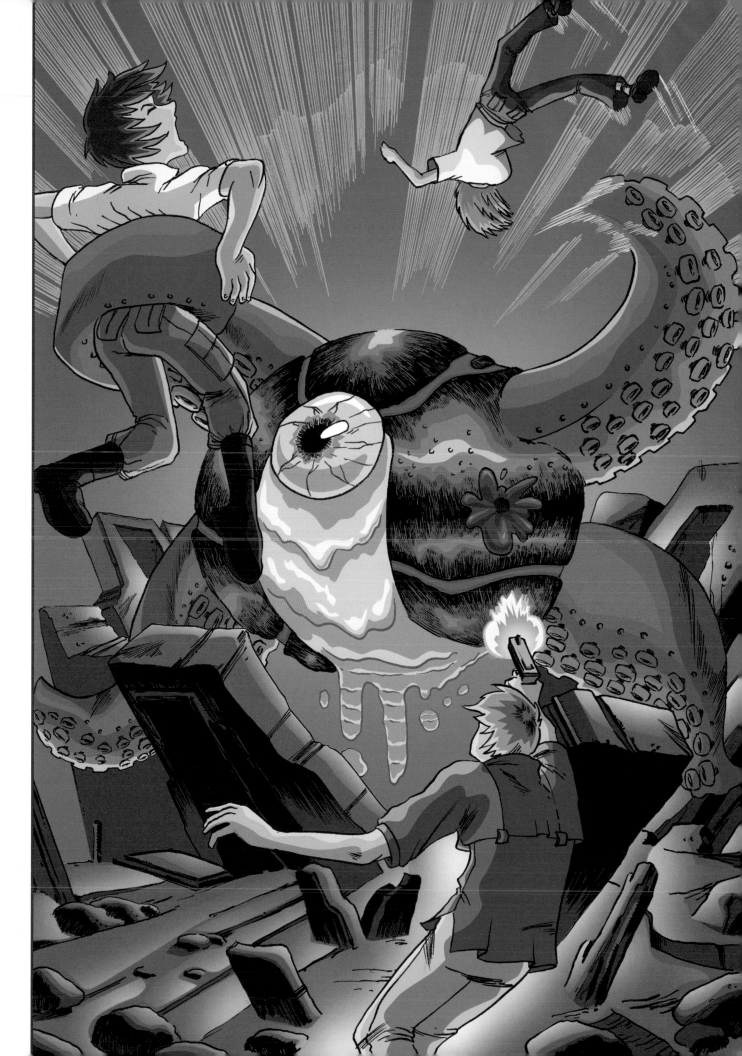

Giant (Mutant) Worm

First disembodied eyeballs, now giant worms. It just keeps getting better. When giant snakes just won't do, giant worms will provide all the gross-out factor you'll ever need. When drawing giant worms, go for an obese, grotesque look. Add a series of spindly, little arms, which makes it look like the creature is sinking in its own fat. Draw the body as a series of sections so that it has an armored look to it. Without the sections, it would look like a plain old worm, which isn't as interesting as if there's a textured, hard shell.

Don't draw too literal a face or it'll look cartoony. Instead, make the face less specific by leaving out the nose. A well-placed horn also helps monster faces. Notice that monster teeth aren't necessarily huge fangs. More often, they're similar to shark's teeth—a series of smaller, sharp triangles that fill the mouth.

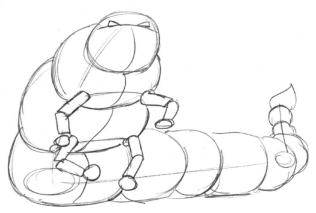

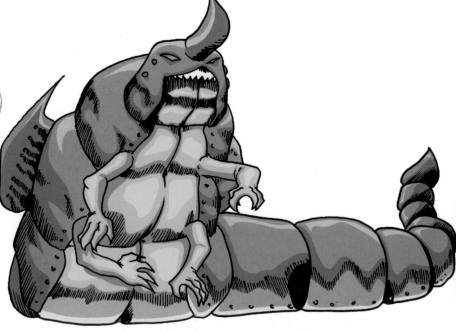

Strange Creatures

Sometimes, a monster is a giant freak of a thing that looks like it was put together by a visually impaired surgeon. The anatomy is all wrong, and that's what looks so cool about it. Take a look at the legs on this guy. They would be correct if this were a person posing with tummy side *up,* but look at the arms. They're positioned as if the torso were tummy-side *down.* It's the impossible combination of these two poses that makes this monster so weird. Add to that the vent tubes on its back, and you've got yourself something that is very hostile—probably because his HMO wouldn't "okay" the corrective surgery.

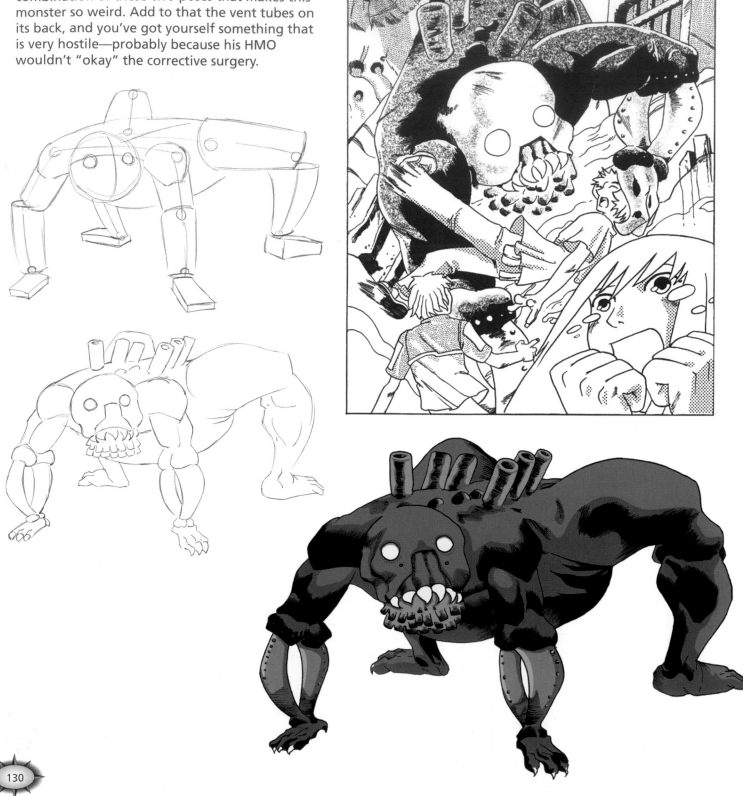

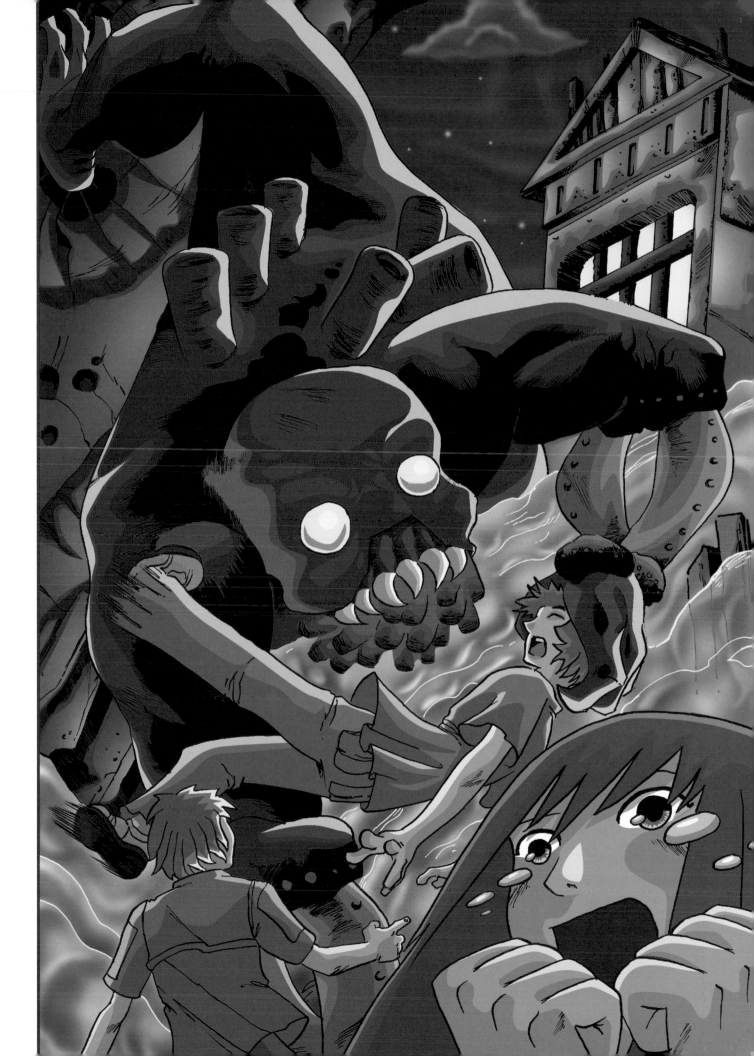

STEAM PUNK

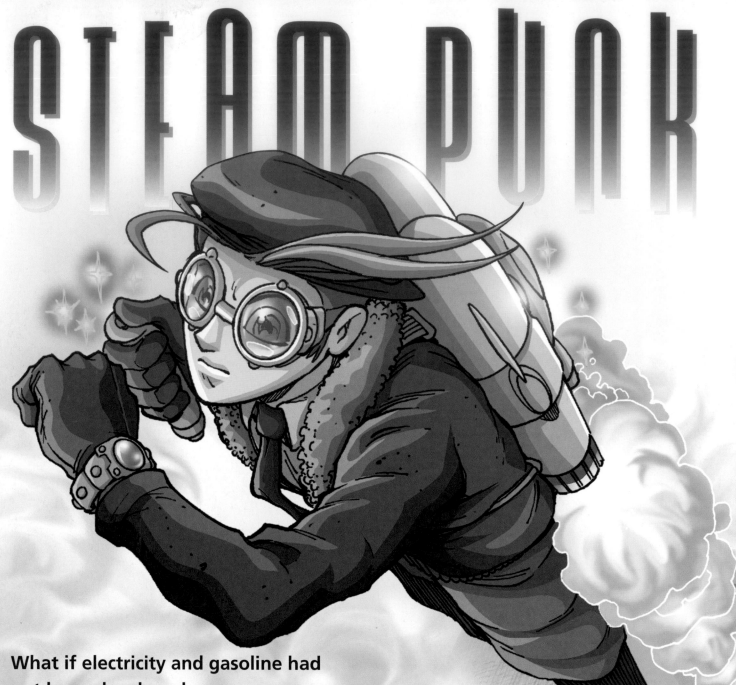

What if electricity and gasoline had not been developed as energy sources because steam power continued to evolve? And it kept on evolving to the point where it was powering advanced technology? This would result in powerful, hybrid machines that run solely on steam. This is the very clever premise of steam punk. It takes place in a time period anywhere from the 1800s up to about the 1930s. It results in an imaginative blend of old fashioned Americana and modern-day gizmos. However, to run on steam, the machines of the steam-punk genre had to evolve differently. So, a telephone in the steam-punk genre would look very different from an actual 1930s telephone. But steam punk is more than gizmos; it's a wondrous world of the future-past.

Steam-Punk Scene, c. 1890

Welcome to the world, not as it was but as it *could have been,* if only. . . . There's the hustle and bustle of turn-of-the-century city streets and stores. But instead of horse-drawn carriages and some primitive automobiles, there are steam-powered motorcycles, steam-powered giant robots, and a flying hero who uses magical jewels to give himself special powers.

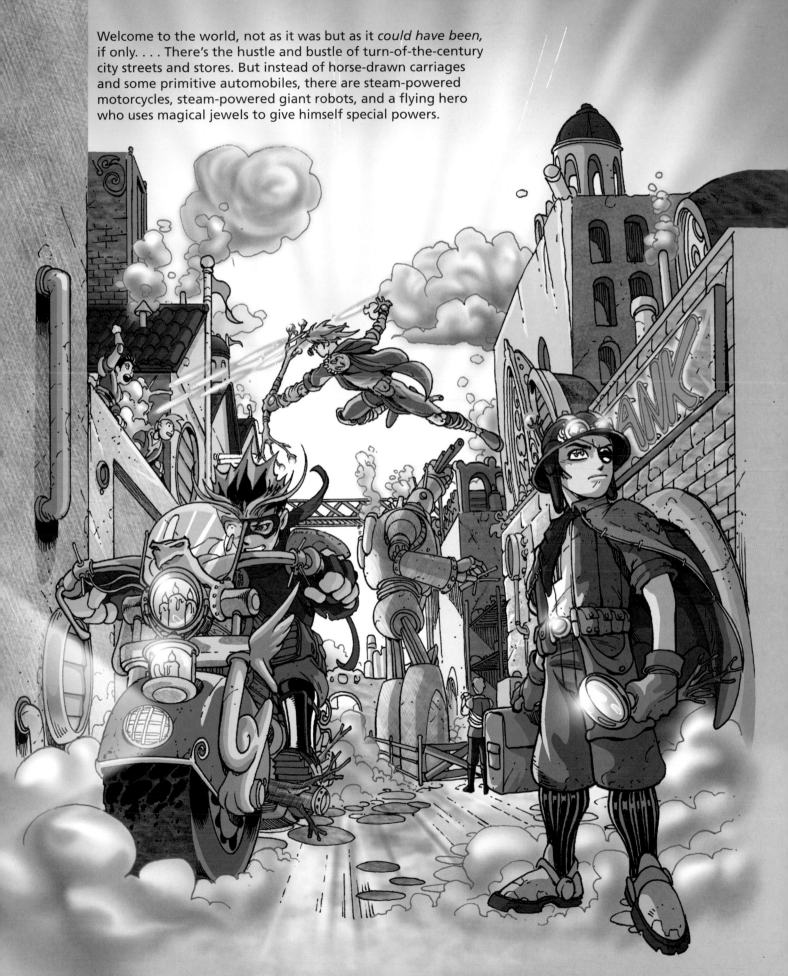

Some Basic Steam-Punk Characters

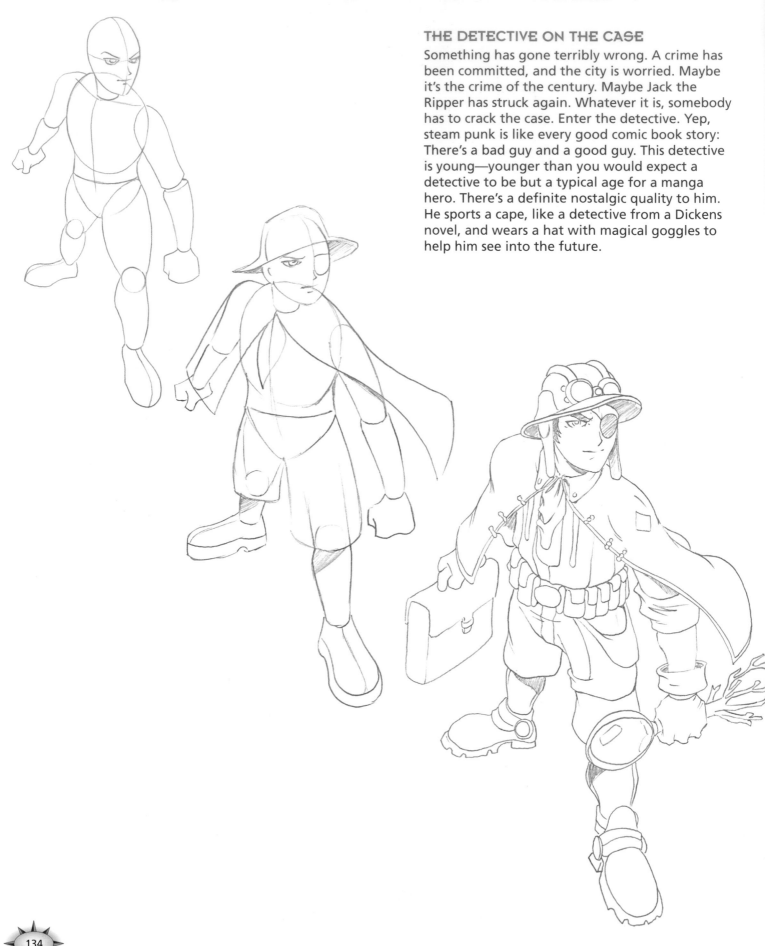

THE DETECTIVE ON THE CASE

Something has gone terribly wrong. A crime has been committed, and the city is worried. Maybe it's the crime of the century. Maybe Jack the Ripper has struck again. Whatever it is, somebody has to crack the case. Enter the detective. Yep, steam punk is like every good comic book story: There's a bad guy and a good guy. This detective is young—younger than you would expect a detective to be but a typical age for a manga hero. There's a definite nostalgic quality to him. He sports a cape, like a detective from a Dickens novel, and wears a hat with magical goggles to help him see into the future.

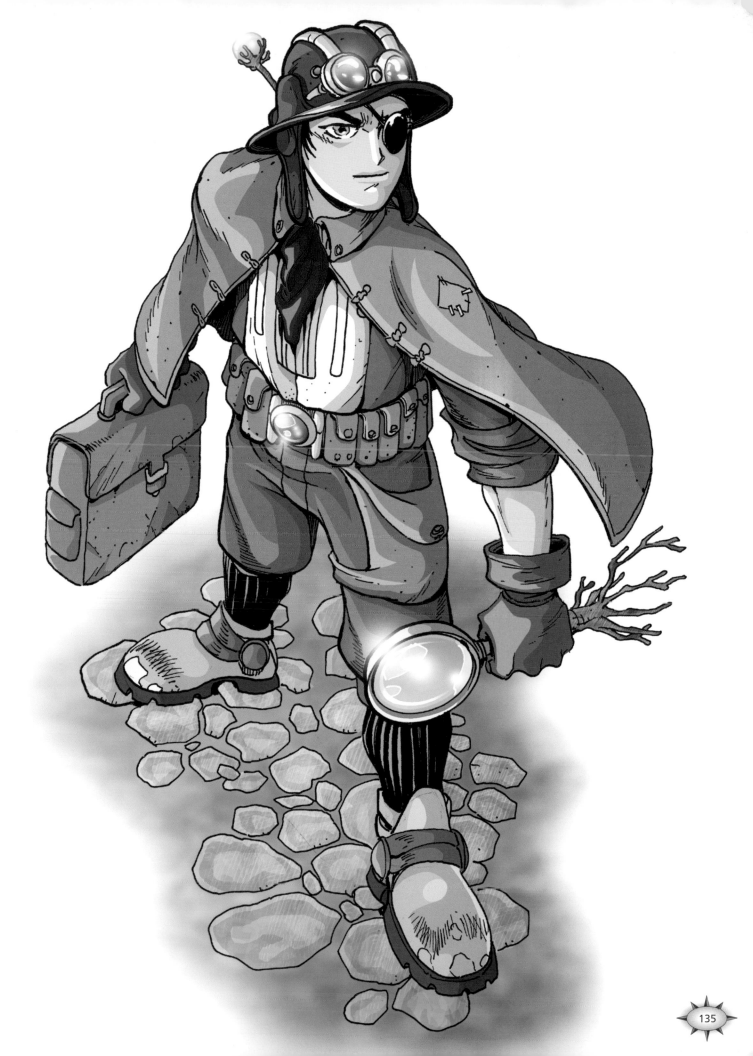

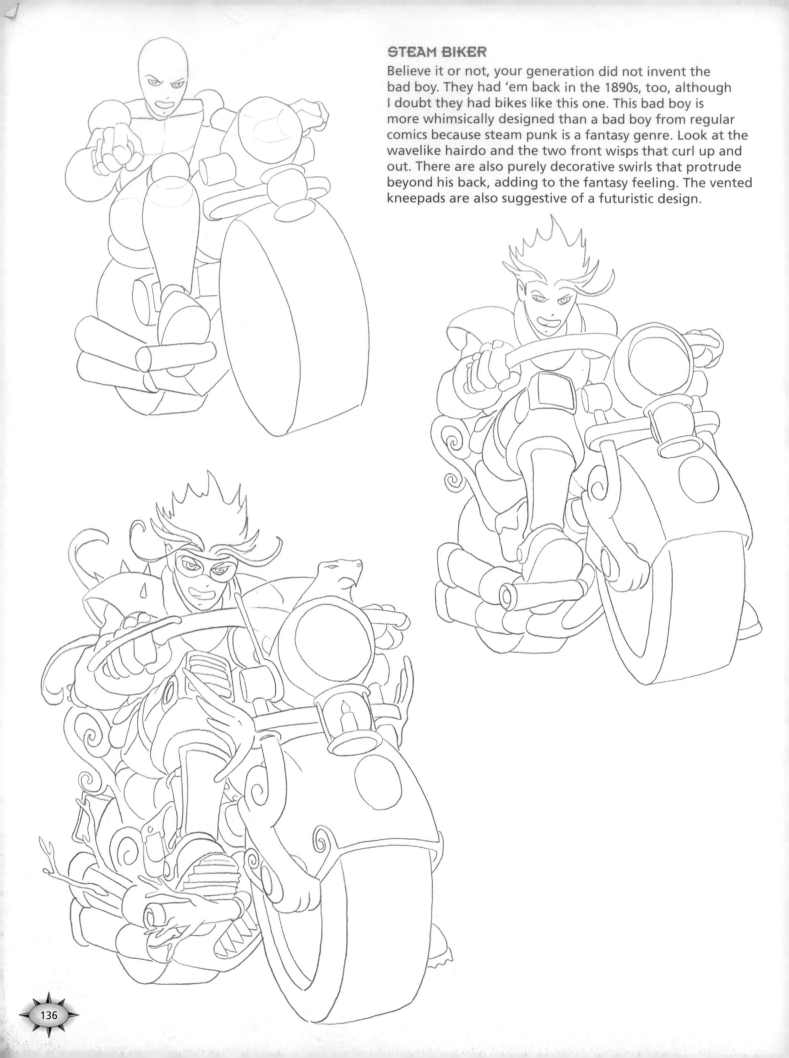

STEAM BIKER

Believe it or not, your generation did not invent the bad boy. They had 'em back in the 1890s, too, although I doubt they had bikes like this one. This bad boy is more whimsically designed than a bad boy from regular comics because steam punk is a fantasy genre. Look at the wavelike hairdo and the two front wisps that curl up and out. There are also purely decorative swirls that protrude beyond his back, adding to the fantasy feeling. The vented kneepads are also suggestive of a futuristic design.

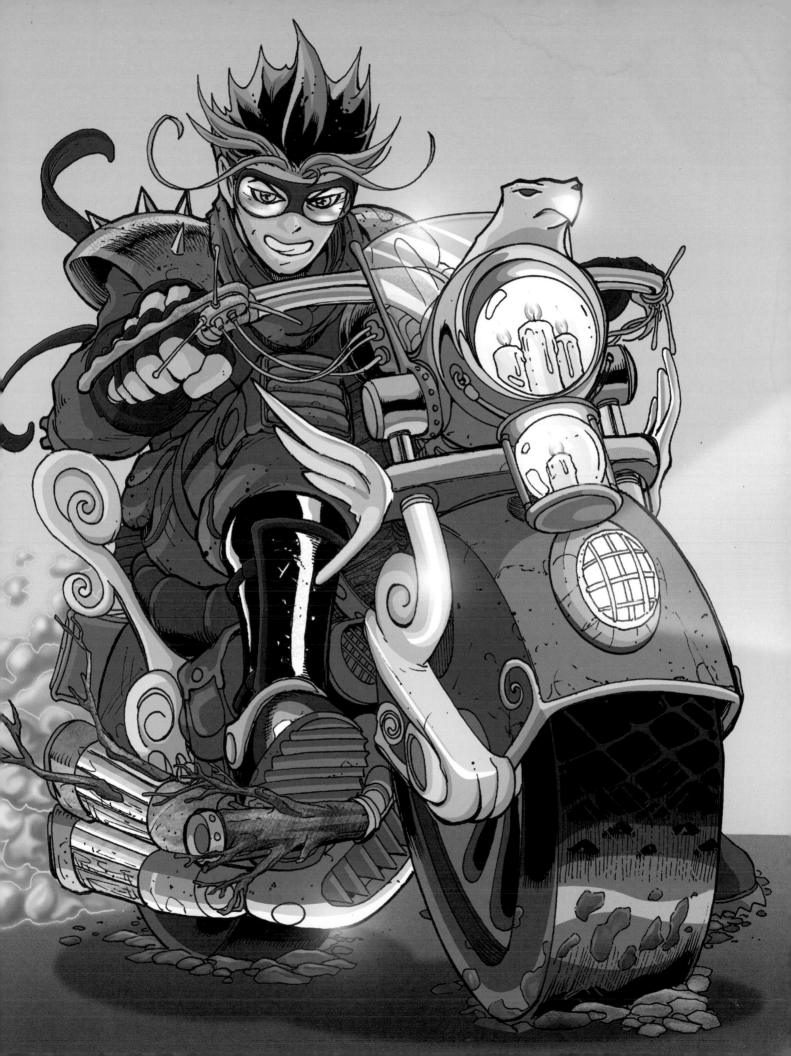

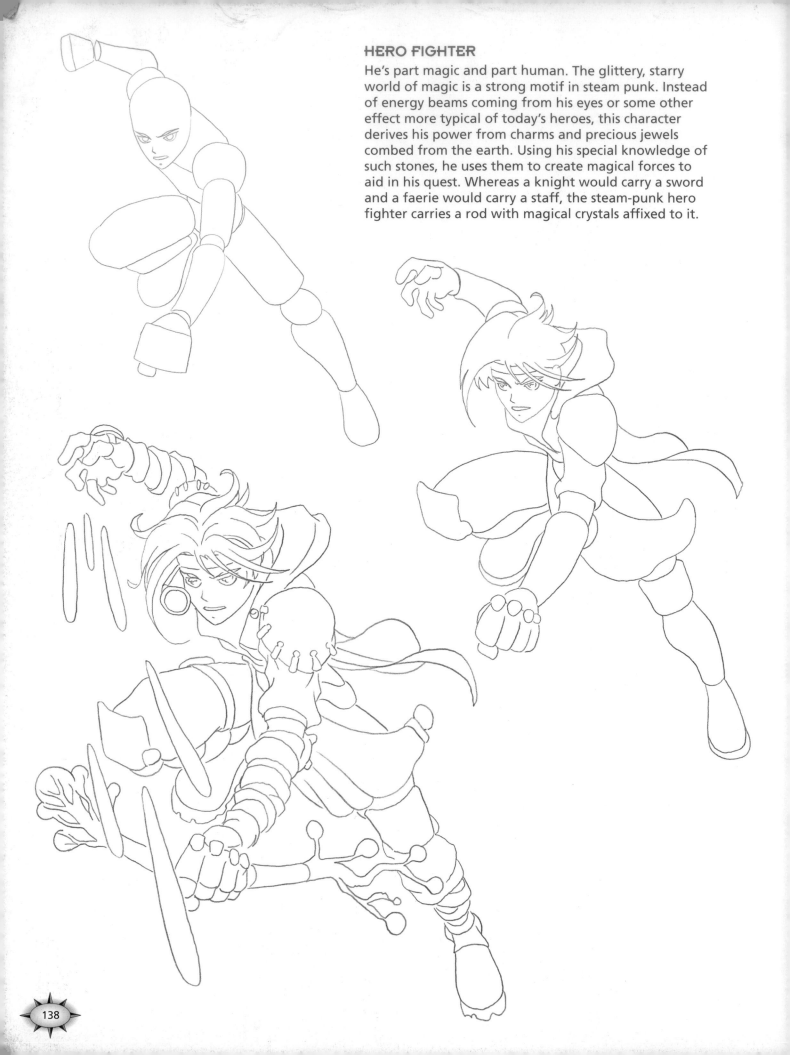

HERO FIGHTER

He's part magic and part human. The glittery, starry world of magic is a strong motif in steam punk. Instead of energy beams coming from his eyes or some other effect more typical of today's heroes, this character derives his power from charms and precious jewels combed from the earth. Using his special knowledge of such stones, he uses them to create magical forces to aid in his quest. Whereas a knight would carry a sword and a faerie would carry a staff, the steam-punk hero fighter carries a rod with magical crystals affixed to it.

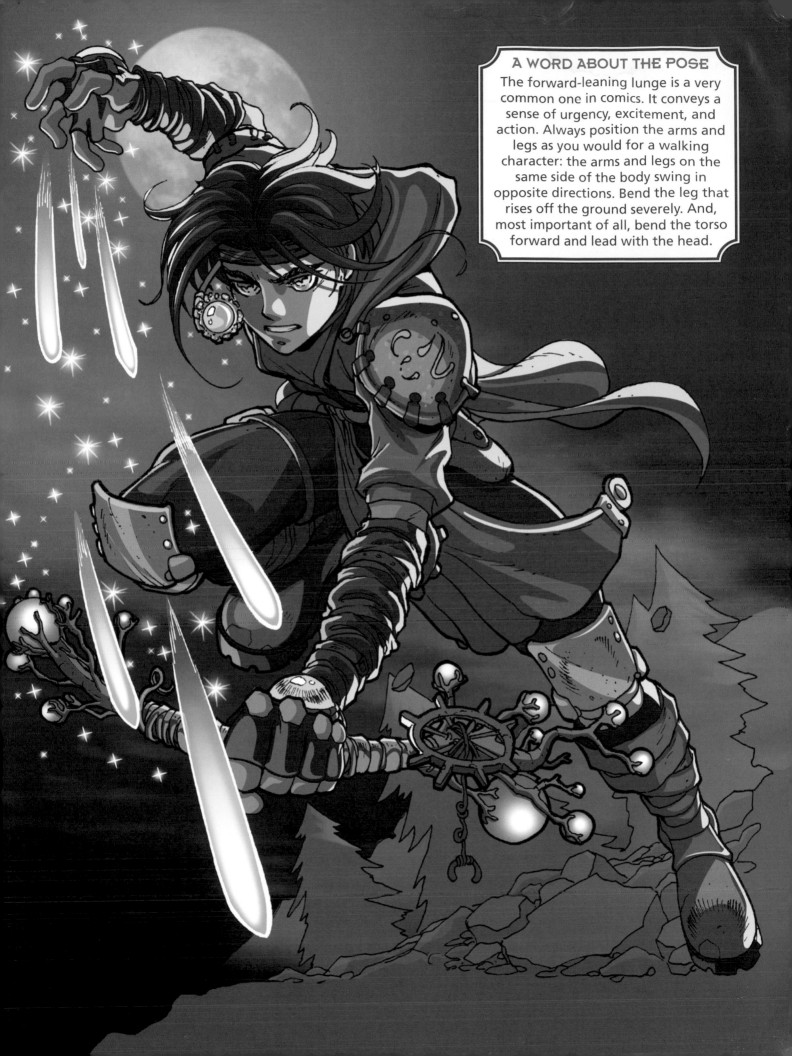

Getting Specific with Gadgets

Everyone loves gadgets, and steam punks are the kings of gadgetry. When you set out to draw the gadgets and gizmos that readers love, noodle around with the details. Get intricate. Readers like to focus on these inventions; it sparks their imaginations.

It's really important to make the gadgets look functional, even if you don't know what the heck they're supposed to do! The gadgets that look most convincing are the ones that are based on real objects and are then tweaked.

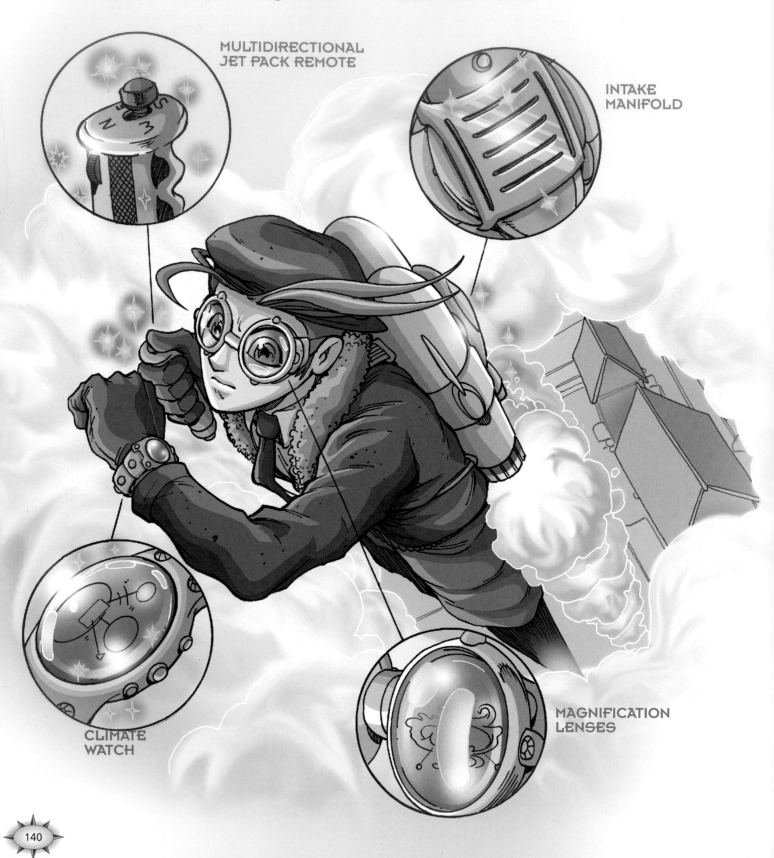

MULTIDIRECTIONAL JET PACK REMOTE

INTAKE MANIFOLD

CLIMATE WATCH

MAGNIFICATION LENSES

Steam-Punk Robots

The difference between a steam-punk robot and a futuristic mecha robot is huge. It's the difference between a steam train and the space shuttle. The steam-punk robot should look as if it is made from the spare parts of a washer-dryer set. It's big, steal, and round—and it's a friendly robot. There are no laser-fired torpedoes sprouting from its chest. It's a helper, not a fighter. And, it's ponderously slow. There are no faring shoulders, no weaponized hands. Just big, round eyes and lots of steam vents. The mecha robot, on the other hand, is a fierce fighting machine with a complex arrangement of armor plates and a very angular face.

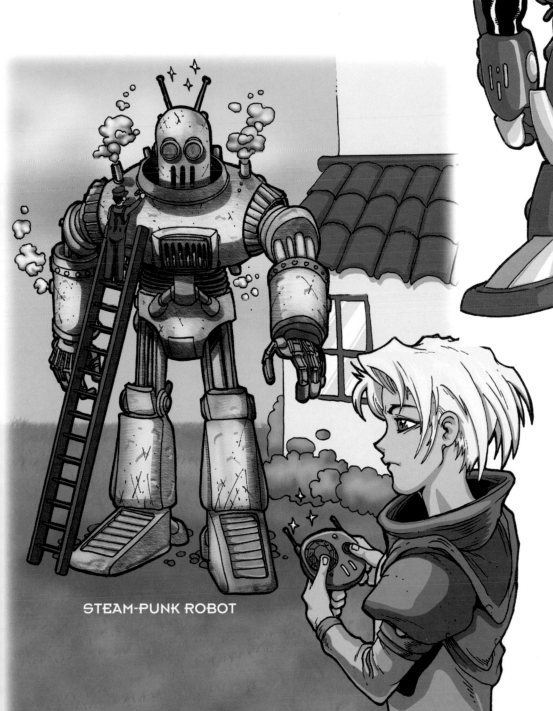

STEAM-PUNK ROBOT

MECHA ROBOT

Steam-Powered Transportation

There are many ways to travel in a world that could have been: high-speed steam trains, flying bicycles, jet backpacks, steamcycles, passenger hot air balloons, and any more you can invent. What about a steam-powered helicopter?

As you combine the past and future, don't forget to include the human element. We think about the past fondly because we generally believe it was a more innocent time. Try to capture that spirit: Draw costumes from that period and create a more clean-cut look.

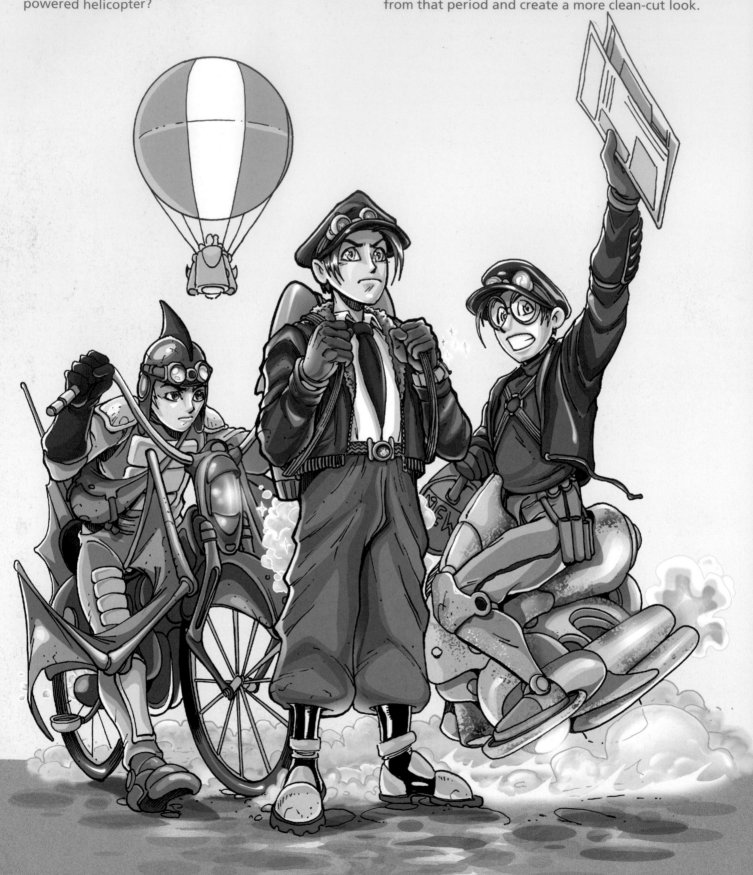

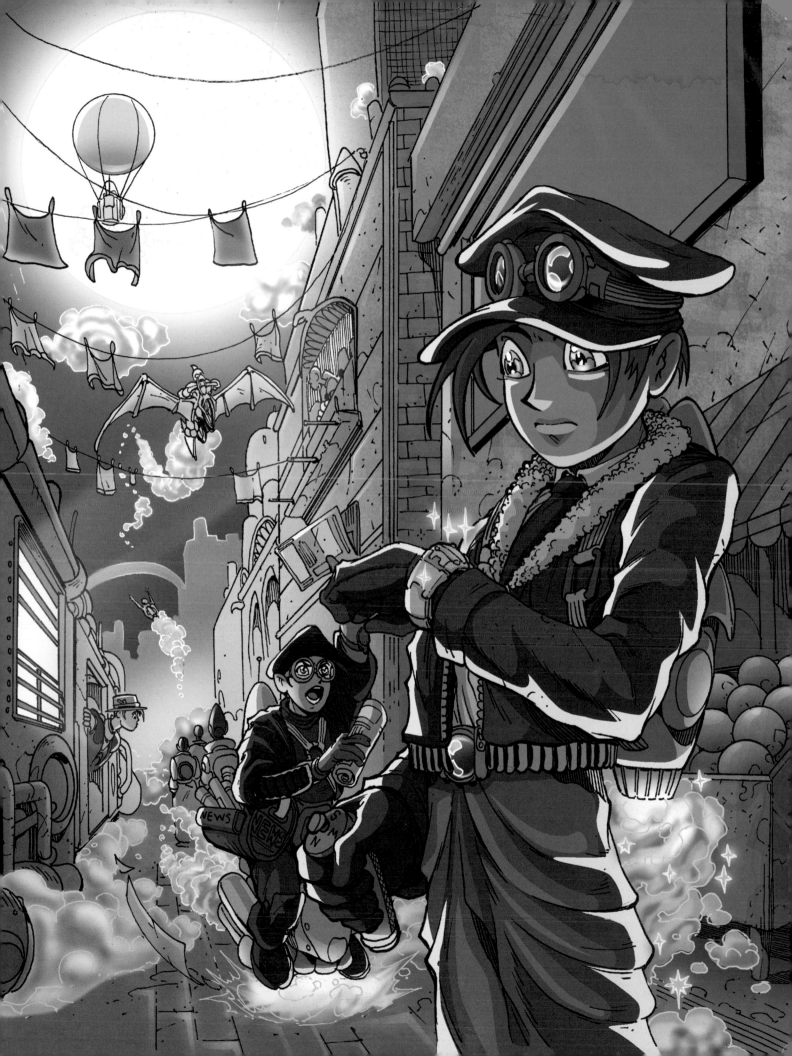

INDEX